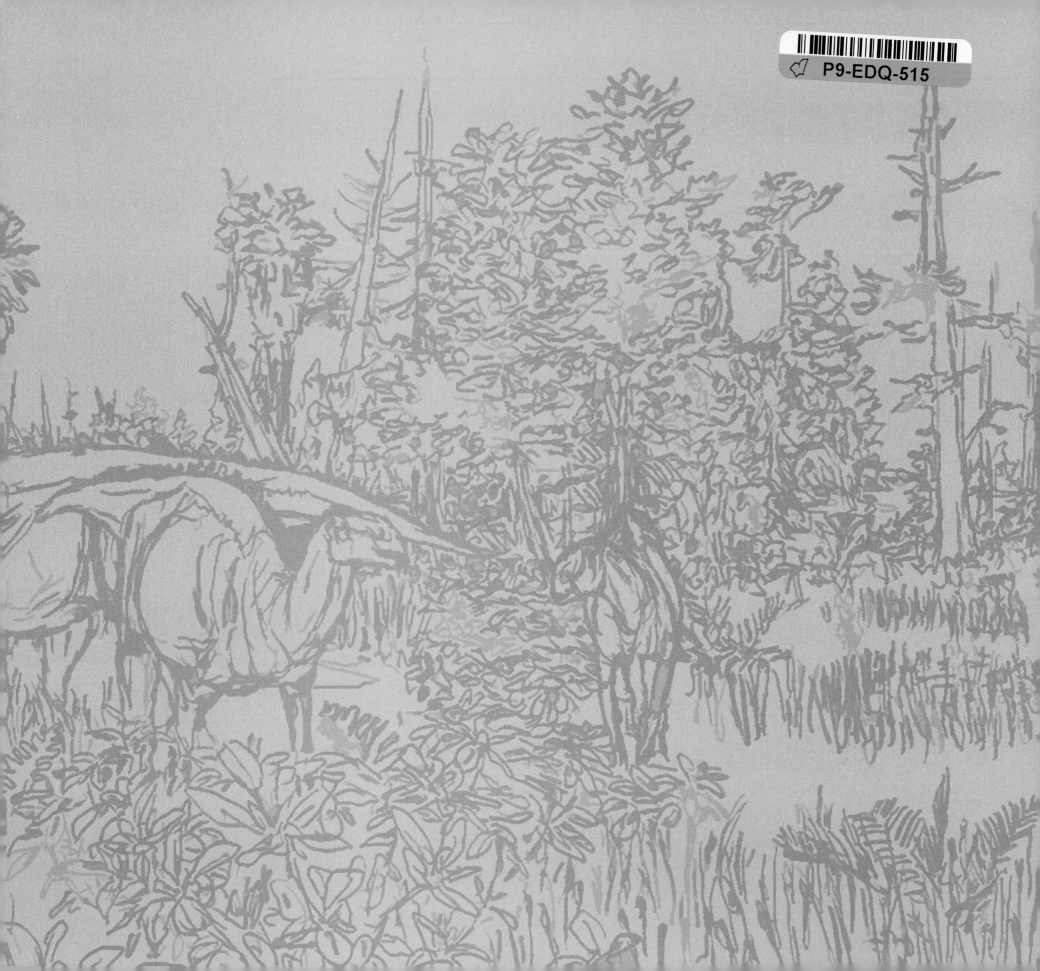

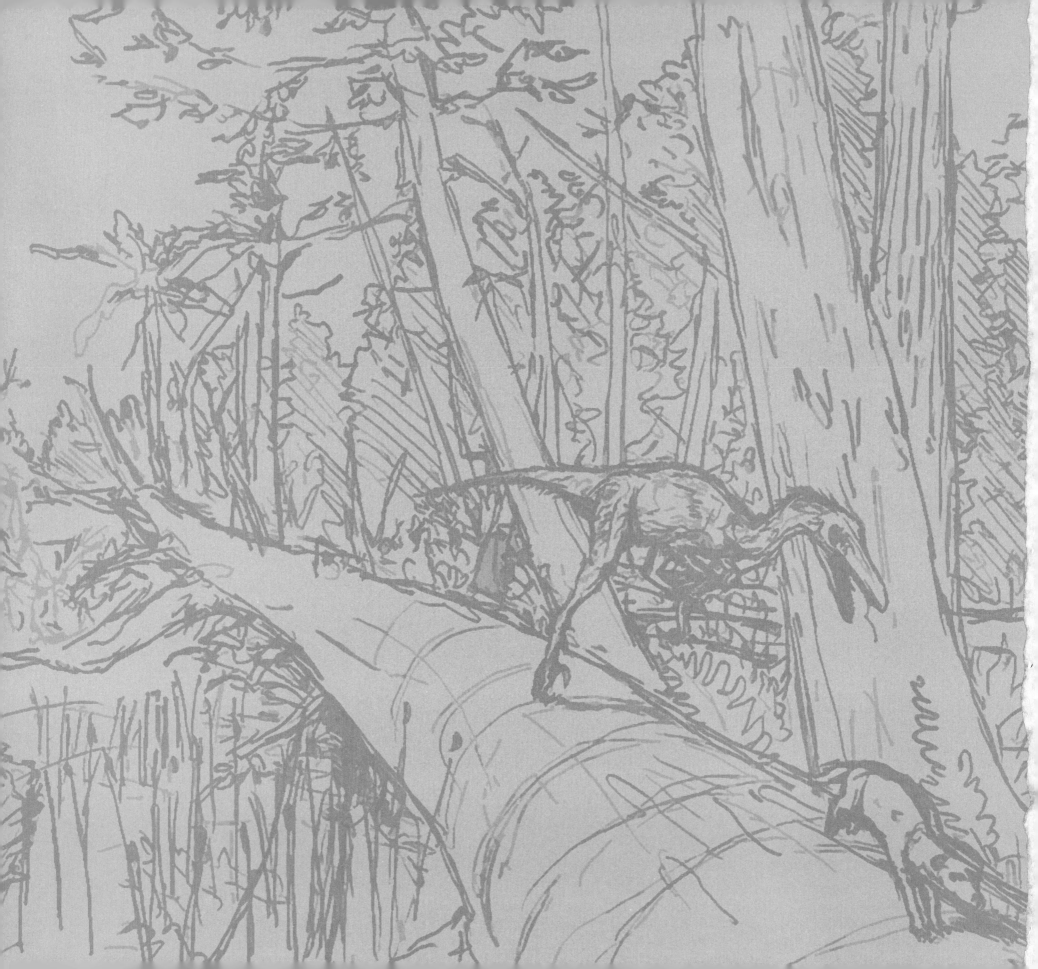

THE PALEOART OF
JULIUS CSOTONYI

DINOSAURS, SABER-TOOTHS & BEYOND

The Paleoart of Julius Csotonyi: Dinosaurs, Saber-Tooths & Beyond
ISBN 9781781169124

Published by
Titan Books
A division of Titan Publishing Group Ltd.
144 Southwark St.
London
SE1 0UP

First edition: May 2014

10 9 8 7 6 5 4 3

All artwork, excluding page 9, is copyright © 2014 Julius Csotonyi, unless otherwise noted in the image caption.

Acknowledgements
Julius Csotonyi would like to thank: first, Steve White and the team at Titan Books for extending this opportunity to share my collection of artworks with the public in such a beautifully designed book; those, such as Mike Fredericks and Dougal Dixon, who first sought out my work and helped to introduce it to the world; the helpful scientists, exhibit design teams, and publishing teams who shared their time to guide both the scientific direction and artistic development of my restorations for exciting projects at places such as the Royal Tyrrell Museum, the Royal Ontario Museum, the Los Angeles County Museum of Natural History, the Houston Museum of Natural Science, Gondwana Studios, the Canadian Museum of Nature, the Manitoba Museum, the Royal Canadian Mint, the Museum of the Red River, and the University of Alberta; the many paleontologists who volunteered their time to contribute to this volume in the form of constructive feedback on artwork or scientific stories; my loving wife, Alexandra, for her support, patience, inspirational ideas, and collaboration in the creation of artworks; and my wonderful family, friends, and mentors for encouraging me on my winding path through science and scientific illustration to the present.

Steve White would very much like to thank Julius Csotonyi for coming on board for this enterprise and producing some stunning artwork for us; Tim Scrivens for pulling together said art into a wonderful-looking book; and to Jo Boylett, my ever patient eye-of-the-storm line editor.

Titan Books would like to thank Julius Csotonyi for sharing his work, thoughts, and time with us on this project, as well as all those paleontologists who contributed to the accompanying text. With special thanks to Dr. David C. Evans for the Foreword and Dr. Robert T. Bakker for the introduction. Thank you also to Steve White for introducing us to paleoart and many of the talented artists who work in that field.

Did you enjoy this book? We love to hear from our readers. Please e-mail us at readerfeedback@titanemail.com or write to Reader Feedback at the above address.

To receive advance information, news, competitions, and exclusive offers online, please sign up for the Titan newsletter on our website: **www.titanbooks.com**

"*Spinops* is a fascinating beast within the history of paleontology. The original bones were discovered in 1916 by the famed Sternberg fossil hunting family, but sat neglected on a London museum shelf for decades. Several colleagues and I recognized them as a previously unknown species – unknown to us, that is. The Sternbergs knew this way back in 1916, but were ignored at that time by the paleontologists in London. *Spinops* turns out to be a close relative of *Centrosaurus*, and the two animals differ primarily in the shape and prominence of the spikes on the back of the frill."
Dr. Andrew Farke, Curator of Paleontology, Raymond M. Alf Museum of Paleontology

"*Spinops*, an interesting, new centrosaurine ceratopsian described in 2011 but with a mystery attached. Poor 1916 field locality information means the site is lost despite best efforts to relocate it. But the search continues..."
Darren Tanke, Senior Technician, Royal Tyrrell Museum

(Page 1) **Tycho Crater Impact Event and *Thalassodromeus*.** Digital painting. 2013.

(Page 3) ***Tyrannosaurus*.** Graphite. Commission: Terror of the South exhibit, North Carolina Museum of Natural Sciences. 2006.
Tyrannosaurus was one of the most fearsome terrestrial predators of all time. This image was commissioned to distinguish its features from another North American super-predator, around which the exhibit was built: *Acrocanthosaurus*.

(Pages 4-5) **Laramidia: Hell Creek Formation.** Photographic composite. Commission: Royal Ontario Museum. 2012.
Courtesy of the Royal Ontario Museum, © ROM, Toronto, Ontario, Canada.

(Pages 6-7) **Estemmenosuchus in the Permian.** Photographic composite. Commission: Gondwana Studios (Australia). 2011.
This image features (left to right) *Eotitanosuchus*, *Estemmenosuchus*, and *Platyoposaurus*.

THE PALEOART OF
JULIUS CSOTONYI

DINOSAURS, SABER-TOOTHS & BEYOND

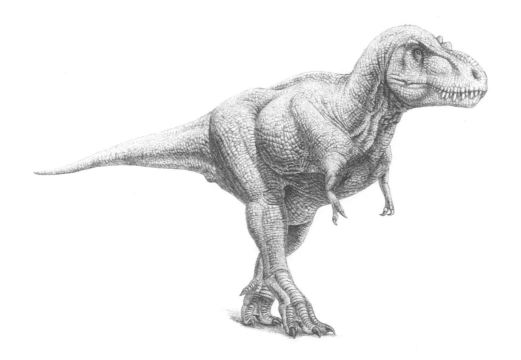

WRITTEN BY JULIUS CSOTONYI & STEVE WHITE

FOREWORD BY DAVID C. EVANS

INTRODUCTION BY ROBERT T. BAKKER

TITAN BOOKS

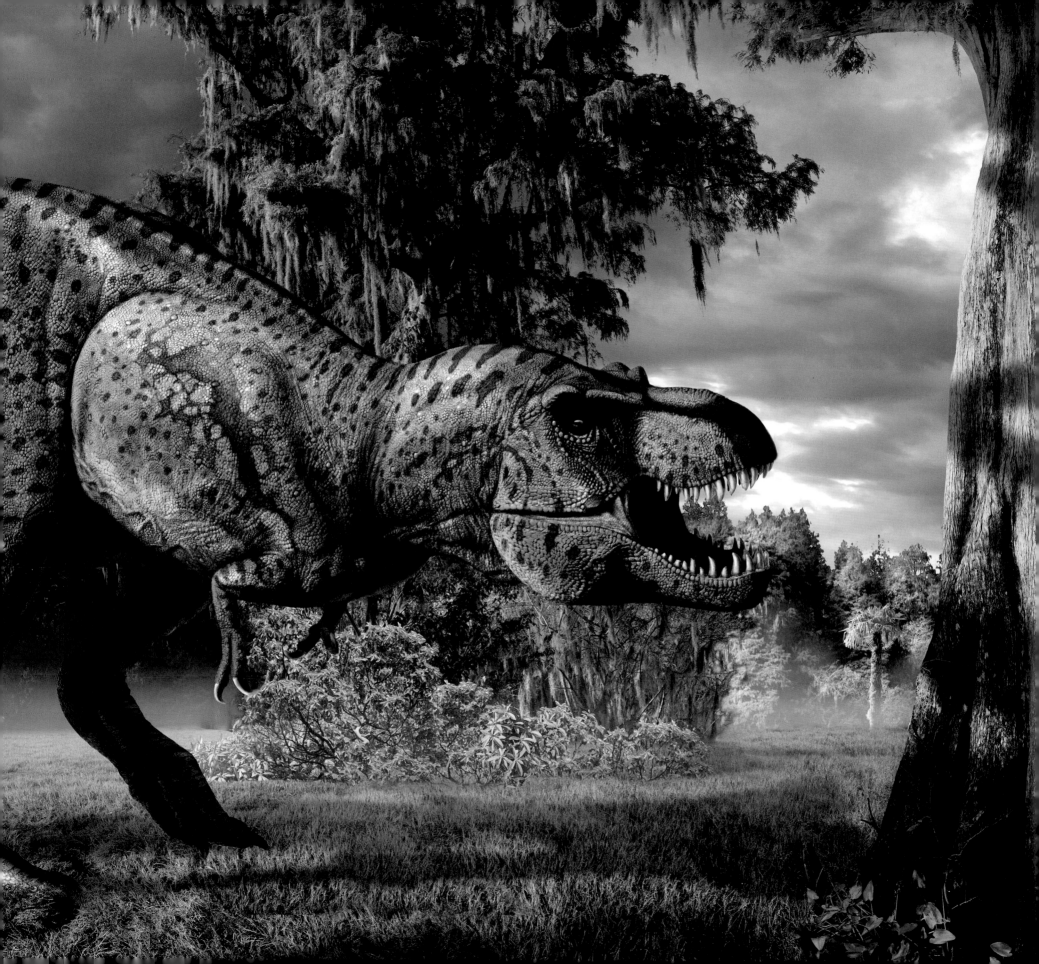

CONTENTS

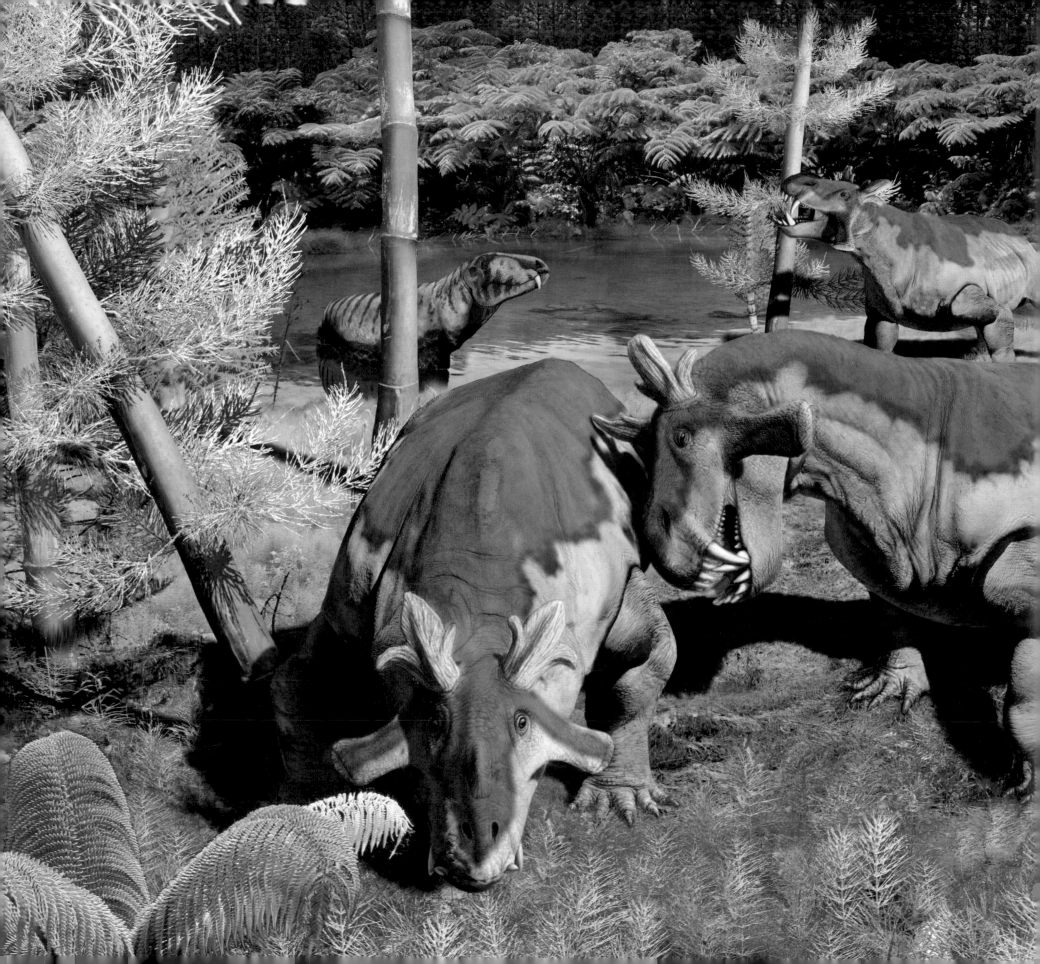

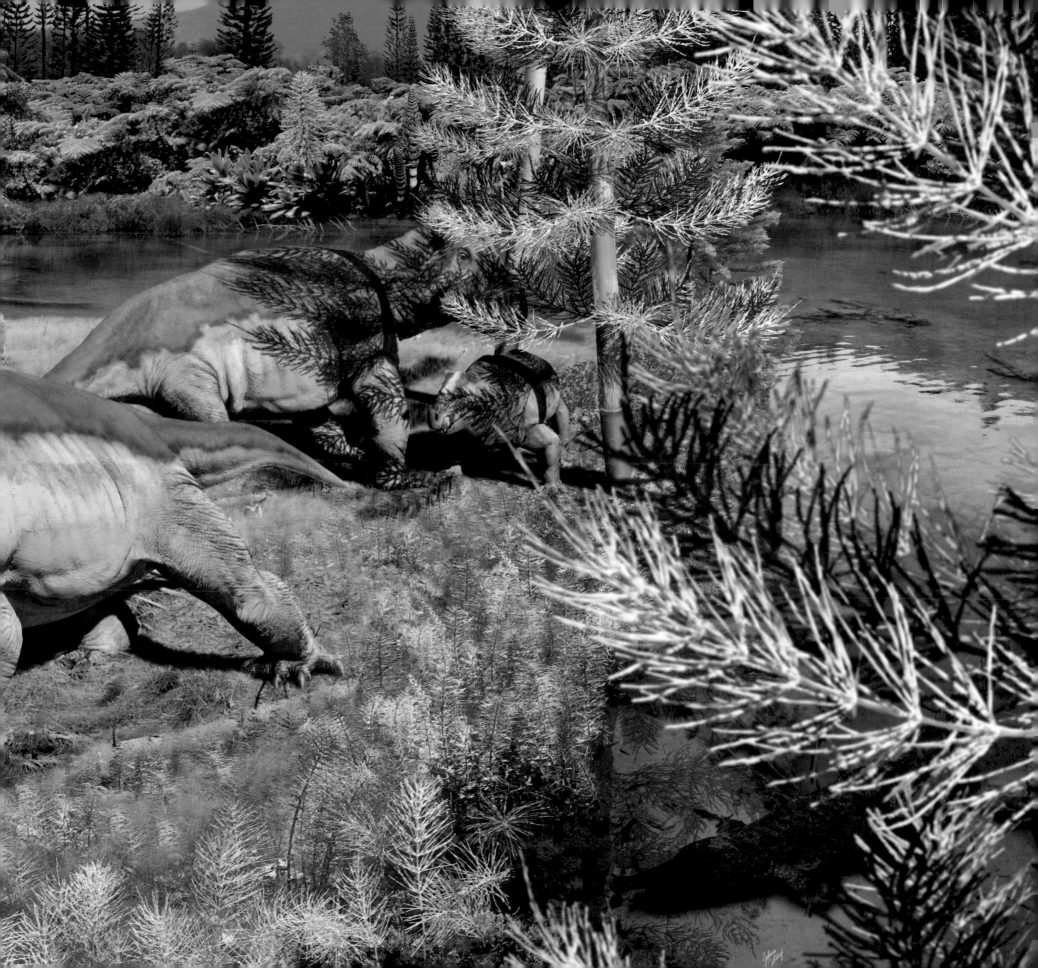

FOREWORD

Fossils are evidence of prehistoric life written in stone. Although some specimens, like the famous fighting *Velociraptor* and *Protoceratops* preserved in combat, can be breathtaking, the fossils themselves are ultimately drab. They range in color from black and brown to white, sometimes with red and yellow hues, but even in the most exceptional states of preservation, delicate fossil leaves have lost their vibrancy and the color of dinosaur skin is still unknown. Color is an attribute of the living.

Artists color prehistoric life, and thereby connect the past with the present – they make it come alive for both scientists and the public. For the non-scientist, color brings deeper accessibility and appreciation, and ultimately a better understanding of evolution and the diversity of life through time. And for scientists working with artists, color often forces us to pause, think more carefully about what we know, and ultimately learn more about the fossils and the world in which they lived so that the reconstruction can be as accurate as possible.

Few artists bring prehistoric animals and landscapes into their full spectrum of color more effectively than Julius Csotonyi. Pioneering the merging of true-to-life photography with digital painting, the lines between what's real and what is reconstruction become even more blurred. With a doctorate degree in microbiology, Julius brings as much science to art as the other way around. He has fleshed out images from some of the smallest of clues; for instance, the skull dome of the *Acrotholus* turned into an inquisitive face-to-face moment with a turtle soaking in a dinosaur footprint. At the other end of the spectrum, he has brought some of the best-known fossil ecosystems back to life, and enhanced numerous museum exhibits – including a spectacular series of murals for the Houston Museum of Natural History. Perhaps his biggest effort to date, in terms of size, has been his life-sized murals for the Royal Ontario Museum's Ultimate Dinosaurs exhibition. When viewed through the ribcage of a full-sized skeletal mount, the monstrous meat-eater *Tyrannosaurus*, in glorious color, has never been more real.

Dr. David C. Evans
Curator of Vertebrate Palaeontology
Royal Ontario Museum

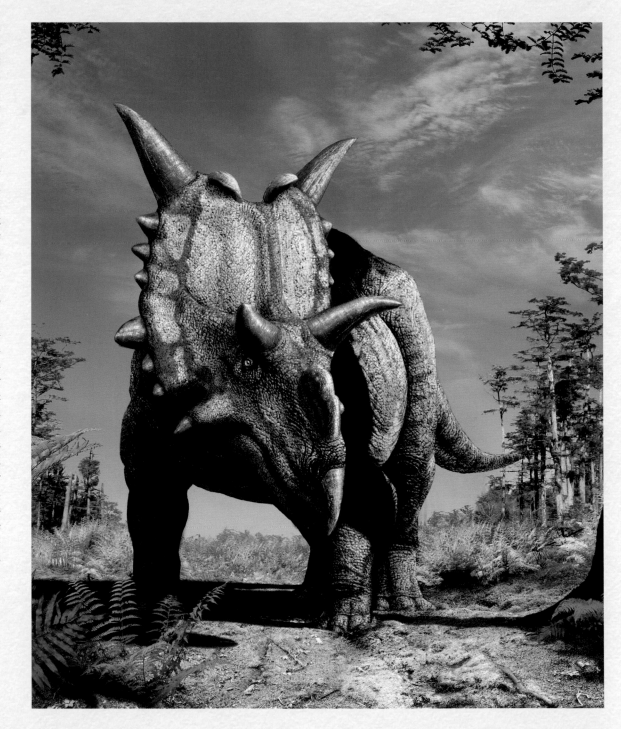

Xenoceratops. Photographic composite. Commission: Dr. Michael Ryan, Cleveland Museum. 2012.
A ceratopsian recently found in the Foremost Formation in Alberta, Canada.

CAPTURING A MOMENT IN DEEP TIME

Julius does more than portray extinct beasts with anatomical precision. And more than setting the ferocious fin-back of the Texas Red Beds in its proper habitat. Julius's marvelous back-lit murals at the Houston Museum of Natural Science capture vivid episodes in the Darwinian drama, moments of Deep Time *that actually happened.*

Each scene is constructed from years – sometimes decades – of field research and lab analysis.

Case in point: the Craddock Bone Bed (part of the Texas Red Beds) mural. Here we see the 'honorary dinosaur' *Dimetrodon* (dimetrodons actually are early mammal-like reptiles, not dinosaurs, but are awarded dino status because of the nifty fin and savage tooth row), Top Predator of the earliest land ecosystem that developed in the Early Permian. Text books tell us that d'dons, being armed with saw-edged fangs, fed upon the big herbivores of the time, notably the shovel-footed diadectids and the 'Ship Lizard' *Edaphosaurus*. Nearly all Early Permian murals show this predator-prey couplet. Makes sense. But it's wrong.

As the late E.C. Olson pointed out back in the 1950s, there just wasn't enough veggie-saur prey to support the dimetrodons. Our Houston expeditions confirm the awkward deficit of herbivore carcasses: over eight years of digging across fifty-five sites, we have, on average, only one herbivore specimen per eight carnivores. So what DID dimetrodons feed upon?

Olson said fish and aquatic amphibians. One mega-site, the Craddock Bone Bed, confirms Olson's notion. A dozen layers of pond mudstone capture episodes when *Dimetrodon* fed on its prey, leaving its shed teeth to identify the predator. What was the number one prey item? Swamp-sharks, xenacanths. The shed teeth are mingled with masses of mangled shark skulls and bodies (xenacanths have highly mineralized skeletons, so they preserve well). What was the number two prey? Flat-bodied, bottom-hugging amphibians like the 'Boomerang-Head' *Diplocaulus*. Chewed Boomers are everywhere in the site, accompanied by numerous shed *Dimetrodon* tooth crowns.

Olson described how this food chain lasted through ten million years at least. How did the sharks and amphibs deal with the *Dimetrodon* predation? The xenacanth sharks carried a long, serrated head spine, grooved to deliver venom. The Boomerang amphibians went for a passive defense, digging burrows to hide. Our bone bed preserves complete Boomers still snuggled in their burrows, as well as many skeletons pulled apart.

Julius's mural puts each petrified act in context. The big d'don is 'Willi', a fine skeleton from an individual with a cleft in his fin. He is trying to subdue a large shark while avoiding the venomous spine. Boomerang Heads are emerging from their sub-surface refuges. A dozen other species wrangle with each other, every combatant recorded by specimens dug from the same level in the same bone bed.

The result: Julius's mural is the most accurate, most dynamic of all the images of *Dimetrodon* and its environs.

We museum folks, fossil-hunters and artists alike, are on the front line of the battle to defend science. The mural works with the exhibited fossils to decipher the narrative written in the rocks. Art and paleontology combine to teach kids and adults how to use their scientific imagination to solve mysteries of evolution.

Dr. Robert T. Bakker

Layers of the Craddock Bone Bed Cutaway.
Image courtesy of Dr. Robert Bakker.

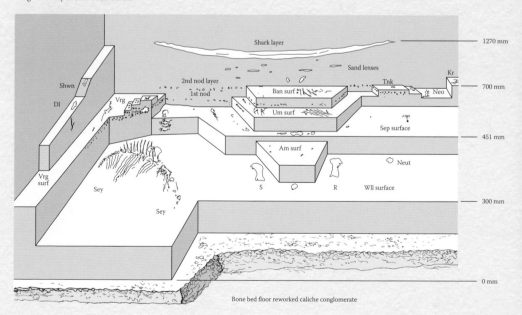

Layers of the Craddock Bone Bed Photo.
Image courtesy of Dr. Robert Bakker.

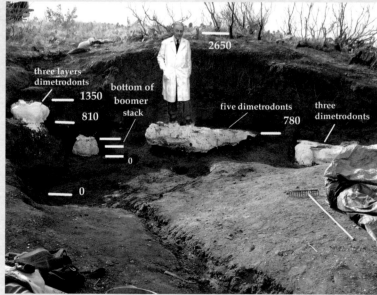

Permian (Texas Red Beds) Scene. Photographic composite.
Commission: Hall of Paleontology at the Houston Museum of Natural
Science. 2012.
Shown here is a terrestrial Texas scene including (left to right)
Eryops (with *Diplocaulus* in its mouth), *Edaphosaurus, Araeoscelis,
Secodontosaurus, Dimetrodon grandis, Dimetrodon giganhomogenes*
(in background), an unnamed sail-backed relative of *Dimetrodon*
attacking *Xenacanthus* and *Diadectes.* In the water are *Trimerorhachis,
Diplocaulus,* and *Meganeuropsis.*

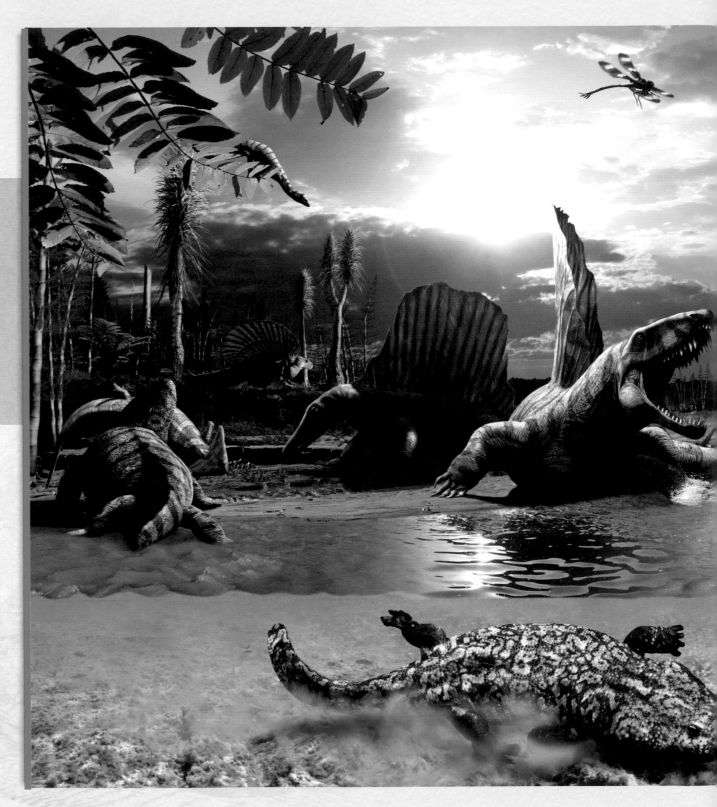

"The murals created for the Morian Hall of Paleontology
depict extinct animals interacting with each other
and their reconstructed ecosystems. These murals
visualize and contextualize the fossils in the hall; they are a visual
translation of paleontological science. The murals also transport the
viewer to a different time, while inspiring and conveying the beauty
and elegance in nature. Julius's techniques meld traditional and
digital techniques which allowed us the flexibility to incorporate
recently discovered anatomical details from the most current
research. This technique also allowed for very close alignment of
the concept drawings created by Dr. Robert Bakker, the skeleton
mounts executed by the Black Hills institute of Geologic Research,
and the art created by Julius. This collaborative process was nimble,
exciting and a wonderful adventure in paleontology. The results
speak for themselves."
David Temple, Associate Curator of Paleontology, Houston
Museum of Natural Science

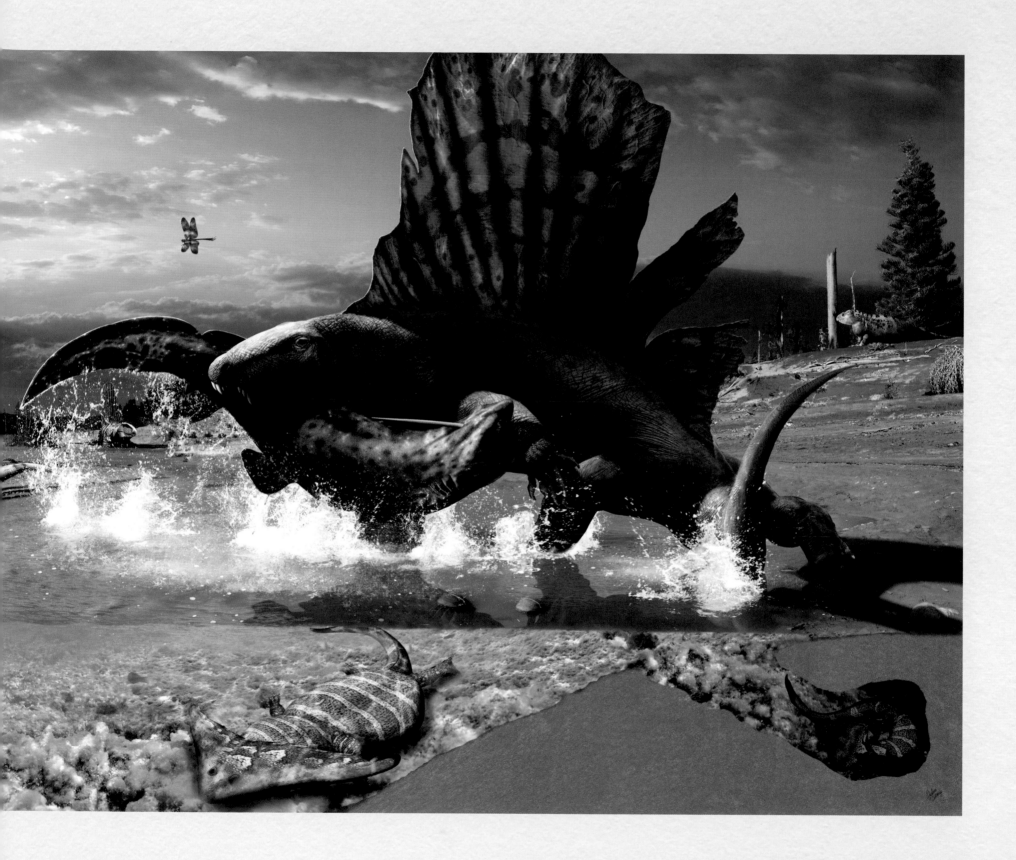

IN CONVERSATION

What was the first dinosaur you drew?

My very first drawing of any kind, at the age of three, according to my parents, was a dinosaur. I don't recall doing it, but luckily my parents kept the drawing. It appears to have been intended to depict a rooster on yellow paper. Given that galliform birds such as chickens nest taxonomically within the Dinosauria, it seems that my obsession with dinosaurs began earlier than I remember. Then again, the drawing may have been a very anatomically compromised llama.

Is your family artistic?

My wife, Alexandra Lefort, drew and painted as a hobby for years, and is now rapidly developing her innate skills with pencil, pastel, and paint as a wildlife and portrait artist. Like me, she has a scientific background. She is trained as a planetary scientist (geomorphologist/remote sensing specialist), and has worked on a diversity of projects, from investigating the history of water on Mars to lunar surface composition to periglacial landforms on Earth and the detection of erosion of the Peruvian Nazca plateau from space. In fact, we first met at the Third International Conference on Mars Polar Science in Lake Louise, Canada in 2003, which we were both attending, she from Switzerland for her PhD on unusual martian geology, and I from central Canada during my PhD, out of an interest in the search for extraterrestrial microbial life. However, with her analytical and technical skills, Alexandra is extraordinarily fast at mastering artistic techniques, and we are about to embark on teaming up to create natural history works together in addition to our respective solo pieces.

The rest of my family is also artistic, each in a different way, and I owe a lot of my artist development to their encouraging attitude over the years. My mother, Irene, has always had great drawing skills, and I still remember the excitement I felt when she drew me a *Diplodocus* similar to one of [classic paleoartist] Peter Zallinger's pieces when I was probably about five or six years old. It was done in red, green, and brown colored pencils, with sweeping curved strokes to bring out the animal's volume, and I can still remember the details of the animal's face and even the neatly drawn thin green false frame around the border. I don't recall too many other gifts from my childhood with such clarity. My mother also did a considerable amount of skillful figure sculpting in clay. I always admired her ability to capture emotions in her figures. My father – also named Julius – is an inventor at heart, and I recall seeing a very large number of conceptual engineering drawings of incomprehensibly complex machines when I was a child. He also used to carve the most amazingly detailed miniature monkeys from peach pits. My sister, Timea, did quite a bit of wonderful drawing during her childhood, but more recently, she has mastered sculpture of a different sort: body sculpting. She has won several figure competitions and earned numerous medals for her impressive body building.

Describe your career trajectory.

Although I began creating larger paleoart pieces around 1998, it was still only a hobby, since I was building up a portfolio. I had always thought that I would keep my artwork out of the breadwinning pipeline. The intention was to prevent my creativity from becoming stifled by the pressures of deadlines and work quotas. In 2002, I began a doctoral program in microbiology, which at first sapped all of my effort as I familiarized myself with my particular field of study and established my research projects. This schedule left no time for

Early Csotonyi Works: (Left) 1981. Grade one expression of paleontological ambitions. (Below) 1985. Drawing of dinosaurs inspired by first visit to the Tyrrell Museum of Palaeontology. (Right) 1983. Fantasy drawing inspired in part by Dougal Dixon's creative work.

paleoart. Meanwhile, however, I had built a web-based gallery of my work, and had also regularly submitted artwork to Mike Fredericks' *Prehistoric Times* magazine and Michael Keesey's (now defunct) The Dinosauricon site, where the pieces were getting exposure.

Then, in 2005, I was contacted by the British publisher Anness Publishing with a request to produce illustrations for a dinosaur encyclopedia authored by Dougal Dixon. I recognized Dixon from his earlier, wonderfully creative work, including his *After Man* speculative evolution work. Suddenly, here was the prospect of actually making a living from my artwork and collaborating with someone I admired, so I thought it couldn't hurt to try. I used the *Illustrated Encyclopedia of Dinosaurs* project as a relatively low risk means of evaluating my performance as a paid paleoartist. I found that even with a full-time research program running simultaneously, I did not feel overburdened by the fast-paced illustration schedule. I certainly lost a lot of sleep (and I still do), but the key result was

that I felt stimulated by the work. That, to me, was the point at which I made the decision to really actively pursue paleoart as a career. The sheer enjoyment that I got from painting during even the crushing deadlines of the last weeks and days of projects was the strongest indicator to me that I had chosen a career to which I was well-suited and that promised to be highly rewarding in both short and long terms.

Since then, work has spiraled upward through an ever-developing network of contacts, largely via word-of-mouth advertising. For example, the murals that I created for the Houston Museum of Natural Science's Hall of Paleontology (2012) and the Manitoba Museum's Cretaceous Life exhibit (2009) were spurred by interest in the 2008 exhibit Dinosaur Mummy CSI: Cretaceous Science Investigation, which in turn grew out of work with investigators of the mummified *Brachylophosaurus* that starred in the show, which in turn resulted from attention attracted by artwork that I created for the ceratopsian exhibit for the Dinosaur Hall at the

Royal Tyrrell Museum of Palaeontology (2007). Of course, a consequence of the growing interest in my artwork has been fewer hours of sleep per night. It has been a very rewarding start to a career, but it has also required a great investment of time and effort; more, in fact, than did my PhD research during its busiest period. If natural history artwork wasn't my absolute dream job, I doubt that I'd have kept doing it full time for this long. Fortunately, it is.

Having been influenced by Rudolph Zallinger and his mural work, how does it feel to now be doing murals yourself?

It's extremely rewarding to see one's work displayed at full size after having worked on it for months. I very much enjoy the process of creating it, but to see it fully assembled and fulfilling the role that it was designed for, i.e. to entertain and hopefully help to educate the public by providing visual support to scientific text and fossil displays, conveys a deep sense of satisfaction (balanced by a constant hope that I've done a satisfactory job on the accuracy of the subjects). I think this is true for any artist who loves what they do, but with my passion for scientific education as well, it is doubly rewarding to be able to nurture two very different interests simultaneously. This inherent wedding of art and science is why I love paleoart and scientific illustration so much. The objective of my artwork is to attempt to open windows as realistically as possible on worlds that can never be photographed, to hopefully immerse the viewer so realistically in the imagery that they can not only see but feel what a Permian morning might have been like. Creating life-sized murals brings me one step closer to this objective, by allowing me to literally wrap a prehistoric scene fully around a viewer. I can appreciate the desire of masters such as Rudolph Zallinger to overwhelm his viewers with the awesome size of magnificent prehistoric fauna and flora.

There is, of course, a big difference between my work and that of traditional muralists such as Zallinger. The advent of digital imaging, manipulation, and reproduction technologies that were not available in Zallinger's day allows me to work at very different and more variable scales than the fixed scale

Early Work: Menagerie of Prehistoric Plants. 1988. Featuring plants from various time periods.

at which Zallinger had to paint his masterpieces directly on walls. The first time that I walked through a museum exhibit showing my work – the ceratopsian exhibit in the Royal Tyrrell Museum, Drumheller, Canada – it felt surreal to see life-sized enlargements of ink drawings that I had created at a much smaller scale with an ultra-fine pen and then scanned. Similarly, I now work almost entirely digitally, and I usually see only small sections at a time of murals on the digital display of my computer system. This shift in production or reproduction techniques has given modern muralists at least one major advantage: we need not use ladders to paint a sauropod's head. It has also enormously reduced the amount of muscle work required. Although the same number of paint strokes may be necessary in new digital paintings or small-scale traditional paintings as in direct life-sized paintings, the smaller scale of originals reduces the absolute length of these strokes through which an artist's hand must travel.

Do you work closely with palaeontologists when illustrating an academic paper or is it a little more anonymous?

I enjoy working closely with paleontologists on illustrations. Although published scientific literature is invaluable to reconstructions, and I do use it when I work on my own, the freshest research is only accessible by communicating with the researchers themselves, and this forefront of science is the most exciting to me. Working with paleontologists on cutting-edge research is akin to surfing the crest of a wave – always changing and very dynamic. I suppose that my own taste of the excitement of research from my academic background fuels much of this enthusiasm. I have also illustrated several new discoveries based on recently published results, independently of collaboration with the researchers. Often their published descriptions have been thorough enough for me to do a comprehensive reconstruction without personal communication, and this has frequently generated good feedback from the respective researchers, which feels very rewarding to me.

Having made the transition from traditional to digital art, explain a little about your use of photos, as both reference and art tool.

There are two main ways that I use photographs. The first is the same way artists have always used photographs: as a study aid to guide my development of form, color, and lighting. After taking photos of scenes and subjects under conditions that I wish to reproduce in a painting, I can display the photos on a monitor and use the images as reference to help me properly mix colors to paint true-to-life hues and tones.

This method also allows me to ensure anatomical accuracy of the animals and plants that I paint. It is especially important for restoring species that must be reconstructed from fossils. I visit museums to take photos of skeletons of prehistoric animals from many angles, because the profile of a skeleton can change markedly from different viewing angles. This is especially true of the complex shapes of ceratopsian skulls. Naturally, I must also account for distortion that the fossilized bones may have acquired through geological processes, but photos do go a long way to helping accurately portray the way in which prehistoric creatures filled space.

The other way in which I utilize photos, namely compositing, has helped me to carve out a large part of my particular niche in the paleoart community. This method absolutely requires digital artistic techniques. I complete a lot of my work in a photorealistic way, which requires me to build up a large photographic database of snapshots of appropriate environments, plants, and animals from which to digitally extract components and textures to incorporate into my artwork. I am probably best known for these photorealistic pieces of paleoart, and they spring naturally from my desire to expose my viewers to as realistic a portrayal of paleo-environments as I can.

As a result, I have had to organize trips to many places on Earth to acquire photographs of environments that are analogous to the prehistoric environments that I wish to depict. My quest for a photorealistic look has resulted in an accumulation of about 300,000 photographs by the end of 2013. Fortunately, the available size of external storage devices has so far (just barely) outpaced my requirements for digital storage space to accommodate both my rapidly growing photographic library and gigantic multi-layered digital image files.

Is it paradoxical to use photos of the modern world to illustrate a world we'll never truly know?

This question has implications for much more than my photorealistic paleoart pieces… There are analogous environments in select places on Earth that contain at least globally similar-looking plant species and sometimes even communities to those that existed during the Pleistocene or even Cretaceous. But whereas the geological topography of some landscapes has not changed too much since the Pleistocene – aside from processes like glaciation or volcanism – we have to keep in mind that whole mountain ranges and oceans have come and gone in the billions of years since life got a foothold on our planet. And ancient animals, plants, and landscapes generally look increasingly different from those of modern ecosystems the further back we peer into the fossil record, so we can't freely paint plein-air landscapes and use them directly to stand in for prehistoric scenes.

Fortunately, the recent explosion in paleontological research has filled a great many gaps in our knowledge about numerous paleoenvironments. Of course, this plethora of information has also repealed much of the artistic license that paleoartists like myself could once exercise in lieu of well-established empirical observations. Therefore, when I am painting traditionally using a brush or stylus, the greatest challenge to overcome in order to achieve as accurate a reconstruction as possible is to do sufficient background research. This quest for information may involve both a search through the published peer-reviewed scientific literature and, when necessary, correspondence with paleontologists, paleobotanists, and geologists.

However, construction of a composited image using photographic elements introduces an additional challenge: how to utilize fully formed images of modern animals, plants, and landscapes to generate representations of long-gone ecosystems that often differ markedly from their most similar modern morphological analogues. The challenge is roughly similar to the problem of mastering a new type of martial art or dance when one is already familiar with a different style. It requires the unlearning or modification of a set of ingrained reflexes. I have to substantially modify the photographic components by a variety of methods after integrating them into a composited painting in order to guarantee that the depiction agrees with the morphology that paleontologists have inferred from the fossilized remains. In fact, I usually need to build up prehistoric animals like a jigsaw puzzle from numerous small portions of existing images. When skin textures are known for extinct species, I need to work from even more basic material to achieve accuracy. It is this modular approach that allows me to use photographic material from modern subjects to restore prehistoric animals.

Does striving for photorealism limit the artistic process?

Regarding the technique of photographic compositing per se, i.e. the incorporation of actual photographic material into the artwork, probably the greatest limitation introduced by the application of a photorealistic technique is that the direction and quality of lighting is already burned into the photographic components, and this is more difficult to alter than shape or size. Therefore, I often plan a scene in advance of taking the photos

for it, with the aim of satisfying specific lighting conditions established in the rough draft. Because I make extensive use of the beautiful lighting conditions that are present in what artists and photographers call the 'golden hour', I have taken a lot of photos in both early morning and late evening settings. Even then, I still often need to adjust or fine-tune the positions of shadows and highlights in my subjects after integrating them, because weather and geography do not always cooperate with me. This is where powerful post-processing software is useful.

In a more general sense, one might expect that striving for photorealism necessarily stifles some of the expressive quality that other schools of artwork possess. For example, the palette is limited by the gamut of colors actually present in a natural scene, and forms are rigidly governed by anatomy and perspective. However, I do not find that these factors necessarily limit the artistic process very much. The natural world is spectacularly diverse in its expression of color and form, and the photorealistic artist need only select the right moment and setting to achieve the desired emotional impact. Think of the breadth of color through which the sky sweeps during sunrises and sunsets, or under different weather conditions or canopies of vegetation. Consider the astounding variety of body forms that evolution has shaped among living things over the past 3.9 billion years, or the spectacular range of landscapes that the interplay of different geological and biological processes has hewn on our planet over its history. Furthermore, even observing the requirements of known paleogeography, artists still have wide latitude in establishing the composition of a scene at small scales, which provides another powerful tool of expression.

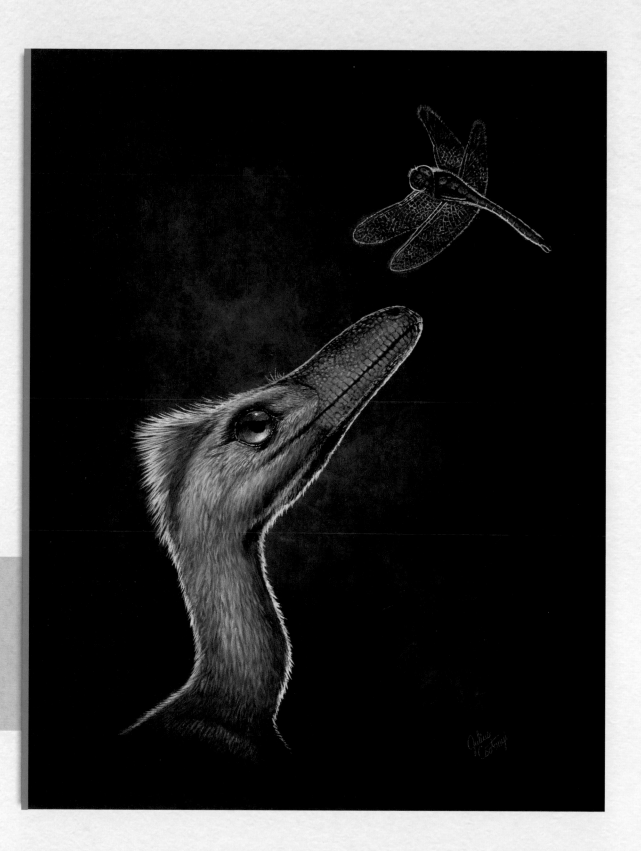

"To raise funds for the construction of the Philip J. Currie Dinosaur Museum, we hosted several glittery events that gathered local politicians, supporters, and quite a few famous people like actor Dan Aykroyd and his wife Donna Dixon. The museum's logo, a *Troodon* in death pose, has become something of a favorite topic for artists who have contributed to the silent auctions that are a big part of these events. Julius became one of the museum's biggest advocates and as a special treat produced several 'live' paintings that were auctioned. This painting he produced in 2013 in front of 300 attendees who, like myself, stood enraptured around his easel during the course of the evening."
Dr. Phil Bell, University of New England (Australia)

Troodon. Acrylic on canvas (24 x 30"). Philip J. Currie Dinosaur Museum fundraiser auction, Grand Prairie, Alberta, Canada. 2013. Created during the banquet of the Dino Ball 2013, and auctioned off immediately after dinner, this was the second of a pair of auctions for which I did 'live' painting to raise funds for this museum, in 2012 and 2013. (See also page 47.)

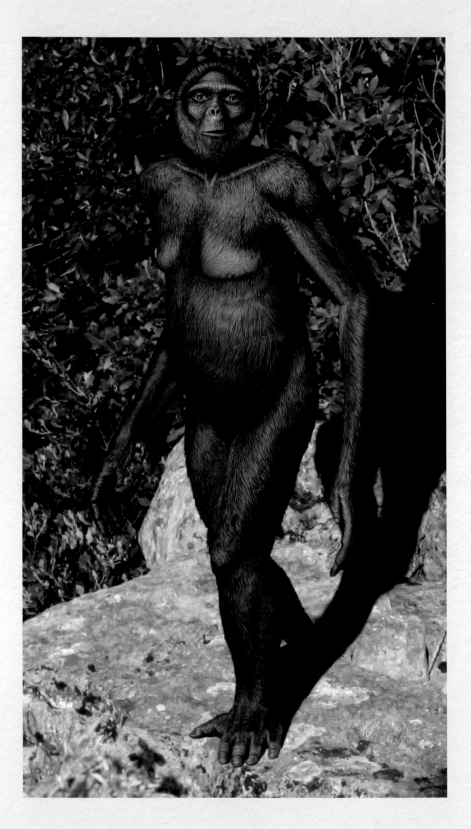

Do you miss using more traditional media?

There is a delicious satisfaction in applying thick creamy paint in a rainbow of colors to the fine tiling of fibers on a canvas that photographic compositing and even digital painting with a stylus has never been able to match for me. Widely available digital media have not yet mastered a sufficiently realistic simulation of the physics of fluid dynamics and textural feedback in three dimensions to generate the same experiential effect.

To be sure, I enjoy the reward of being able to generate images that, when successful, are indistinguishable from photographs. However, the artwork that moves me the most when viewing it is still manually painted pieces that result from masters skillfully making thick colorful goopy liquids pretend to be a delicately feathered avian dinosaur preening in a steamy verdant rainforest or a herd of Oligocene camels kicking up palls of dry ochre dust illuminated by the warm golden setting sun.

Digital techniques are wonderful for bringing to life creatures that can no longer be photographed, which I suspect is why they are so popular with many of my paleontological clients. That, and the fact that for scientific illustration, nothing beats a digital format for ease of review and revision. However, it is very rewarding to be able to convince a coat of pigments to closely mimic scenes from the real world. I very much enjoy realistic painting, and I intend to continue to strive to master traditional techniques in order to broaden my portfolio by completing traditional paintings – or graphite, ink, or scratchboard pieces – as much as my schedule allows.

I still have a very long way to go to attain the level of drawing and painting skills of those who I admire the most among realist painters. These include (in alphabetical order), but are certainly not limited to, John Agnew, Andrey Atuchin, Robert Bateman, Carl Brenders, John Gurche, James Gurney, Mark Hallett, Douglas Henderson, Mark Hobson, Terry Isaac, Raúl Martín, Jay Matternes, Denis Mayer Jr., Michael Sheeler, and Peter Trusler. Many of these artists are not paleoartists per se, but rather painters of extant wildlife. I think that paleoart exhibits a substantially lower frequency of hyper-realistic pieces than does extant wildlife art. This is probably due in part to the absence of living examples of many of the subjects, but it may also be because extant wildlife art aims more often to achieve the kind of aesthetic appeal that lends itself well to being hung in living rooms than does paleoart. There is certainly a very large body of wildlife art enthusiasts who value hyper-realism. Another way in which wildlife art differs somewhat from a lot of paleoart is in not unduly emphasizing a central animal subject at the expense of the background, but rather more harmoniously integrating the animals into their equally important botanical, geological, and meteorological environments. This is accomplished in the attention to sharpness, color palette, and lighting. Paleoartistic reconstructions often require a strong central animal focus, but I think that relatively stronger environmental emphasis also has merit.

Speaking of lighting, traditional painting also helps me to refresh my understanding of how light behaves in scenes – a crucial base of knowledge for an artist – because it forces me to carefully observe how, for example, the values of shadows and highlights change subtly with conditions rather than simply utilizing photographs in which the lighting has already been established by nature. This improved understanding of optics can then also feed back into more judicious selection of photographic elements for composite scenes, leading to an improved piece of artwork.

Finally, traditional artwork opens other doors of opportunity that digital art has not yet managed to breach. Although I usually take longer to complete detailed pieces, I have had a

Ardipithecus ramidus. Photographic composite and digital painting. 2009.
The (currently) oldest known bipedal hominid. I created the primate by digitally warping a photograph of myself to establish correct anatomy, and then painted the (extensive) additional hair onto the body manually.

couple of opportunities to create live on-site paintings during museum fundraising banquets for immediate auctioning. The first was a pastel drawing of a hypothetical down-covered tyrannosaur hatchling (2012) and the second was a larger acrylic portrait of a *Troodon* (2013), both for the Philip J. Currie Dinosaur Museum in Grande Prairie (currently under construction and due to open in late 2014). Not only does it feel good to give something back to promote the research and paleontological institutions that support my career, but it's also a lot of fun. Donation of artwork to promote biological conservation initiatives through sales also appeals greatly to me, especially given my biological sciences background. This kind of contribution is most effectively accomplished using traditional original artworks.

Do you doodle or sketch?

Surprisingly little, nowadays. I often do numerous preliminary rough sketches of a scene as I plan it, but I do not frequently sit down and sketch or doodle for the sake of practice. I suspect that it has a lot to do with the deficiency of leisure time that I feel I have. I probably ought to slow down from time to time for my own good, but every time I am presented with the prospect of a new project, I get so excited about it that I find it difficult to say no. I do have quite a few sketches stored in my collection from previous years, when I was experimenting with speculative evolution and exobiological imagination. I had a lot of ideas that I jotted down in the form of quick sketches, and one day I'd like to develop these further.

How's your figure work?

In my early years as an artist, I was relatively more skilled at depicting wildlife or technological subjects, and the human figure was my greatest artistic scourge. The anachronistic human set into an unnatural assemblage of species for scale always looked too much like an articulated collection of cans and barrels, and this irked me. Therefore, one of the exercises that I took on around the time I started completing a lot of my larger pieces was portrait and figure drawing. I studied the human form in greater detail, and worked from both photographs and live models to reproduce the subtle curves generated by muscle groups and bones under the skin. An introductory fine art course at university certainly helped a lot. Gradually, portraying the human form became less an ordeal

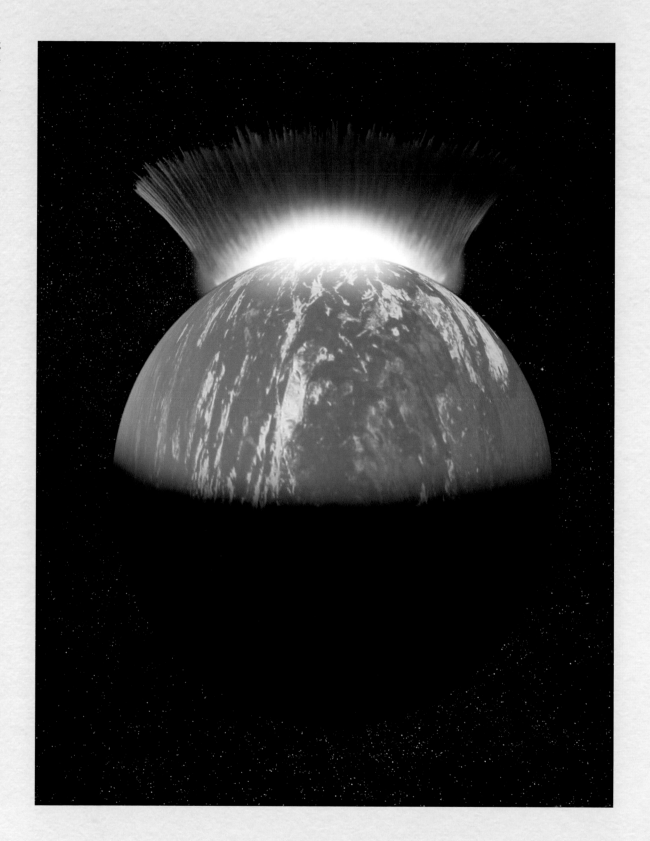

Birth of the Moon. Photographic composite and digital painting. 2011. Depiction of the colossal impact that led to the formation of the moon.

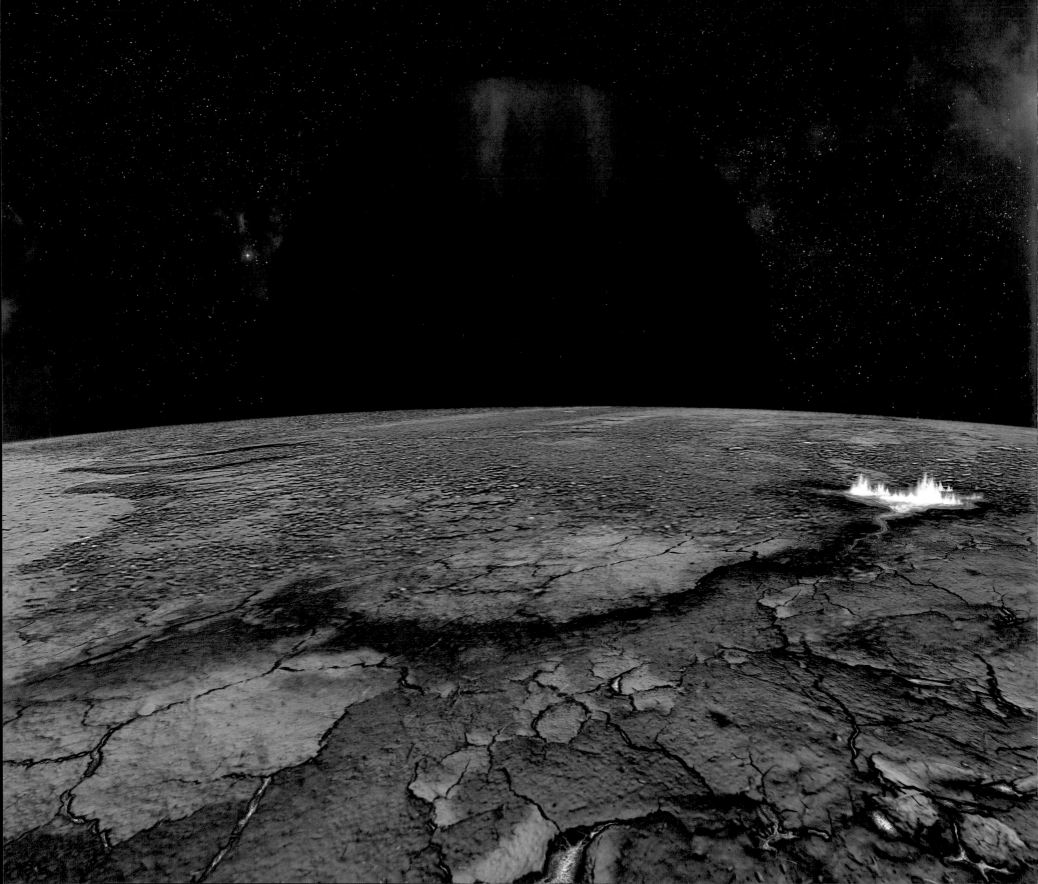

and more a pleasure as I found the drawings actually starting to resemble their intended subjects. A couple of wedding portraits for friends was one of the results of this activity.

Although I produce relatively little figure artwork these days – owing, I think, mainly to the absence of hominids in the Mesozoic or Paleozoic – there are two main applications of figure work in my current scope: illustration of the history of paleontology or science in general on one hand, and depiction of human evolution on the other. The latter is of special interest to me, partly because of my own visceral fascination with our deep past. I also wish to help disseminate a scientifically supported visual account of anthropological paleontology, because there is still a surprising amount of misunderstanding about and resistance to the idea of human evolution from anatomically very different ancestors. I have done relatively little paleoanthropological artwork, but a restoration of *Ardipithecus ramidus* was an enjoyable first step into this field. This image was scooped up by the Natural History Museum of Los Angeles County for their Age of Mammals exhibit, and it was then fun to stand face to face with a life-sized print of my *Ardipithecus* depiction.

You're an active advocate of evolution and atheism. Does that impact on your art?

I would say that I am an advocate of science and critical thinking. I know of no more reliable way to decipher the nature of our universe, and it provides me with the knowledge base for all of my scientific illustration. To me, it naturally follows that my paleontological artwork would reflect evolution, which is the only scientifically supported model of the history of life on Earth. Artwork is a great way to celebrate the wonder of scientific discovery and to disseminate it to a wider audience, and this is the main driving force behind most of my work. I feel a lot of gratitude that it has been used by several institutions in an educational manner.

By the same token, I am staunchly against pseudoscience and antiscientific attitudes. One of the most obvious antiscientific movements that impinges on paleontology and paleoart is the teaching of young Earth creationism, which is surprisingly common, at least in North America. It has no basis in science, but rather is actively opposed to evolution for nothing more than

fundamentalist reasons. It is unfortunate that an invaluable field of science would experience opposition due to an aggressive antiscientific campaign. Since misinformation may effectively be fought by a sustained presentation of accurate information, I think that the young Earth creationism ideology is best tackled by education, and it is in support of public education about evolution that I hope that my artwork is most useful. In this regard, perhaps the most impactful of my pieces are those that demonstrate the concepts of evolutionary biology most starkly. These include artwork of species that clearly exhibit evolutionary intermediacy in their features between their ancestors and their descendants or more derived sister groups, e.g. *Anchiornis*, *Ardipithecus*, and *Aardonyx*, or groups of taxa that exhibit convergent evolution, e.g. sabre-toothed marsupial *Thylacosmilus* versus the felid *Smilodon*.

Although I am an agnostic atheist, i.e. I do not believe positively in that which cannot be supported evidentially, but I do not claim to know certainly that I am right, I defend everybody's right to believe as they wish, so long as those beliefs do not lead to harm. I feel fortunate to have grown up in a country that does not force people to conform one way or the other. In fact, my public advocacy of atheism stems largely from a desire to encourage increased acceptance of people that embrace a non-belief-based way of life, for there are many places where a lack of belief is still not well received. I have no quarrel with theists; I know many excellent scientists who hold religious beliefs, but who successfully isolate their personal beliefs from their evidence-based scientific research and who perform rigorous work in fields such as paleontology and geology. Because I feel strongly that people ought to be able to get along despite differing personal beliefs or lack of any, my advocacy of atheism does not really influence my art, unless one takes the marked lack of religious iconography in my work as a significant trend.

You have an academic background in microbiology that you were interested in developing into astrobiology. What's your fascination with these organisms and how does that translate into astrobiology?

I've always been most fascinated by bizarre and exceptional life forms, which is almost certainly responsible for much of my interest in prehistoric life forms. The more different an organism's appearance or life strategy is from our own, or the more alien it is, the more it interests me. It turns out that microorganisms exhibit the greatest range and overall difference from us in their physiology (e.g., modes of generating energy, ability to chemically alter substances,

tolerances to physical and chemical extremes such as heat or salt concentration). This makes them the ideal research subjects for studying how far life can push the envelope of its habitat and still persist.

I've also always been deeply intrigued by astronomy, from the stupendously diverse planetary environments of our own solar system to the wild and often mysterious processes that influence the evolution of stars, nebulae, galaxies, and more exotic objects such as black holes, quasars, and magnetars. I've often sat in awe under a star-spangled summer sky and wondered whether any of the light that was falling on my retinas had been reflected from the surface of something else alive under another alien sky, on a remote planet many thousands of trillions of kilometers distant.

Out of these two initially competing interests, I chose to follow a biological path of study, and my academic background describes an escalating interest in the biology of organisms that differ a lot from us. I started with research in ecology (the study of the interactions between organisms and their environment) during my undergraduate and M.Sc. programs under Dr. John F. Addicott at the University of Alberta. I specialized in exploring mutualistic (mutually beneficial) and facilitative interactions between animals and plants in relatively harsh environments, such as arid semi-deserts. Intrigued by the interesting strategies by which life copes with stressful environments, I travelled to a conference in Yokohama, Japan that focused on extremophiles, which are organisms that actually do best in conditions under which you or I would either wince in discomfort or die outright. At this conference, I attended a presentation that gave me goose-bumps of excitement. The speaker described the use of a robotic landing spacecraft that would use its onboard mobile science laboratory to search for past or current life just beneath the surface of Mars. Because of the comparatively inhospitable conditions on the red planet, the best way to learn about how to detect the biological activity of any hypothetical extraterrestrial microbial life was to study terrestrial life forms that aren't particularly fazed by such conditions – extremophiles. I was hooked.

This enthusiasm led to a doctoral program in microbiology under Dr. Vladimir Yurkov at the University of Manitoba, where I undertook a multi-pronged research program investigating the physiology and microbial ecology of phototrophic (i.e. using light for energy) bacteria and heavy metal transforming bacteria in extreme environments. These habitats included terrestrial springs in Manitoba with water several times as salty as the ocean and deep-ocean hydrothermal vents along volcanically active faults around 500 kilometers off the coast of British Columbia at depths of more than 1500 meters. Not

HD149026b. Photographic composite and digital painting. 2009.
One of the hottest extrasolar planets currently known to science, designated as HD149026b. The planet is depicted here as viewed from a hypothetical moon. The planet is so hot because of its extremely low albedo. The sunward side of the planet does not so much reflect the light of its sun as glows red-hot with blackbody radiation.

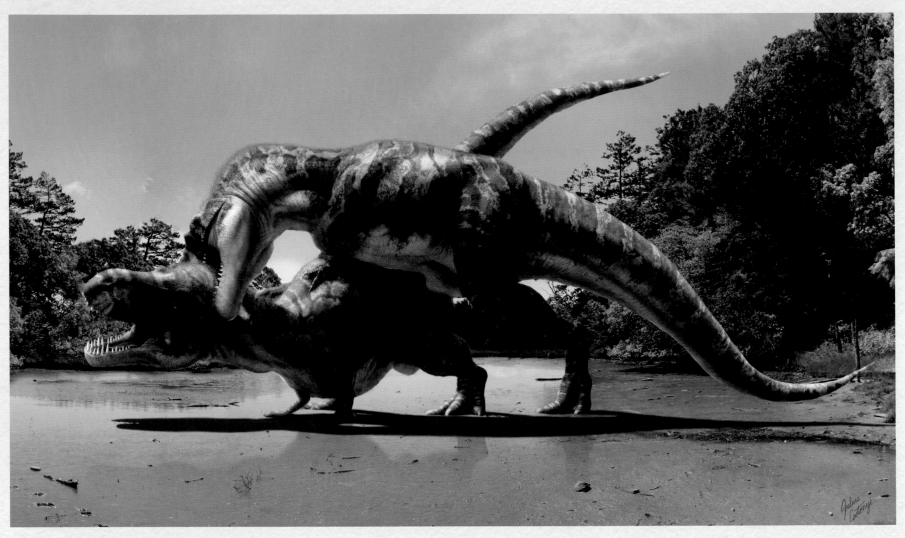

only was it exciting to participate in oceanic research cruises using a remotely operated submersible, but the research resulted in some fascinating discoveries. These included the first isolation of bacteria that can use very high concentrations of toxic oxides of the semi-metal element tellurium in a way roughly analogous to the way that we breathe oxygen; entirely new groups of phototrophic bacteria that were relatively distantly related to known species; and bacteria that could flexibly switch between different modes of using light for energy that had never been seen to be combined before by the same organism.

Many of these bacteria could grow in solutions that were nearly saturated with salt, and others could thrive under a pH as high as that in the soda lakes of Africa. Even more amazingly, some of their close relatives, as well as extremely distant

cousins (some of which are not even bacteria, but are more closely related to us), thrive in temperatures higher than the boiling point of water, or in stomach acid (or stronger acids), or can grow and reproduce in temperatures below freezing, which is only possible in salty solutions that remain liquid far below zero degrees Celsius. Extremophiles are teaching us that life thrives under a far wider range of conditions than originally thought. This has the tantalizing implication that even terrestrial life could conceivably survive in select habitats on several of the planets within our own solar system. Since life got going on Earth only around 100 million years after the sterilizing asteroidal bombardment of its surface eased off, it's not unreasonable to imagine that life could have emerged on the countless planets orbiting other star systems, too. Over a thousand extrasolar planets are known already. Study of

extremophiles demonstrates that in our search for life in the universe – the purview of the field known as astrobiology – we should not rule out planetary environments simply because they don't perfectly match the conditions in a nice temperate or tropical freshwater pool.

Rex On the Beach: *Tyrannosaurus rex.* Photographic composite. 2013. Released on Valentine's Day 2013, this is a reconstruction of *Tyrannosaurus* copulation. I have chosen to portray the small but muscular forelimbs serving a clasping role. The love bite is inspired by the behavior of the males of some modern birds, which could serve to stabilize such a massive coupling. (I imagine that you really wouldn't want to fall over at this size; that could cause an awkward moment.)

Have you ever been tempted to extend paleoart into xenobiology or is that just too speculative?

Xenobiology (or exobiology) and speculative evolution are two of my favourite non-paleoart subjects. The reason that this part of my work is less well known is that most of the pieces are only sketches that I have not scanned and made publically viewable. They were intended mainly for my own enjoyment, from ideas I'd toyed with while doing field work that I had jotted down for later reference. I'd like to do something with this in the future, maybe expand it further and turn it into a project. I enjoy invoking ecological and evolutionary principles to think up plausible routes that evolution may take, either here on Earth, or under vastly different conditions on other planets. Studies of extremophiles show us that life can in fact invade some pretty inhospitable habitats by our standards, so whereas exobiological subjects are certainly speculative, they are by no means beyond the realm of reasonable possibility.

What advances and discoveries in paleontology and science as a whole have excited you?

So many! But to select a few, the increasing detail with which prehistoric ecosystems are known is very exciting to me. Not only are complete skeletons known for more and more animals, but integument, in the form of scales or feathers or filaments, has also been found for many. Heck, soft tissue remains are known for species as far back as the Cambrian for animals or the Precambrian, over a billion years ago, for earlier creatures. This takes a lot of the guesswork out of restoration. Even more amazingly, hints at color patterns have also been discovered from studies of fossilized melanosomes (subcellular organelles) and spectroscopic analysis of materials remaining on the surface of especially well-preserved fossils, possibly representing chemically altered pigment molecules. As an artist, I might be expected to feel stifled by the removal of artistic license in something like color choice. I am not; I'm just amazed that we can know long-gone ecosystems with such clarity.

Another fascinating thing to emerge from the increase in paleontological research is the accumulation of enough specimens of some species, e.g. *Tyrannosaurus rex*, *Pachycephalosaurus wyomingensis*, and *Triceratops horridus*, to begin to unravel the complexities of their population biology and their ontogeny (change in form through life). This has resulted in the realization that some individuals initially thought to be separate species, e.g. *Stygimoloch spirifer*, actually just represent different stages in growth.

In other areas of science, some of the most exciting discoveries have been made in planetary studies. The warm, wet ancient history of Mars, the probable oceans beneath the ice of Europa, the towering geysers of Enceladus, and the dozens-to-hundreds of extrasolar planets not much bigger than Earth have all raised the prospect of finding life beyond our own horizons. This sparks my interest not only from an exobiological research perspective, but also out of an enjoyment of creating speculative xenobiological artwork.

Someone on the Dinosaur Mailing List asked recently, "Why study dinosaurs?" What would your answer be to that question from both a personal and maybe general viewpoint?

Indeed, with all of the existing problems that really desperately need tending to on Earth, why should we spend resources on digging up the remains of animals and plants that are long gone? To me, there are a couple of answers that stand out.

Partly, it is because the awe and fascination that the pursuit of the unknown kindles in us fills a basic human need to satisfy our curiosity. And this is a good thing, because the wonder that this enthusiastic drive to know inspires in us fosters an appreciation for the beauty of the natural world. I think that inspiration and wonder are powerful motivators for positive change, and to me few things are as marvelous to imagine as the gargantuan giants that once thundered across the alien-looking landscapes that our planet long ago hosted. I am grateful that I am able to express my wonder visually to the community through my artwork.

Also, studying prehistoric ecosystems helps to inform us about the consequences of our own activities and to hopefully head off harmful practices. The enormous changes in global climate and species redistributions that the planet has experienced in the deep past and the way in which these changes have impacted the survival of populations and communities of species represent invaluable lessons that we can apply to our own ecosystem-influencing activities. This information is useful for the effort to preserve the biological diversity of Earth, and to ensure our own survival as well.

Any behaviour you would love to see us have a clearer understanding of in dinosaurs?

Behaviour is some of the most difficult bits of a living thing to reconstruct after it's been dead for millions of years. Isolated bones rarely fossilize. Complete skeletons are even rarer, and soft body parts are almost never preserved. Behaviour can only be read indirectly from the traces that actions leave on bodies and the environment. These ichnofossils and traces are also relatively rare and include bite marks on bones (which is why we understand predatory behaviours so much better than many other types of behavior); footprints in mud (giving us useful insight into herding behaviour or migratory pathways); and distributions of nests (which tell us a lot about parenting roles in dinosaurs).

Of course, the more complex a behaviour, the less well it can be understood by inference from rare fossilized traces of activity. Some of the most complex behaviors in modern animals include courtship displays, and they are also often the most impressively infused with color and movement (and therefore lend themselves well to depiction in artwork). I would love for us to know more about dinosaur courtship and reproductive behaviour. The only living descendants of dinosaurs – birds – demonstrate that these behaviors can be remarkably complex and beautiful. Now try to imagine what a *Tyrannosaurus* courtship display would have looked like or, as Brian Switek has pondered in his book *My Beloved Brontosaurus*, how a pair of impressively spiny *Kentrosaurus* would have 'done the deed'.

A number of researchers have tried to piece together how such perplexing behaviours may have appeared. Given how many spectacular new finds are being unearthed, perhaps it's just a matter of time and great effort before the find is announced of an unfortunate pair of dinosaurs that met death swiftly and unexpectedly while in the throes of *amour* and were preserved under exceptionally good conditions. There are already hints of courtship behaviour in the fossil record. For example, a male/female pair of the bizarre Carboniferous shark *Falcatus falcatus* were preserved with the female grasping the male's characteristic dorsal crest in her mouth. Of course, reconstructing courtship behaviour that involved complex movement would be far more difficult to accomplish.

Given a time machine, where and when would you love to go back to and draw from life?

At least three settings come to mind. For one, I would draw on my fascination with the bizarre, and set my time machine to a point in time when even the vegetation on Earth was very different looking than today, say when weird bifurcating club mosses grew to the heights of skyscrapers, and sail-backed protomammals basked in the Carboniferous sun, or even further back, to the Devonian when many land plants looked not unlike big green scaly snakes and fish were experimenting with limbs for walking. It would have been such a weird and wonderful alien-looking world.

The second time I'd love to visit with my canvas and brushes would be the height of the (nonavian) dinosaur kingdom,

say, during the Jurassic, when some of the largest terrestrial animals – the gigantic brachiosaurids and diplodocids – were thundering across the landscape in what is now the Morrison Formation. It would be awe-inspiring to the extreme to be able to walk (nearly) under them and admire their immensity.

The third retro-time-travel trip that I would enjoy arises from my fascination with our own human deep lineage. I am mystified when pondering the enormous gulfs of time that separate our modern societies from the time when our ancestors started using tools. Over two million years have passed – a thousand times as far back as the age of our modern calendars – since that time, and nearly a million years since our great-great-great… great-grandparents first mastered the generation of fire. I would love to be there to record the very first time that *Homo* learned how to make and control this chemical reaction. The expressions of awe and curiosity and fear on their faces would be priceless to capture on canvas.

Any advice for someone trying to break into the paleoart field?

Do your homework. Apply as much science to your work as possible. I'm all for paleoart being expressive in an artistic sense, but let's all try to avoid the persistent mistakes of old. This means, for example, no more 'bunny hands' on theropods, or ears placed in the lateral temporal fenestra. There is an increasing amount of paleoart being produced, but much of it shows a lack of careful attention to accuracy. Paleontological research is advancing by leaps and bounds so quickly that it may be difficult to keep up with the pace of research publication, and many of my own restorations will quickly fall out of date as groundbreaking discoveries fill in gaps in knowledge that originally required speculative reconstruction. The internet is also often unreliable in the information that it offers, bloated as it is with scientifically uninformed and peer-unreviewed information. This is where regular reading of blogs written by scientifically well-informed individuals is very helpful as a way to stay on top of many fascinating finds – *Scientific American*'s Tetropod Zoology by Darren Naish, *National Geographic*'s Laelaps by Brian Switek, Archosaur Musings or Lost Worlds by David Hone, and The Loom by Carl Zimmer, to name just a few.

Also, be ready for many sleepless nights. Making a living from artwork, especially in the coming days of increased competition resulting from the huge influx of new talent, will be difficult, and is likely to be sustainable only by those who are willing to make quite a few sacrifices.

Is there still a book – or books – inside you trying to get out?

Oh so many! One of my hopes is to collaborate with one or more paleontologists to illustrate a book on newly described dinosaurs (many of which are wonderfully bizarre), or a new book on feathered dinosaurs. My fascination with ecology would lend itself well to a book on paleoecology or reconstructions of Lagerstätten. Other areas that interest me include new reconstructions of Paleozoic life, or even earlier time periods, for which my microbiological background would also be pertinent.

Aside from the numerous books on prehistoric animal, plant, and microbiological diversity that I can imagine materializing, I would really like to turn my art towards making a difference in the world in two ways: conservation, and public scientific education and outreach.

I am fascinated by all life on Earth, but besides dinosaurs, the animals that I most enjoy illustrating are sharks. These misunderstood creatures are also in dire need of conservation efforts to protect numerous species from extinction. I would very much like to illustrate a book on sharks to help raise awareness of and appreciation for the beauty of these animals that are twice as old as the dinosaurs. In a more general sense, I am very motivated to focus more of my artistic efforts on biological conservation, and I hope to be able to produce several picture books that celebrate the magnificence of life on this planet through art, and that would lend financial support to research and conservation

"Julius Csotonyi's sauropod mural at the Natural History Museum of Los Angeles County is as magnificent and vibrant as its imposing scale. Much more than a backdrop, the mural powerfully enhances the exhibit's narrative. With subtlety the large-scale work echoes the patterns in the displays, and with realistic detail it whisks the viewer away to become lost under the open blue sky, walking among the ancient dinosaurs."
Dr. Luis M. Chiappe, Vice President, Research & Collections, Natural History Museum of Los Angeles County

Mamenchisaurus. Digital painting (20 x 6m). Commission: Natural History Museum of Los Angeles County. 2010. One of four nearly life-sized murals, this one features a pair of *Mamenchisaurus*.
Courtesy Los Angeles County Museum of Natural History, Dinosaur Hall; all rights reserved (for reproduction of this image, contact Nancy Batlin, Director of Creative Services; nbatlin@nhm.org).

efforts. This would be very rewarding to me.

Another thing that I would enjoy contributing to is public outreach to promote science. There appears to be a persistent problem of scientific illiteracy in a surprisingly large proportion of the population, at least in North America. This is an area that is very well suited to tackling with artwork, as people that are turned off by textual descriptions (especially technically intense ones) are often more interested when the presentation also involves artwork. Evolution is especially misunderstood, some of this misunderstanding resulting, disturbingly, from deliberate anti-scientific campaigns. I'd be very keen to illustrate books that both help convey a clear understanding of evolution, and inform people about how to

recognize pseudoscience and campaigns of misinformation. I feel that a better understanding of science and development of critical thinking will become increasingly important to our survival as we face ever greater challenges imposed by our growing population density and use of technology.

As I mentioned earlier, my wife Alexandra is a planetary scientist, and we've been discussing the prospect of collaborating on a book that would be heavy with space art, another area that I have been developing lately. I can see us turning such a project toward public outreach in support of space programs, which are currently experiencing a lot of political and financial impedance.

Then there are books that I would really enjoy illustrating that are purely imaginative. I'd love to illustrate books on

speculative evolution. What would the world look like without some of the major past extinction events, or what will it look like 50 or 500 million years hence? It's been done numerous times before, but this is science fiction (admittedly inspired by ecology, paleontology, geology, and a host of other branches of science) and each author's vision is a little different. Books on xenobiology interest me too. Before I go to sleep at night, I sometimes like to let my mind wander and imagine what I might see if I were standing under alien skies, surrounded by the most bizarrely different biological landscapes. One day, I'd like to publish a book of art that visualizes the organ pipe forests and schoals of banner plankton that have occasionally materialized behind my eyelids.

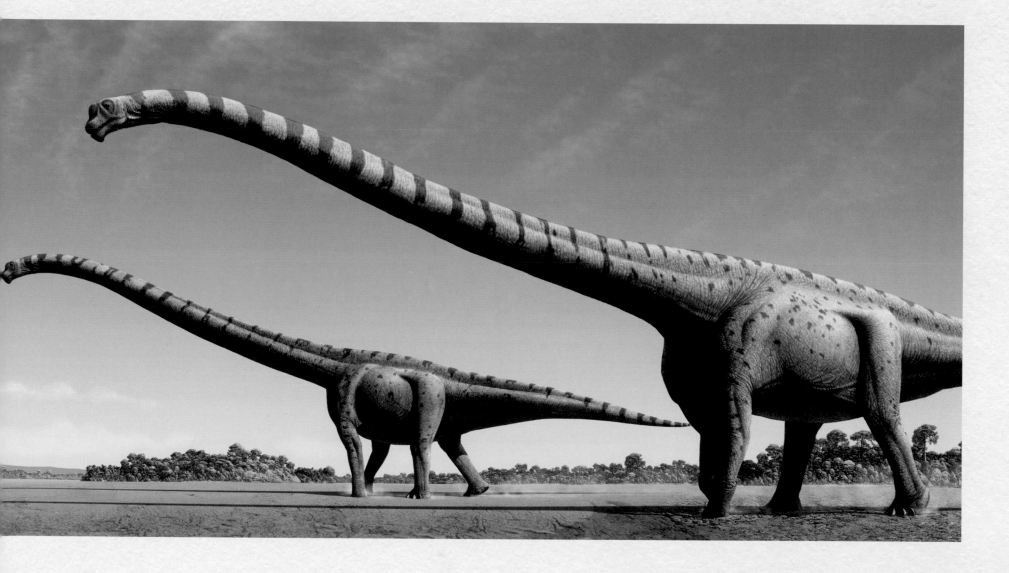

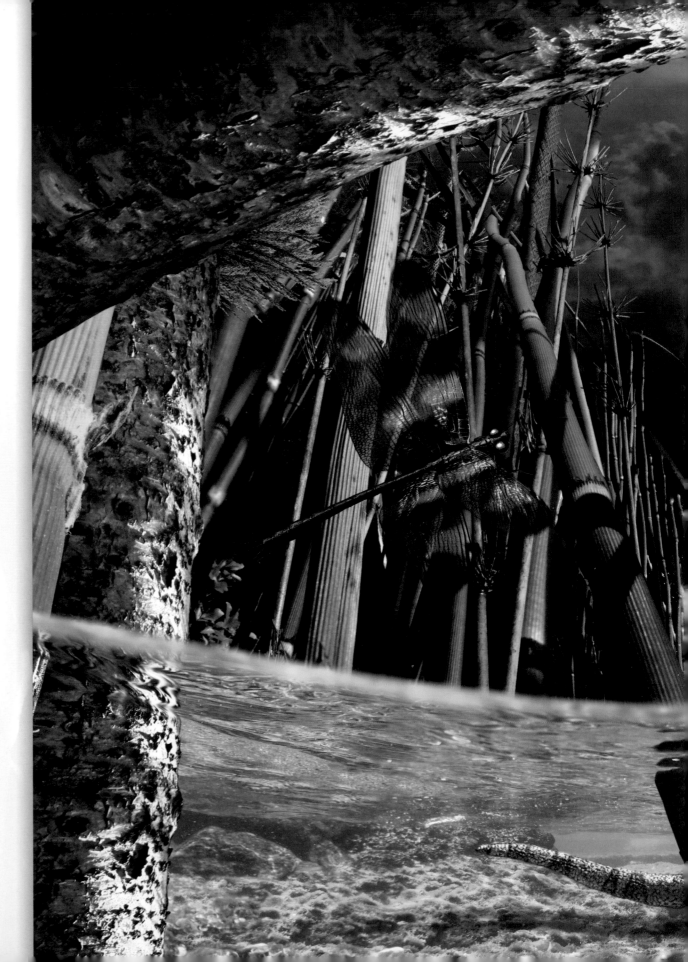

PALEOZOIC

Early Permian Landscape. Photographic composite. Commission: Gondwana Studios (Australia). 2011.
One of eleven murals created for the Permian Monsters: Life Before the Dinosaurs traveling exhibit. This image features (left to right) *Meganeuropsis* (dragonfly), *Eryops*, *Meganeuropsis* holding *Hylonomus*.

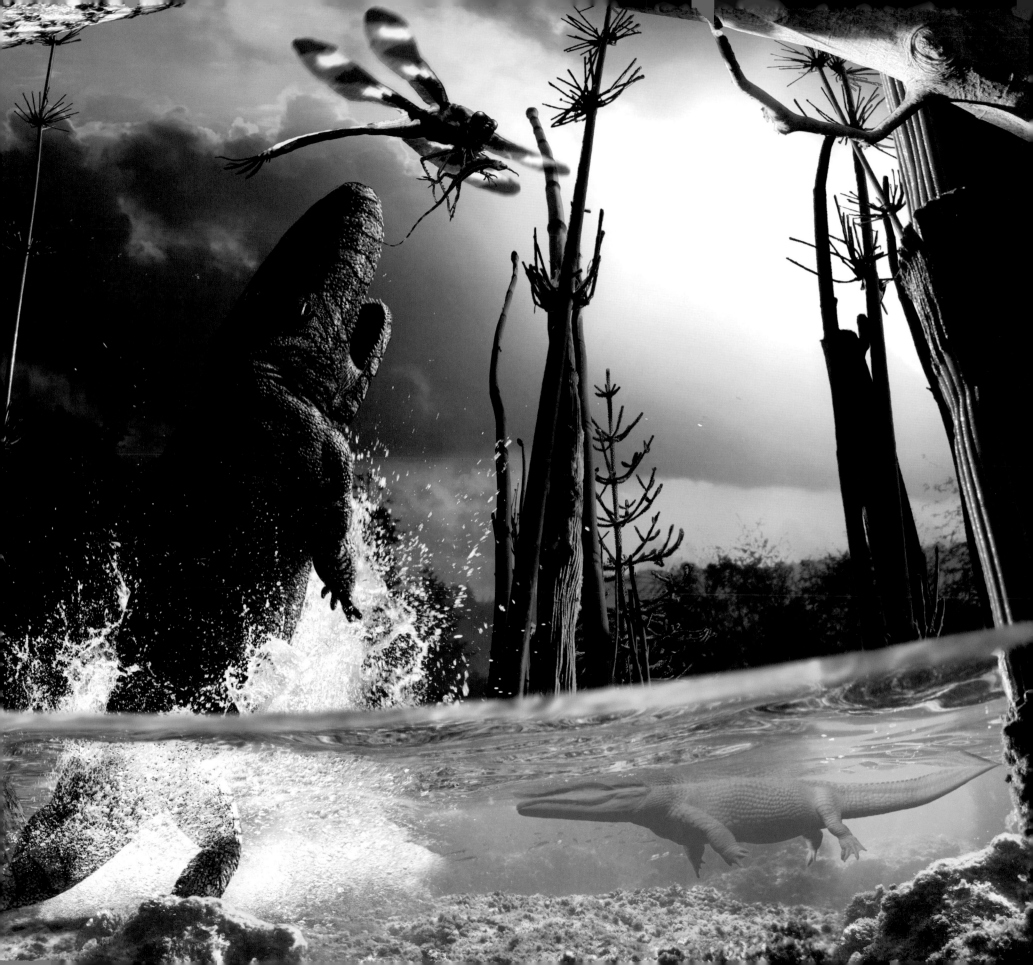

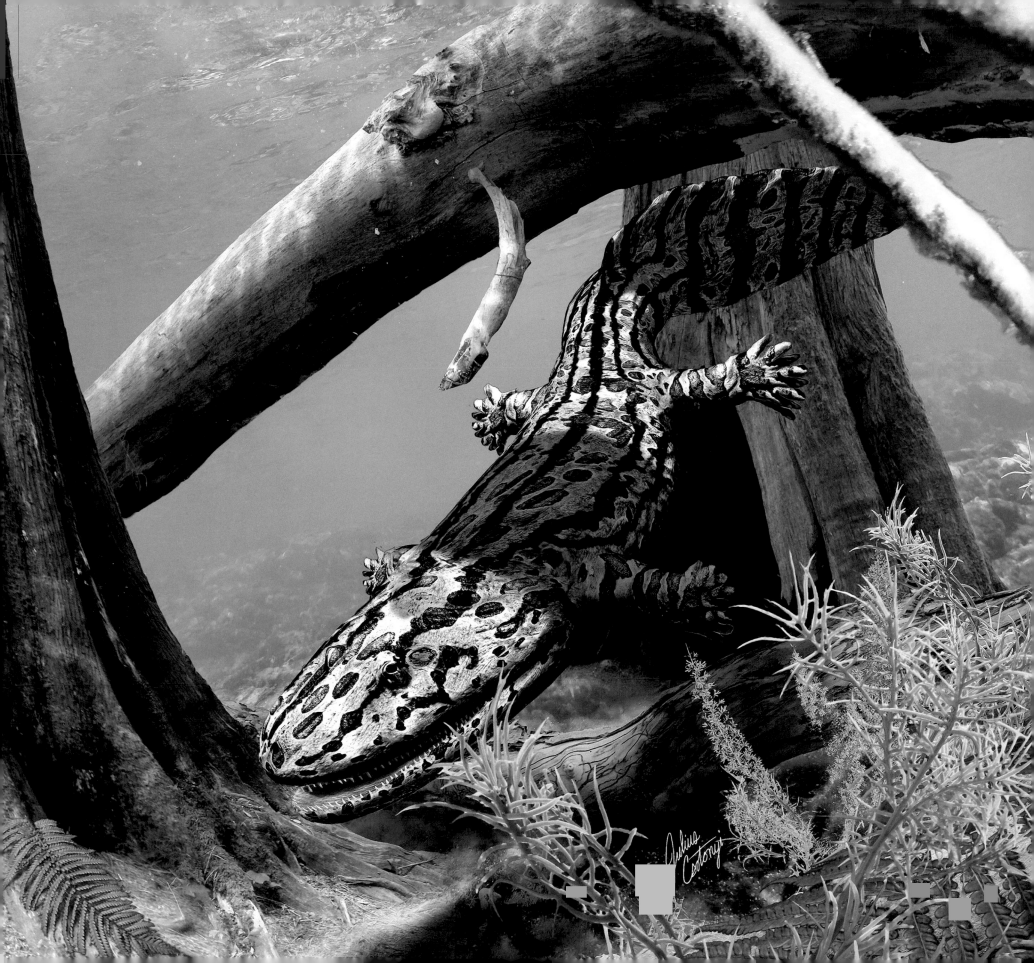

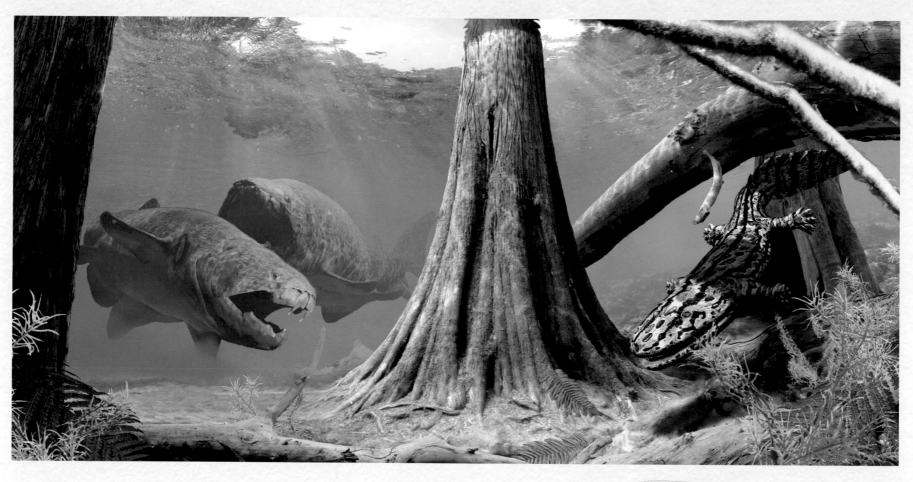

(Left and Above) **Devonian Aquatic Scene.**
Photographic composite. Commission: Hall
of Paleontology at the Houston Museum of
Natural Science. 2012.
Image depicting a sparring or courting pair
of the giant placoderm *Dunkleosteus* and the
early tetrapod *Acanthostega*, in a flooded forest
of *Archaeopteris*.

(Right) ***Placenticeras meeki* (Mesozoic
Ammonite) Chamber Cross-Section.**
Digital drawing. Commission: Royal Tyrrell
Museum. 2010.
Created for the Alberta Unearthed exhibit.
Image courtesy of the Royal Tyrrell Museum
of Palaeontology, Drumheller, Alberta, Canada.

TIKTAALIK

Genus:	*Tiktaalik* (Inuktitut word for the burbot, a freshwater relation of the cod)
Species:	*roseae* (named after an anonymous donor to the expedition that discovered the fossil)
Location:	Ellesmere Island, Canada
Named:	2006
Age:	Frasnian Stage, Late Devonian, 375 million years ago
Length:	2.75m (9ft)

Tiktaalik is a lobe-finned fish adapted to living in shallow, oxygen-poor water. It is considered a 'transitional' genus, marking a new stage in the evolution of terrestrial vertebrates from waterborne ancestors. Its four fins featured basic 'wrist' bones, while the supporting bony rays within the fins had developed into very simple digits. They had become, essentially, the most simple of hands. The limbs and shoulders were strongly muscled, showing load-bearing abilities that suggest *Tiktaalik* used its fins to pull it through shallow, thickly vegetated water, or secure it against fast-running currents. Both these purposes have analogies amongst modern fish and amphibians. Its limbs also enabled *Tiktaalik* to move around on land, and there are prints and impressions in fossilized mud of a similar age that seem to bear this out.

The animal's crocodile-like head also includes spiracles, small breathing holes that opened into its mouth. These were situated atop its flat head and suggest that *Tiktaalik* had some sort of superficial lung as well as gills, hinting again that it lived in low-oxygen water. Its thickened, well-developed ribcage would have supported the animal's body against the pull of gravity when it ventured out of the water.

Rows of sharp teeth and its large size suggest a powerful predator.

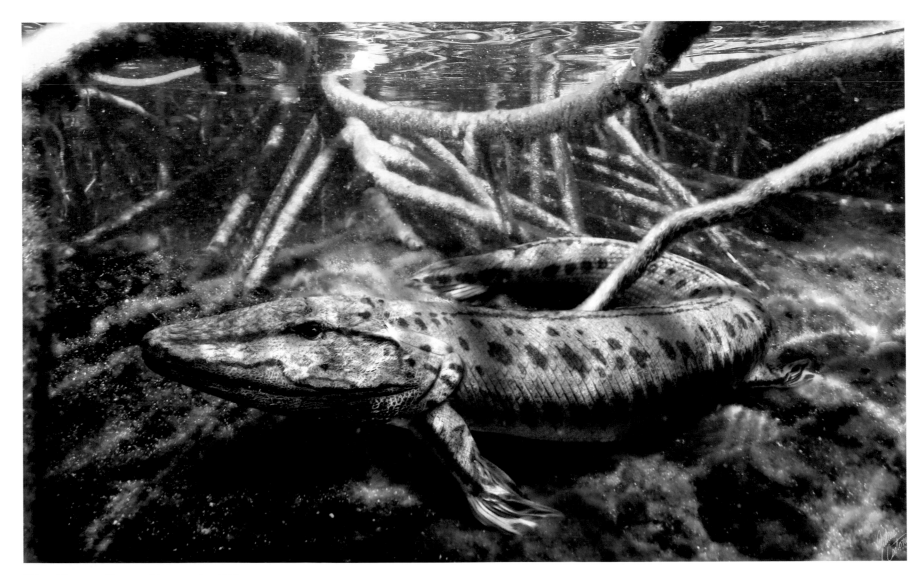

Tiktaalik roseae. Photographic composite. 2013.

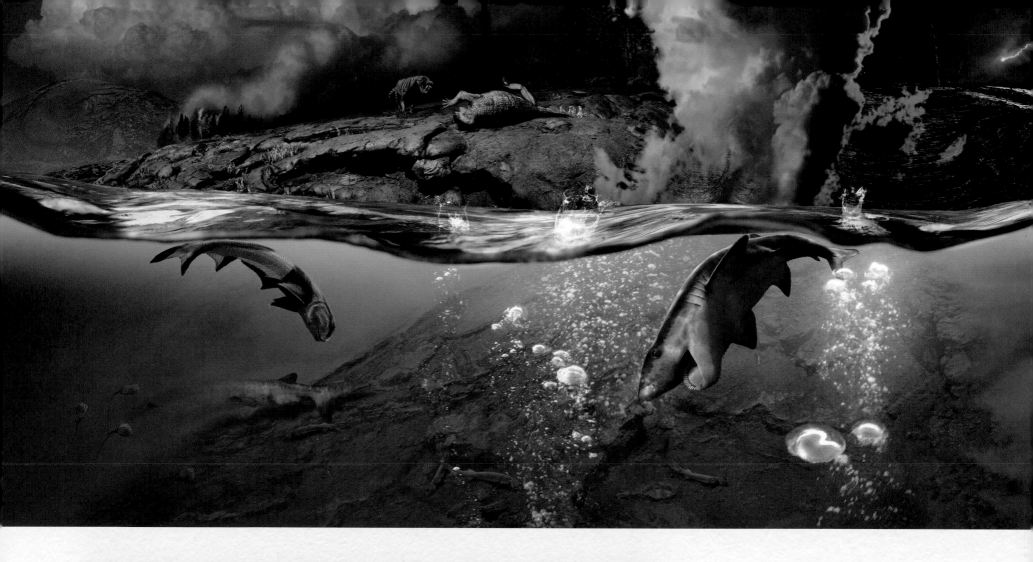

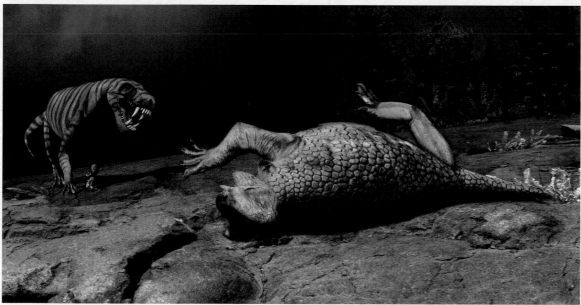

Permian Extinction Scene. Photographic composite. Commission: Gondwana Studios (Australia). 2011.
One of eleven murals created for the Permian Monsters: Life Before the Dinosaurs traveling exhibit. This image features (left to right) in the water an acanthodian and *Helicoprion*, on land *Inostrancevia* and *Scutosaurus*.

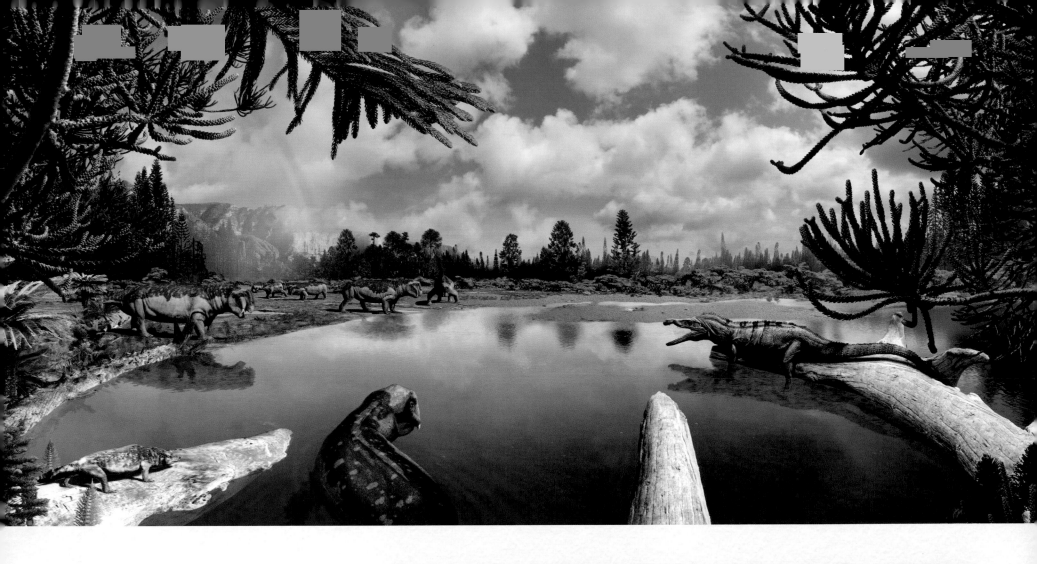

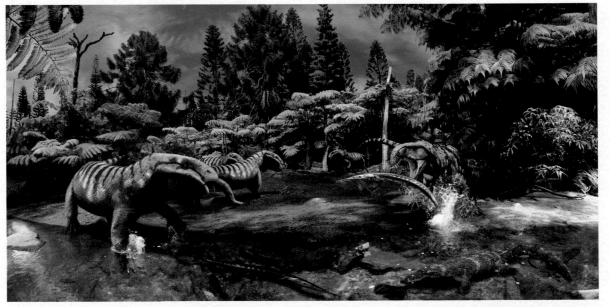

(Above) **Permian Survivors into Early Triassic Scene.** Photographic composite. Commission: Gondwana Studios (Australia). 2011.
One of eleven murals created for the Permian Monsters: Life Before the Dinosaurs traveling exhibit. This image features (left to right) *Thrinaxodon*, *Lystrosaurus*, and *Proterosuchus*.

(Right) **Permian Dicynodonts.** Photographic composite. Commission: Gondwana Studios (Australia). 2011.
This image features (left to right) *Dicynodon*, *Saurichthys*, *Archosaurus*, and *Chroniosuchus*.

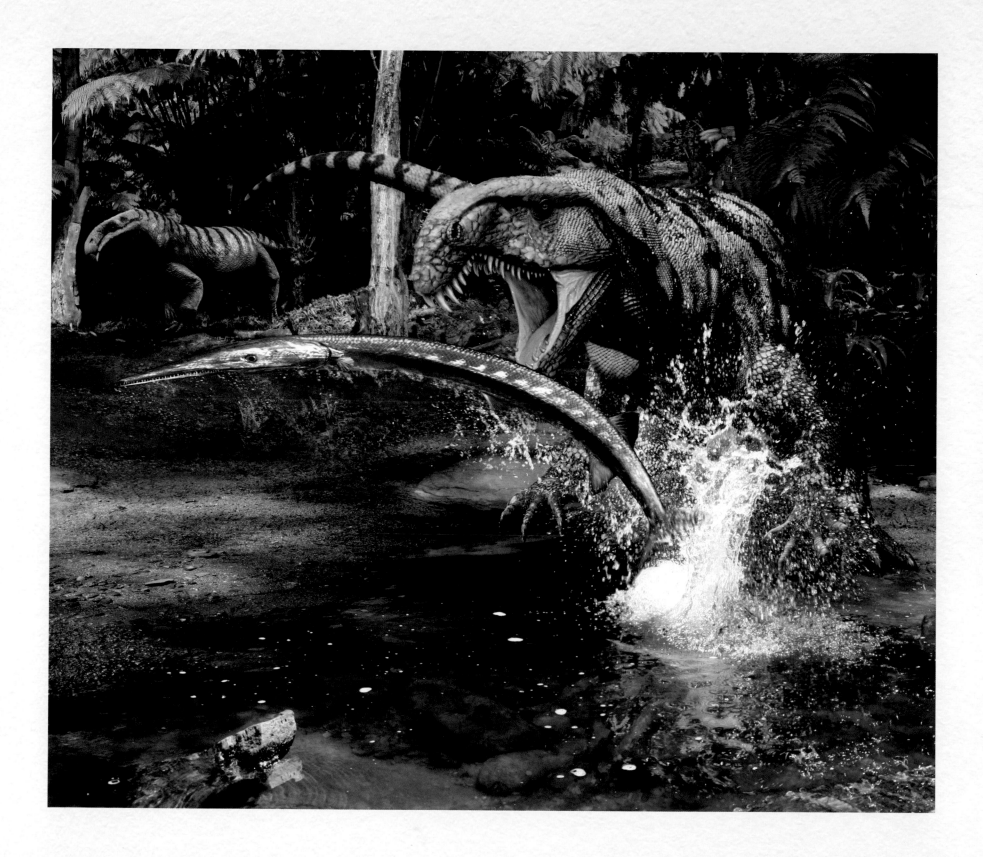

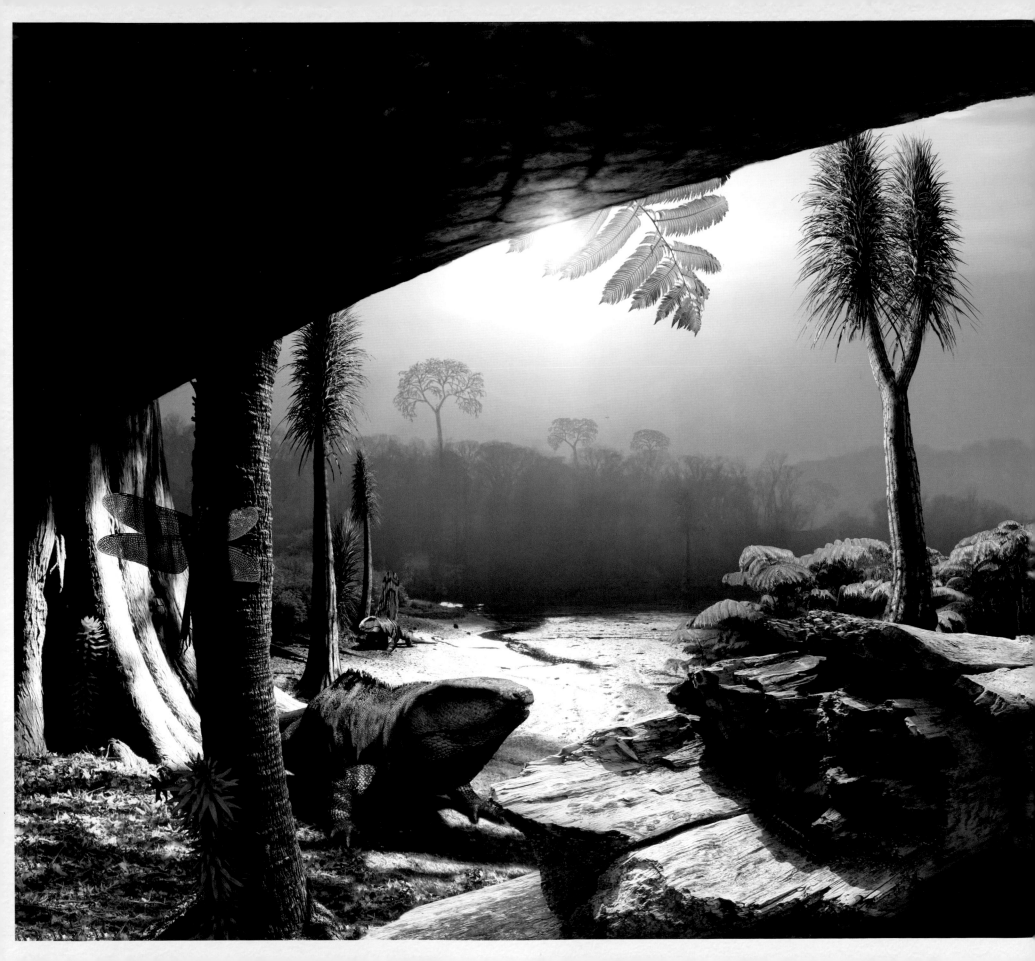

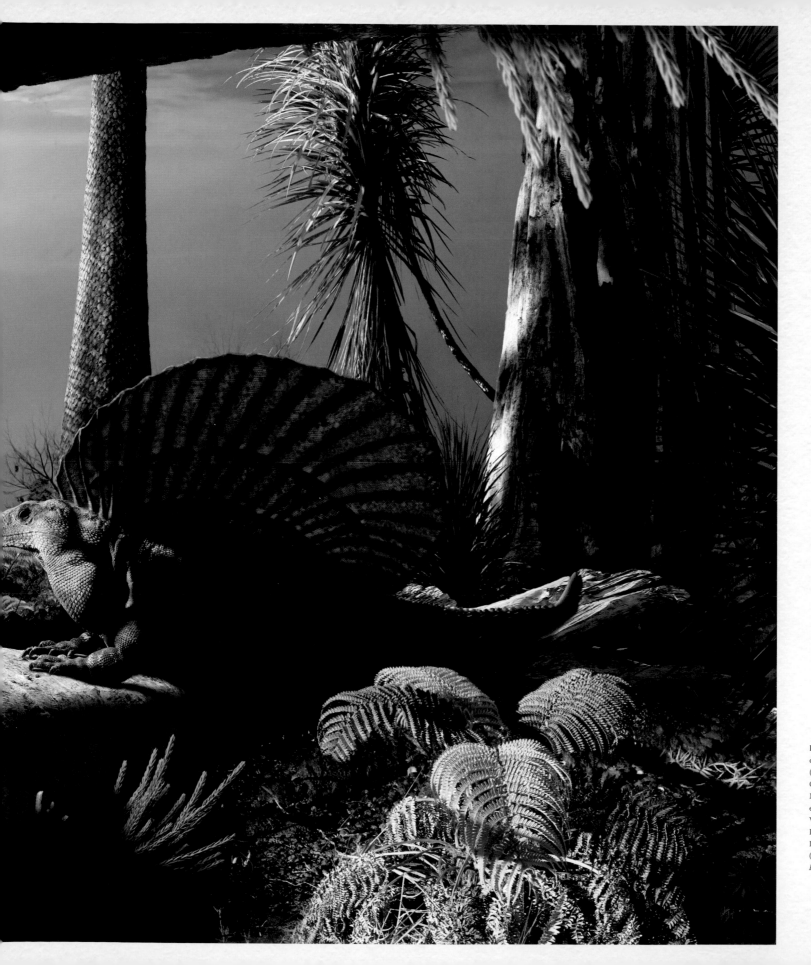

Permian Pelycosaurs Scene. Photographic composite. Commission: Gondwana Studios (Australia). 2011.
One of eleven murals created for the Permian Monsters: Life Before the Dinosaurs traveling exhibit. This image won the Society of Vertebrate Paleontology's 2012 Lanzendorf PaleoArt Prize for Two-Dimensional Art. It features (left to right) *Meganeuropsis* (dragonfly), *Ophiacodon*, *Dimetrodon*, and *Edaphosaurus*.

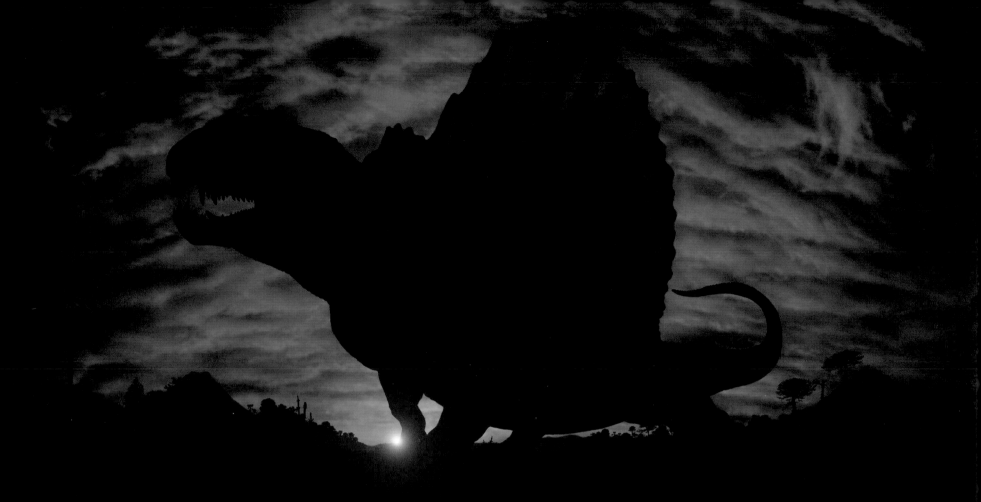

(Above) *Dimetrodon* **Dawn.** Digital painting. Commission: Gondwana Studios (Australia). 2011. One of two marketing images created for the Permian Monsters: Life Before the Dinosaurs traveling exhibit.

(Left) *Titanophoneus* **Dawn.** Digital painting. Commission: Gondwana Studios (Australia). 2011. One of two marketing images created for the Permian Monsters: Life Before the Dinosaurs traveling exhibit.

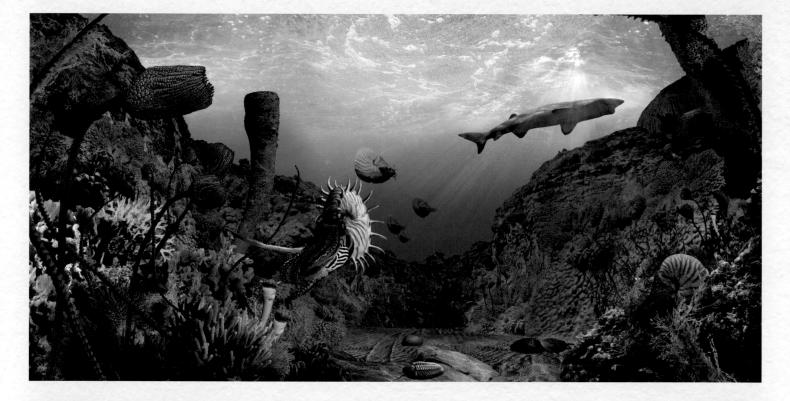

Permian Marine Scene.
Photographic composite.
Commission: Gondwana Studios
(Australia). 2011.
One of eleven murals created for
the Permian Monsters: Life Before
the Dinosaurs traveling exhibit. This
image features (left to right) crinoids,
horn coral, brachyopods, sponges,
Cooperoceras, nautiloids, *Helicoprion*,
and trilobites.

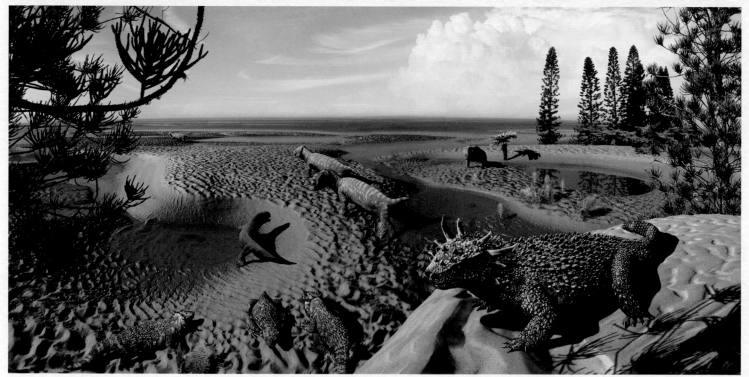

Permian Paraiasaurs Scene.
Photographic composite.
Commission: Gondwana Studios
(Australia). 2011.
Based on tha paleofauna of Elgin,
Scotland, this image features (right to
left) *Elginia*, *Gordonia*, and *Geikia*.

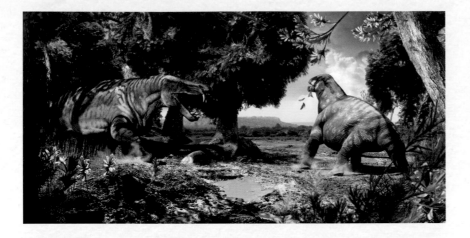

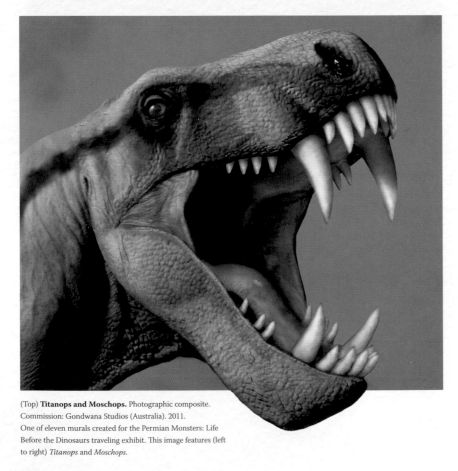

(Top) **Titanops and Moschops.** Photographic composite.
Commission: Gondwana Studios (Australia). 2011.
One of eleven murals created for the Permian Monsters: Life
Before the Dinosaurs traveling exhibit. This image features (left
to right) *Titanops* and *Moschops*.

(Right) **Gorgonopsians.** Photographic composite. Commission:
Gondwana Studios (Australia). 2011.
One of eleven murals created for the Permian Monsters: Life
Before the Dinosaurs traveling exhibit. This image features
Dinogorgon squabbling over a dicynodont's body.

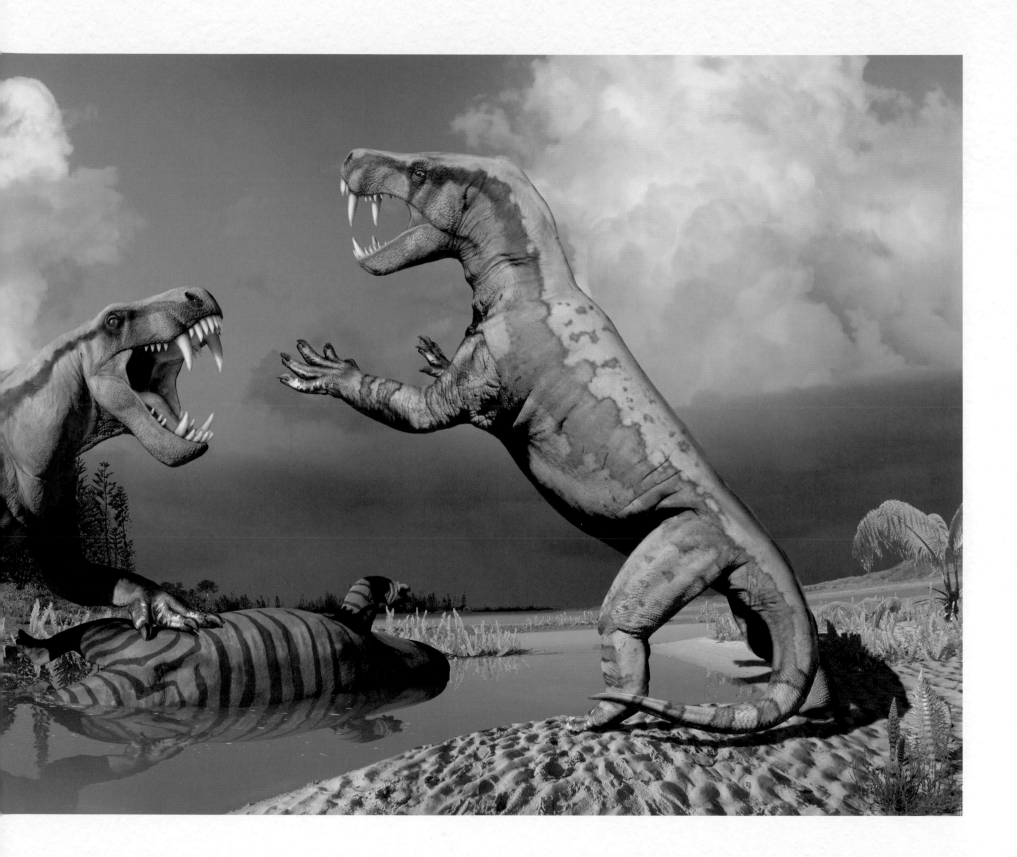

MESOZOIC

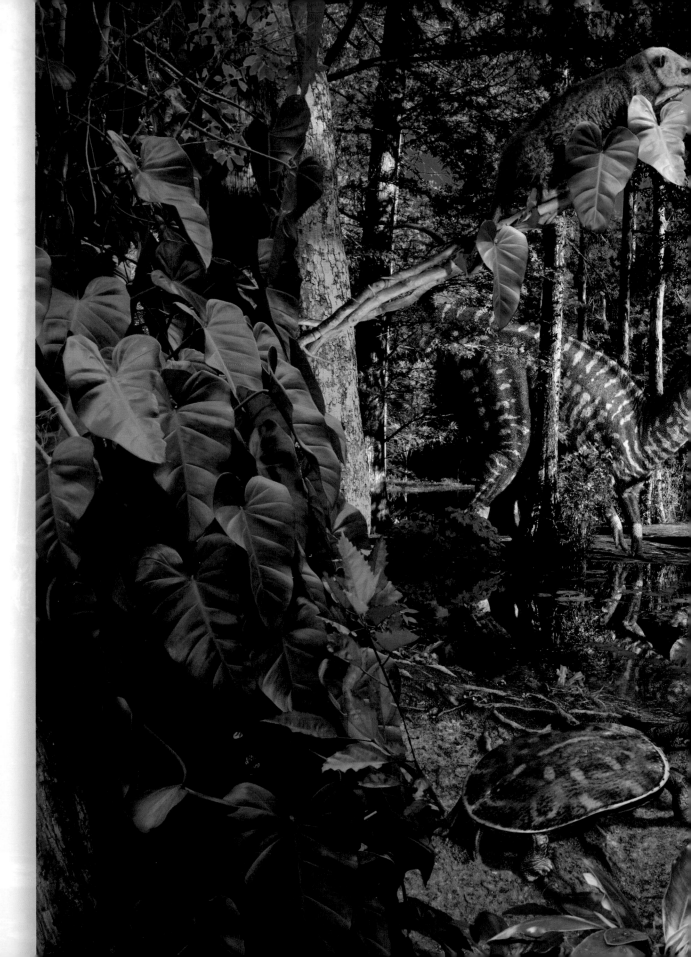

Hell Creek Formation Paleoenvironment.
Photographic composite. Commission: Natural
History Museum of Los Angeles County. 2010.
One of three interactive digital displays in
the museum's Dinosaur Hall, teaching about
the paleoecology of three major Mesozoic
formations. This one features the animals
Cimolestes (mammal), *Edmontosaurus*,
Triceratops, *Asperidites* (turtle), *Plesiobaena*
(turtle on rock), a small eusuchian crocodilian,
Tyrannosaurus, *Pediomys*, and *Pediomys*; and the
plants *Magnolia*, *Philodendron*, and *Taxodium*.
Courtesy Los Angeles County Museum of
Natural History, Dinosaur Hall; all rights reserved
(for reproduction of this image, contact Nancy
Batlin, Director of Creative Services;
nbatlin@nhm.org).

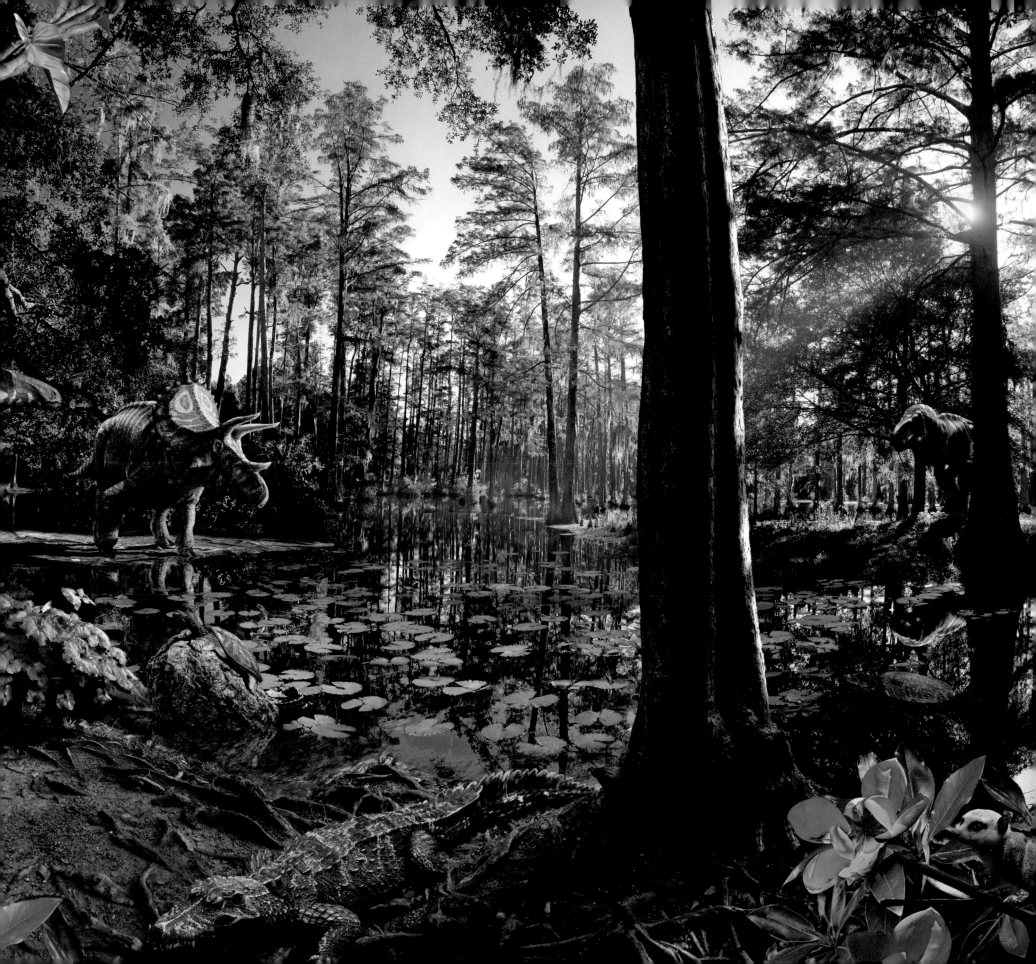

"It was a childhood dream come true – I had helped discover and describe a brand-new dinosaur species! *Aardonyx* was certainly not the flashiest or largest or most bizarre dinosaur, yet it was remarkable to me because it helped answer a question that had been germinating since graduate school: What did the animals on the road to the giant sauropods look like? Adam Yates, one of my fellow paleontologist colleagues and the lead author on the study, did a meticulous reconstruction of the skeleton, and I tried my skills at a life restoration, which I was happy with in a cartoonish sort of way. About a month after our discovery was published, I went to modify some information on *Aardonyx* on the web, and my search engine produced the beautiful life portrait you see here. What I like about Julius's picture is how he took information both from our anatomical description and from the geology of Early Jurassic South Africa and presented *Aardonyx* in its environment. Here was what *Aardonyx* was to me in my mind, and Julius's picture is probably the closest we'll ever get to going back in time to see that animal stride proudly through its prehistoric wilderness. This illustration of *Aardonyx*, like all the other illustrations Julius has produced, shows, to me, why the sciences and arts need each other. In one frame, Julius has transported us back to a younger, more alien Earth, and conveys to expert and non-expert alike what our discovery means."
Dr. Matthew Bonnan, Associate Professor, Richard Stockton College of New Jersey

Aardonyx celestae. Photographic composite. 2009.
A wonderful example of a species displaying evolutionarily intermediate features between earlier bipedal prosauropods and more advanced quadrupeds, the legs of the early Jurassic prosauropod *Aardonyx celestae* possessed bone structure indicating increased tendency toward walking on all fours. This trait is taken to the extreme in the often-gigantic descendants of prosauropods, the sauropods. To highlight this development, I chose to depict the animal in a low bipedal stance, in that off-balance intermediate posture that occurs in the process of lowering onto all fours. This digital piece is one of the examples of uncommissioned, independent work spurred by my interest in illustrating newly published discoveries in the scientific literature.

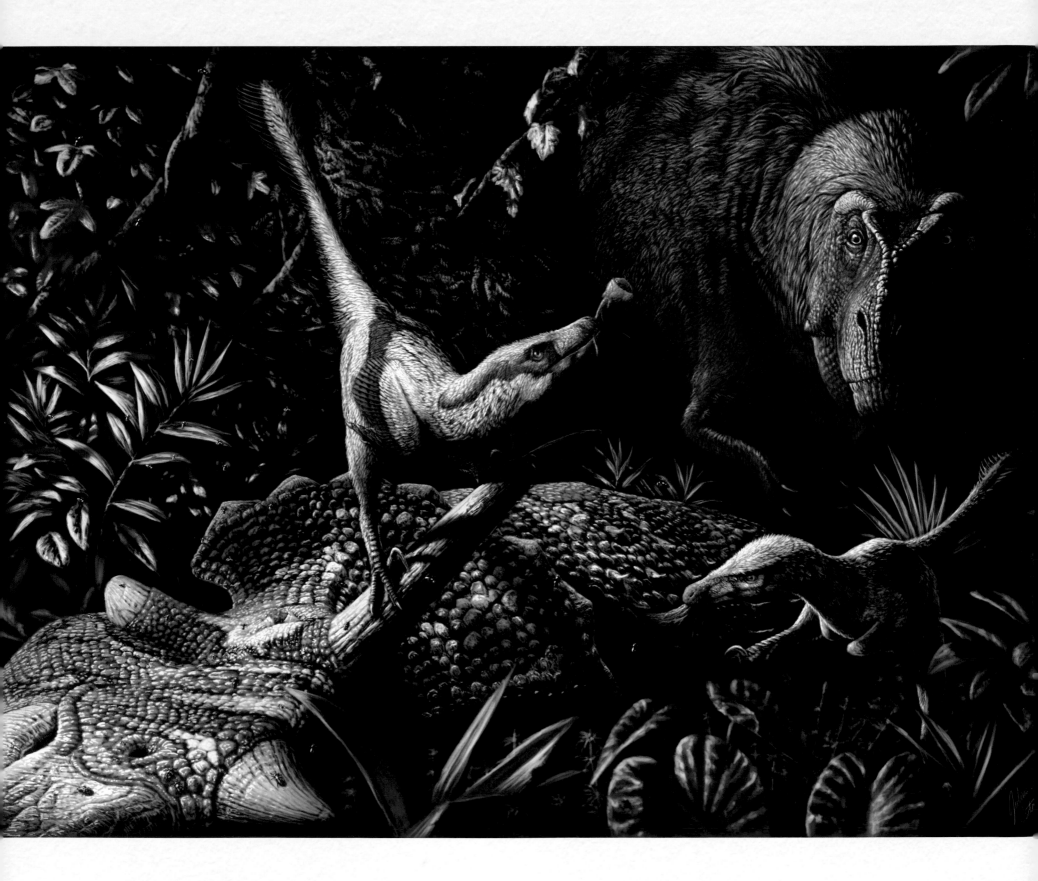

THE PALEOART OF JULIUS CSOTONYI

Hell Creek Dromaeosaurid *Acheroraptor temertyorum.* Digital painting. Commission: Dr. David Evans. 2013.
The long-awaited description of a *Velociraptor*-like dromaeosaurid from the Hell Creek Formation, here shown with typical Hell Creek fauna, *Tyrannosaurus*, and *Triceratops*.

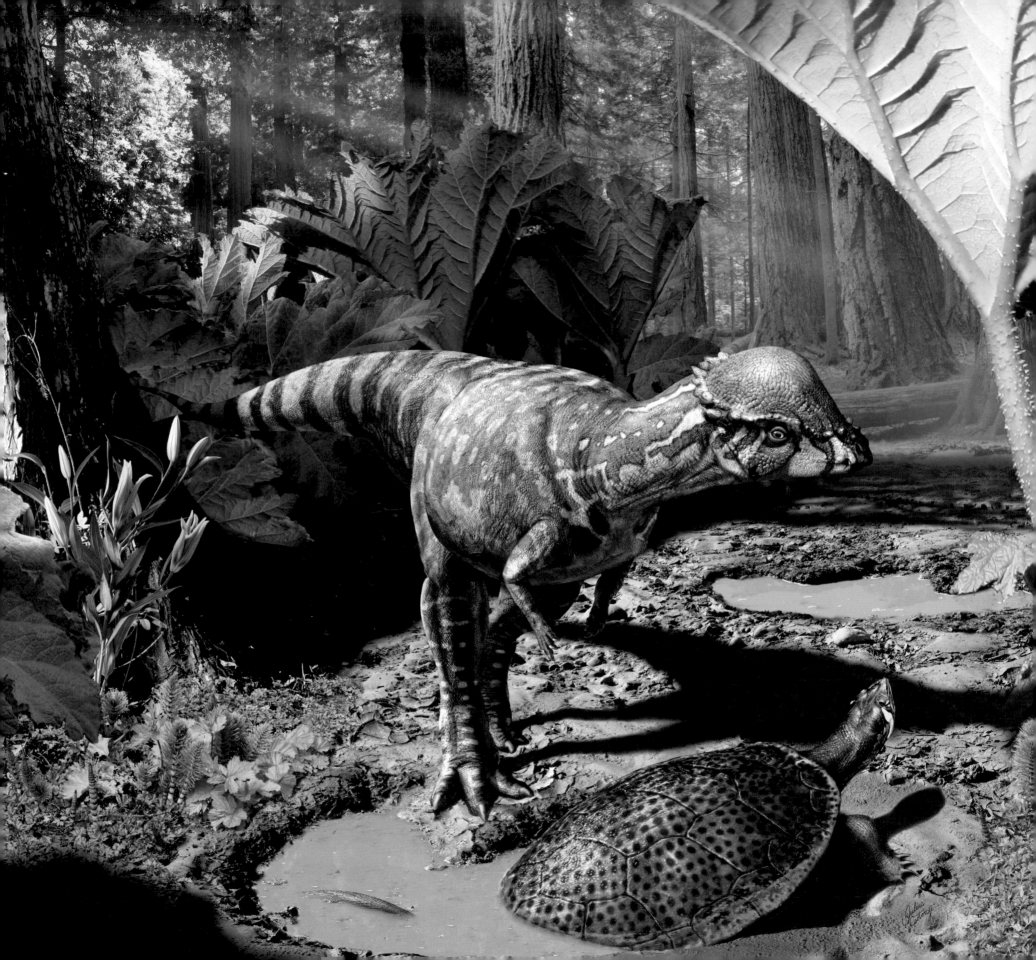

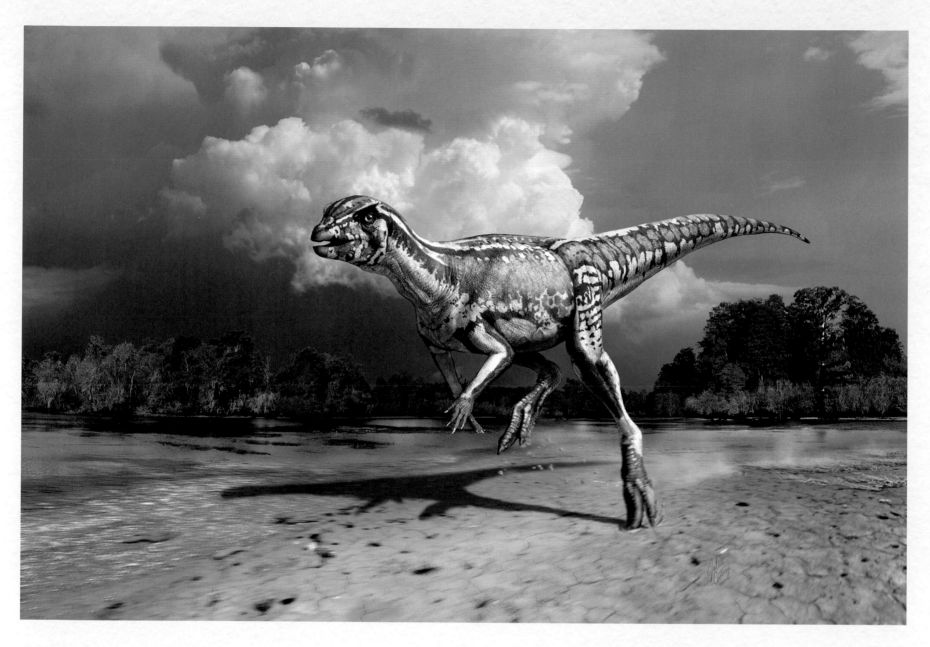

(Left) ***Acrotholus audeti*** and ***Neurankylus lithographicus.*** Photographic composite. Commission: Evans *et al.* (multidisciplinary group; 2013). 2013.

This piece is an example of artwork that was commissioned by Dr. Evans to appear in press releases, in order to boost public knowledge of his research and help spread the word, through newspapers, television, and digital media, much farther than would publication solely in a scientific journal. This scene shows the newly described dome-headed dinosaur *Acrotholus* exiting a stand of giant *Gunnera* leaves and coming across a *Neurankylus* turtle soaking in the footprint of a hadrosaur that had passed by earlier. Note the small size of the dinosaur next to the footprint. The intention here was to bring attention to the fascinating outcomes of the research: That using the thick and relatively frequently preserved skullcaps of pachycephalosaurids gives a more reliable estimate of the diversity of these small dinosaurs than does their enumeration based on less robust and typically less well preserved parts of their skeletons. The results indicate that using less preservation-prone parts underestimates their abundance, and the implications are that small dinosaur diversity in general is markedly underestimated by the material on which this estimate is currently based. The Mesozoic was likely a more interesting place than the available fossil record indicates!

(Above) ***Albertadromeus syntarsus.*** Photographic composite. Commission: Brown *et al.* (multidisciplinary group; 2013). 2013.

It was very exciting to learn that my illustration of a newly described ornithischian dinosaur, *Albertadromeus*, was selected as the cover image for the May 2013 issue of the *Journal of Vertebrate Paleontology*. Promotion of scientific research and education through the illustration of museum exhibits, educational books, research publications, and press releases is the main driving force behind my work. Therefore, the first occurrence of my work on the cover of a major research journal was a milestone for me. The artwork depicts a small ornithopod from Cretaceous Alberta with fused leg bones (tibia and fibula), a strengthening feature that indicated the capacity for fast running. I restored the creature in mid-sprint, adding a radial motion blur to convey the feeling of high speed.

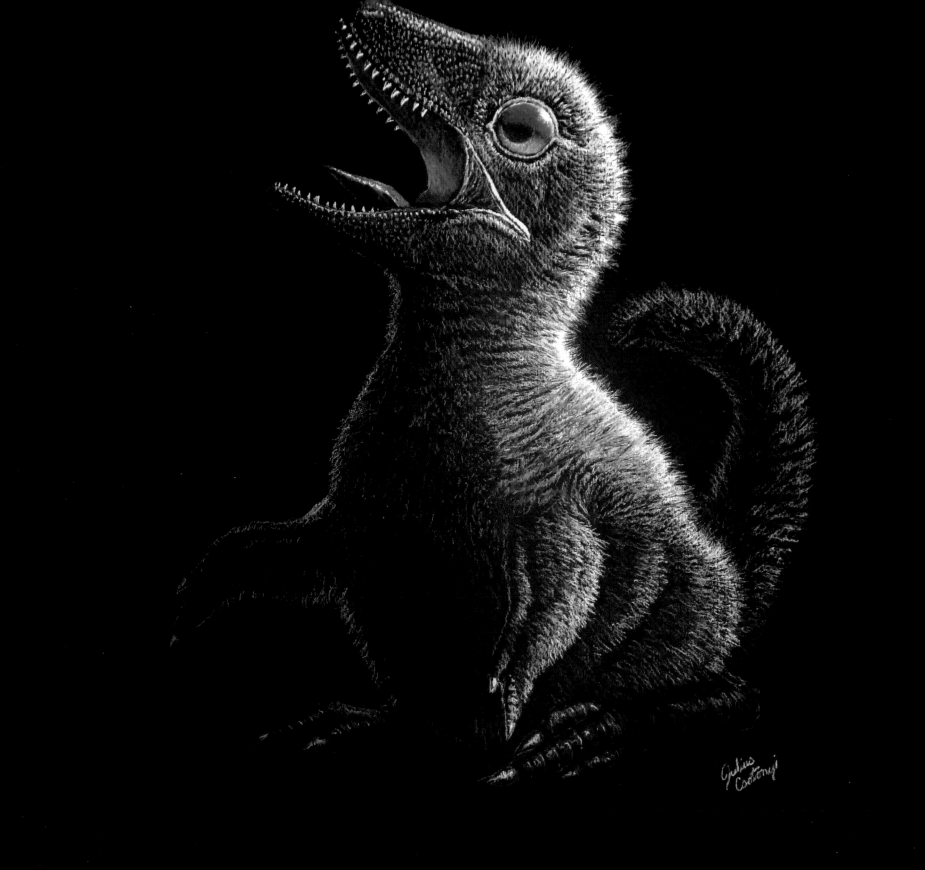

(Above) **Troodon.** Digital drawing. Commission: Royal Tyrrell Museum. 2010. Created for the Alberta Unearthed exhibit.
Image courtesy of the Royal Tyrrell Museum of Palaeontology, Drumheller, Alberta, Canada.

(Left) **Tyrannosaur Chick.** Dry pastel on paper (20 x 30"). Philip J. Currie Dinosaur Museum fundraiser auction, Grand Prairie, Alberta, Canada. 2012. 'Live' artwork created in the space of two hours during the banquet of the Dino Country Ball 2012, and auctioned off immediately after dinner, this was the first of a pair of auctions for which I did live painting to raise funds for this museum, in 2012 and 2013. (See also page 15.) Much of the impetus for the development of the Philip J. Currie Dinosaur Museum has come from the fruits of the excavations of the productive fossil-bearing strata near Grande Prairie.

(Right) **Troodon's Gaze.** Digital painting and photographic composite. Commission: *New Trail* magazine. 2013.
This piece was commissioned for the cover of the Autumn 2013 edition of the alumni magazine of my alma mater, the University of Alberta, to support a story, 'Dinosaur Hunters,' on some of the university's prestigious paleontological research team, including Philip Currie, Michael Caldwell, Victoria Arbour, and Scott Persons. The cover uses a close crop of a restoration of *Troodon*, with the eye reflecting the happenings of a paleontological excavation in the Grande Prairie region of Alberta, featuring Scott Persons in the foreground with his geological hammer, based on photographs of the excavation. The cover design was awarded the 2014 CASE District VIII Communications Award (gold) for the Photography and Illustration category 23a (Illustration and Photo-Illustration-Individual), submitted by Lisa Cook, University of Alberta.
Additional credits: Marcey Andrews (designer at *New Trail* who came up with the idea for the close-cropped view of the dinosaur eye); John Ulan (photographer who provided the photo of Scott Persons).

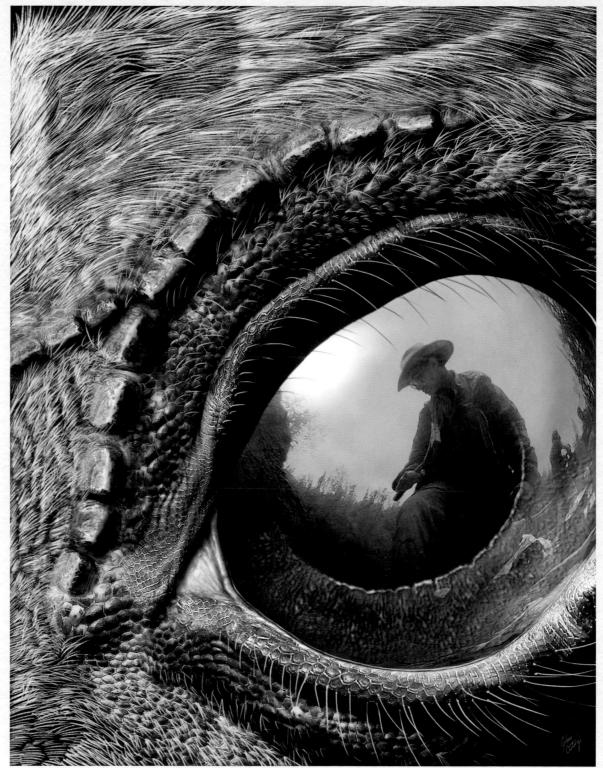

(Above) *Mei long,* **Second Published Specimen.** Digital painting. 2012.
An illustration of the second published specimen of *Mei long.* Like the first (see right), amazingly also found in a sleeping posture.

(Right) *Mei long,* **First Published Specimen.** Digital painting. 2007.
An illustration of the first published specimen of the troodontid *Mei long* (a name which in Chinese means 'sleeping dragon') from the Yixian Formation in China, in a posture similar to that adopted by sleeping birds of today. In this reconstruction, I wished to illustrate the concept of cryptic coloration, referring to the color patterns of an animal closely matching those of its surrounding, and which is employed by modern animals to hide from predators. It may have been a useful trait for small theropods that slept on the ground, unless they had other means of hiding, such as inhabiting burrows or other concealing cover.

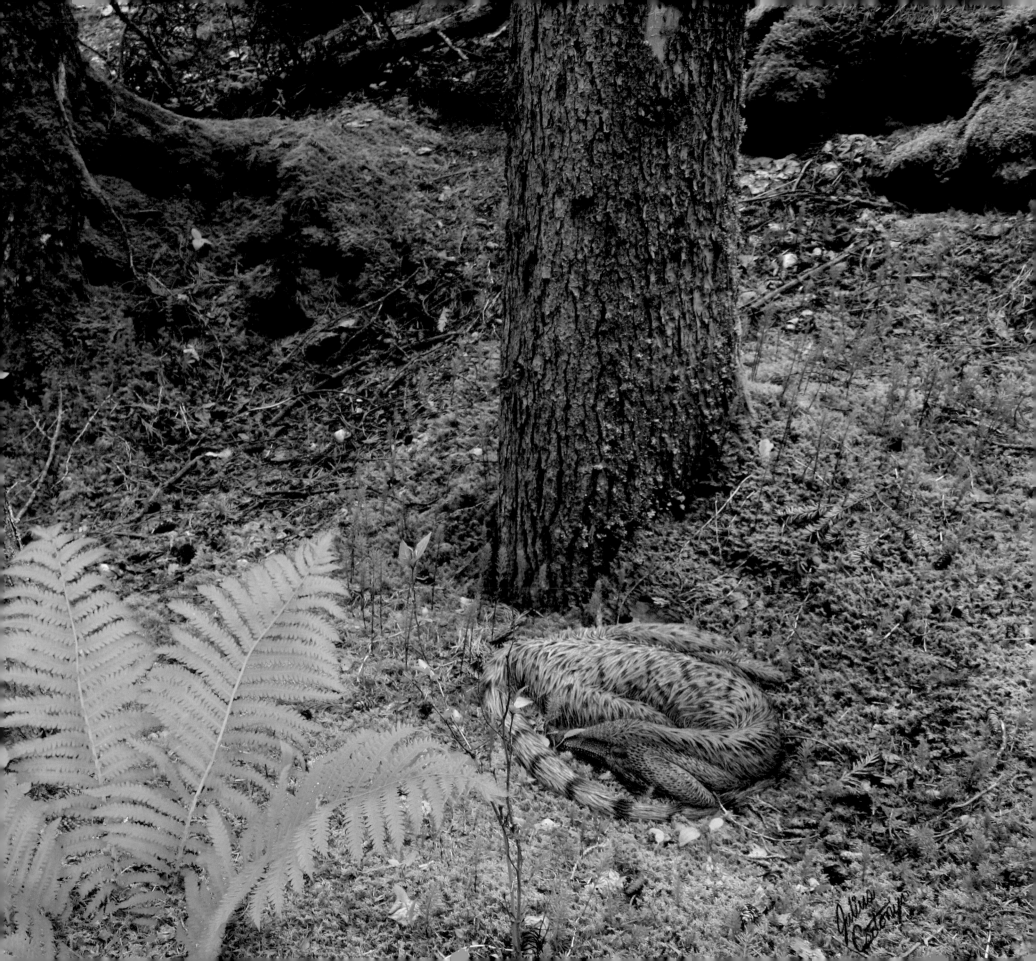

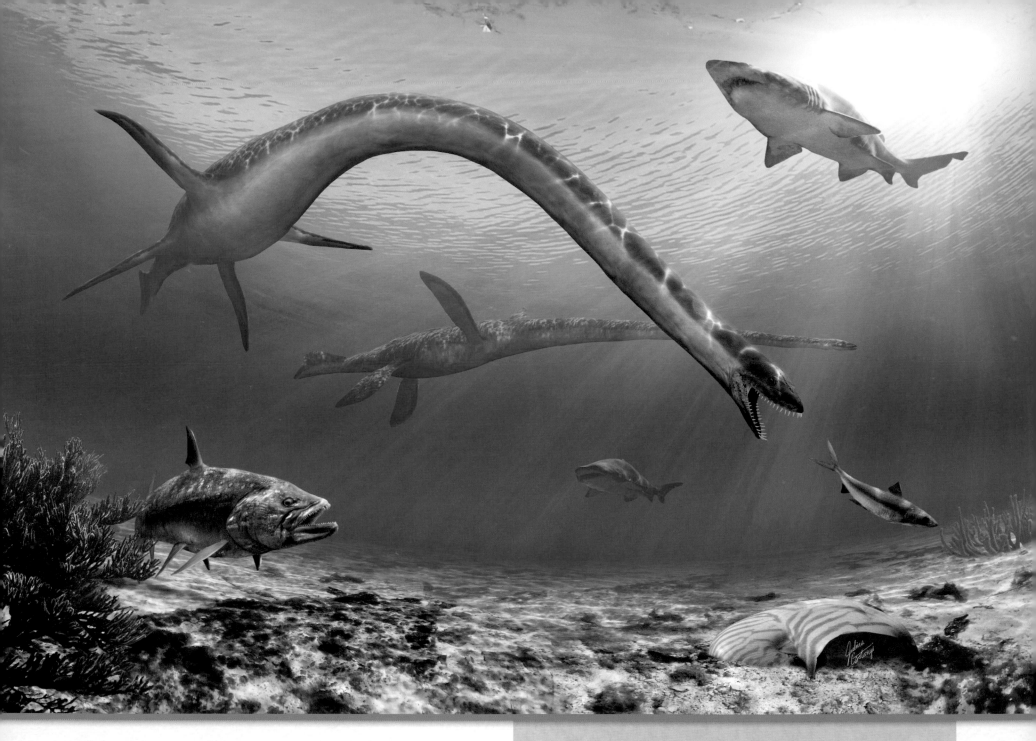

***Albertonectes* in the Bearpaw Sea.** Photographic composite. Commission: Pipestone Creek Dinosaur Initiative in support of the Philip J. Currie Dinosaur Museum, Grande Prairie, Alberta, Canada. 2012.

It's been rewarding to be involved in the fundraising efforts of Brian Brake's team on the way to making a long-awaited dream come true: The building of Canada's newest paleontological museum, the Philip J. Currie Dinosaur Museum, just off the Alaska Highway. This piece, commissioned to be sold as prints for fundraising, depicts the extremely long-necked plesiosaur *Albertonectes* hunting fish in the Bearpaw Sea, a Late Cretaceous environment of the Western Interior Seaway that once covered much of Alberta and is an exceptionally well-known paleo-ecosystem from the fossil record.

"A gentleman came into the office reporting that he'd found some dinosaur bones on the Spirit River in Alberta. However, when I looked at the bones it was clear that they weren't dinosaur but plesiosaur – those toothy, flipper-footed marine reptiles. As these were the first plesiosaur bones from the area, we were excited, as was the local media. I contacted Julius to see if he could do a reconstruction from the few vertebrae we had, which he was willing to do. From the available bones, the animal could be identified as an elasmosaur – a particular group of plesiosaurs with spectacular long necks – but we had no knowledge of what particular species it could be. Instead we used another newly described elasmosaur, *Albertonectes*, from similarly aged rocks in southern Alberta as our model and placed it in a marine setting reflective of the northern Albertan waters from which it came."
Dr. Phil Bell, University of New England (Australia)

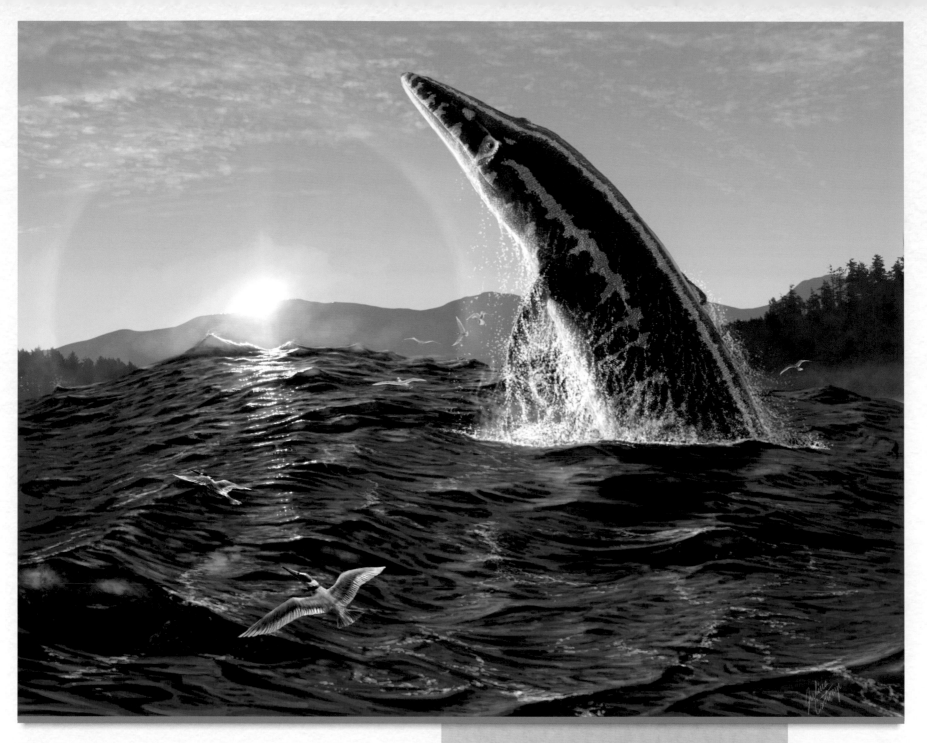

Tylosaurus pembinensis. Digital painting. 2013.

For this, I really wanted to create a piece that conveyed the whale-like imposing size of the largest mosasaurs. The reconstruction is based on the massive specimen of *Tylosaurus pembinensis* known as 'Bruce' (specimen number M.74.06.06). The individual is swimming here off the western coast of Laramidia, breaching under a rising Late Cretaceous sun. I added a loose flock of gull-sized ichthyornid seabirds trailing off into the distance to help provide a sense of scale.

"*Tylosaurus pembinensis*: Known to have reached thirteen meters in length, this truly colossal marine lizard, a mosasaur, was at the pinnacle of the apex predators inhabiting the ancient seaway that covered the Canadian Prairies some 80 million years ago. Their eyes were small relative to their body size; good vision didn't seem important for *T. pembinensis*'s survival: For one thing, it probably needn't watch out for its natural predators, of which it had none. While *T. pembinensis* could enjoy its ecological dominance of its time, other mosasaurs eventually caught up with *Tylosaurus* in size, and were in constant competition with the descendants of *T. pembinensis* by 70 million years ago."
Dr. Takuya Konishi, Royal Tyrrell Museum

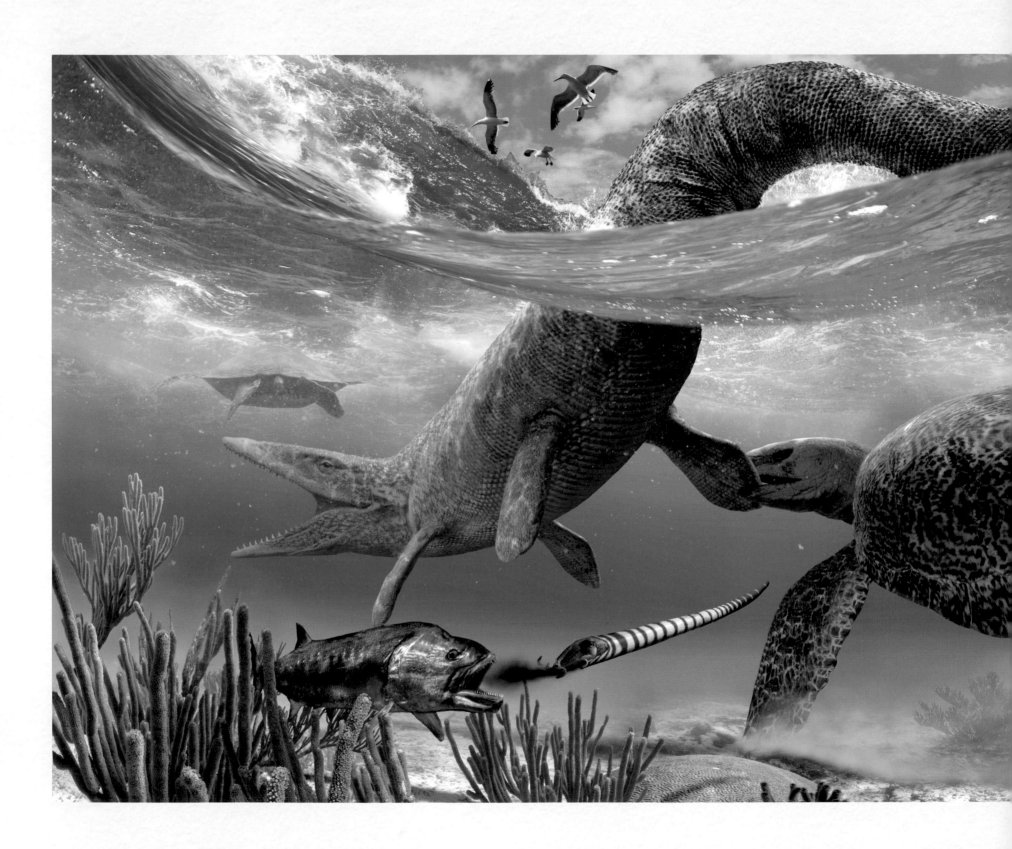

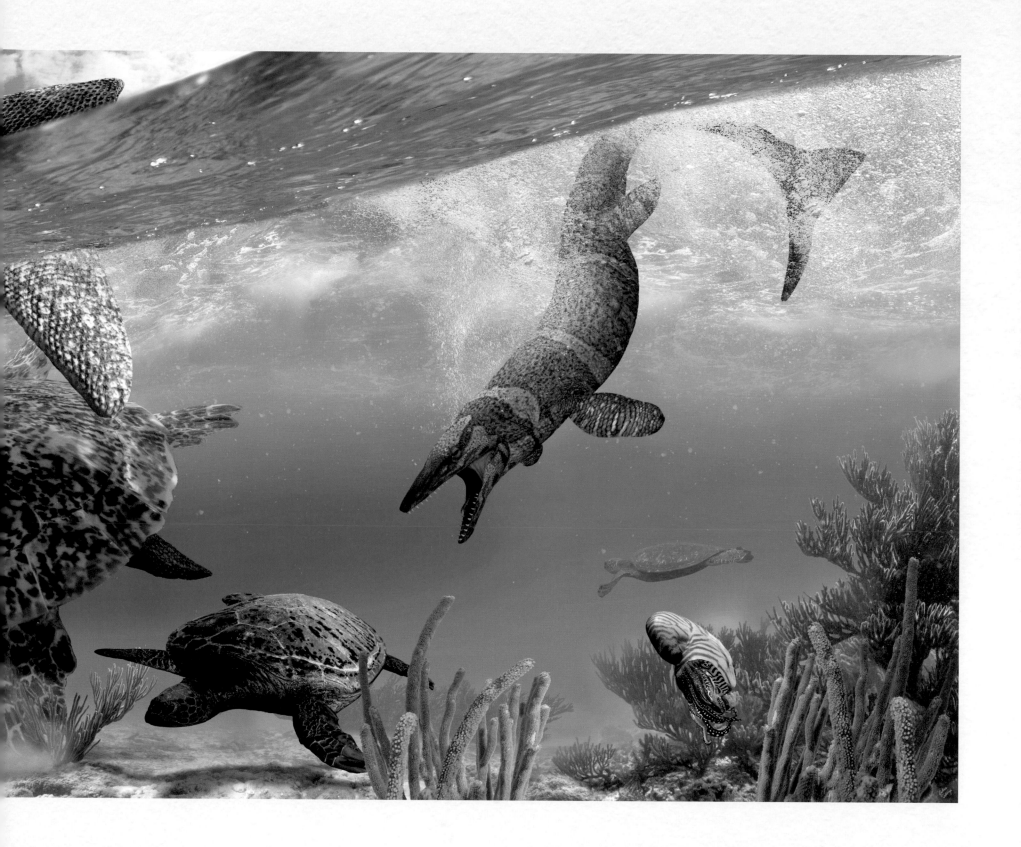

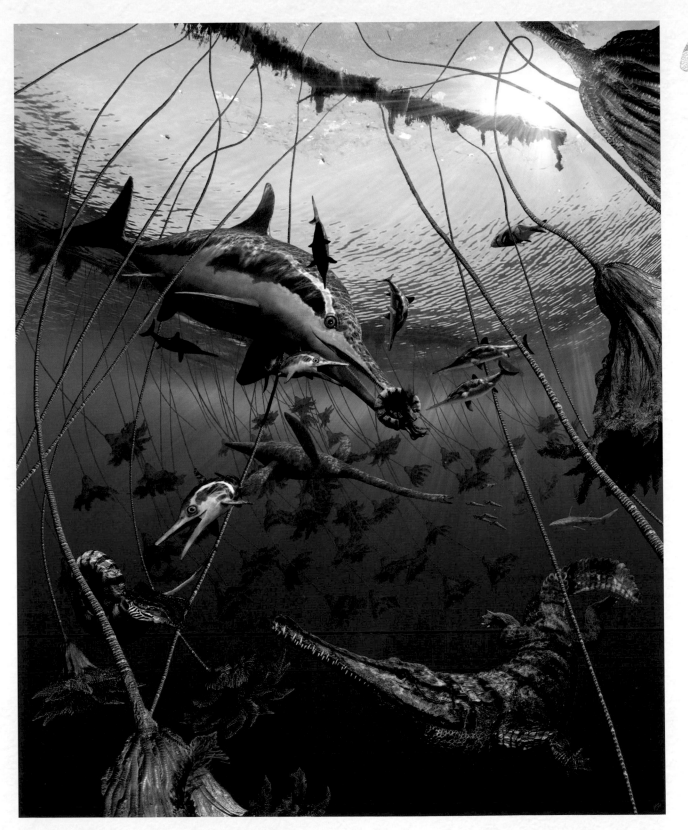

(Previous Spread) **Cretaceous Marine Scene.** Photographic composite. Commission: Hall of Paleontology at the Houston Museum of Natural Science. 2012.

This image depicts a dense assemblage of marine species of reptiles, birds, fish, and invertebrates that inhabited Cretaceous oceans in the great Western Interior Seaway. Taxa depicted (left to right) are *Ichthyornis* (bird), *Ichthyodectes* (fish), *Tylosaurus*, *Baculites* (shelled cephalopod), *Archelon*, *Toxochelys*, *Plioplatecarpus*, and *Placenticeras* (Nautilus-like cephalopod).

(Left) **Jurassic (Holzmaden Shale) Marine Scene.**
Photographic composite. Commission: Hall of Paleontology at the Houston Museum of Natural Science. 2012.

A mother *Stenopterygius* with seven young is inspected by a passing *Steneosaurus* (marine crocodile) while a distant *Plesiosaurus* hunts squid. Also shown are the shark *Hybodus*, the bony fish *Lepidotes*, the ammonite *Harpoceras*, and hanging stalks of *Seirocrinus*. An alternative reconstruction would have *Seirocrinus* rising upward from waterlogged benthic logs.

(Above) **Prognathodon**. Digital drawing. Commission: Royal Tyrrell Museum. 2010.
Created for the Alberta Unearthed exhibit.
Image courtesy of the Royal Tyrrell Museum of Palaeontology, Drumheller, Alberta, Canada.

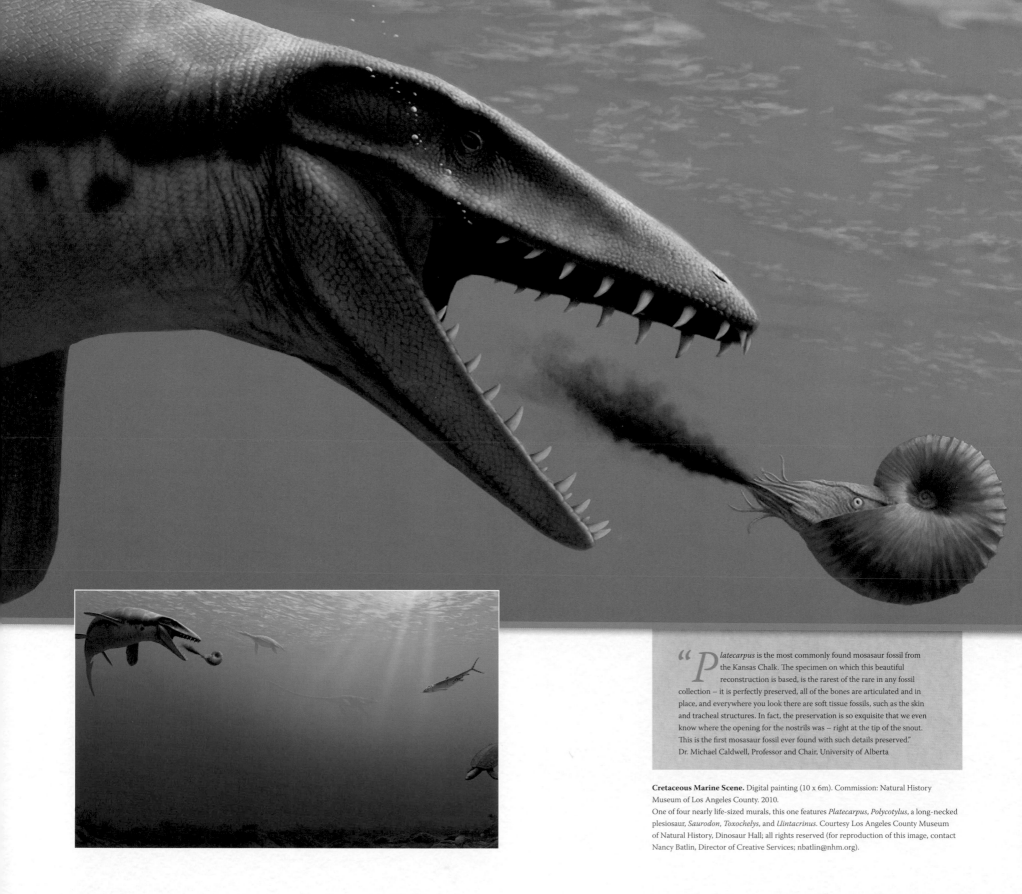

Cretaceous Marine Scene. Digital painting (10 x 6m). Commission: Natural History Museum of Los Angeles County. 2010.
One of four nearly life-sized murals, this one features *Platecarpus*, *Polycotylus*, a long-necked plesiosaur, *Saurodon*, *Toxochelys*, and *Uintacrinus*.

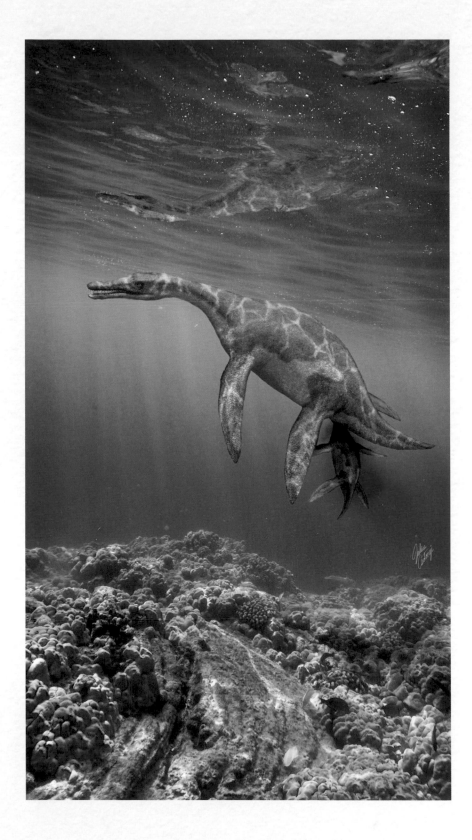

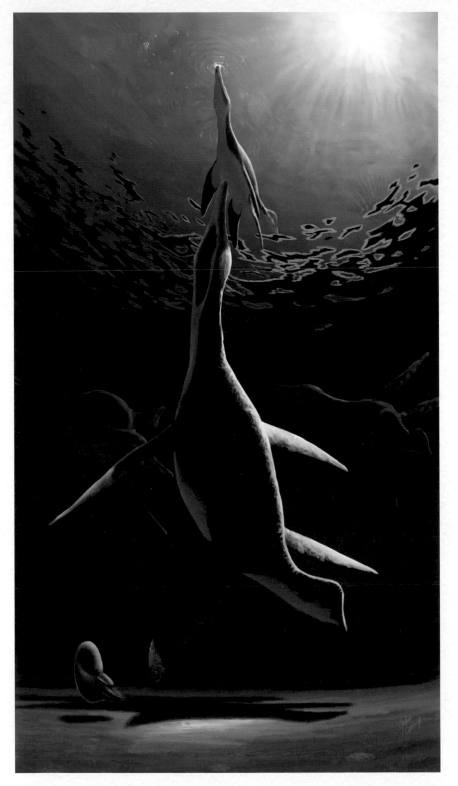

THE PALEOART OF JULIUS CSOTONYI

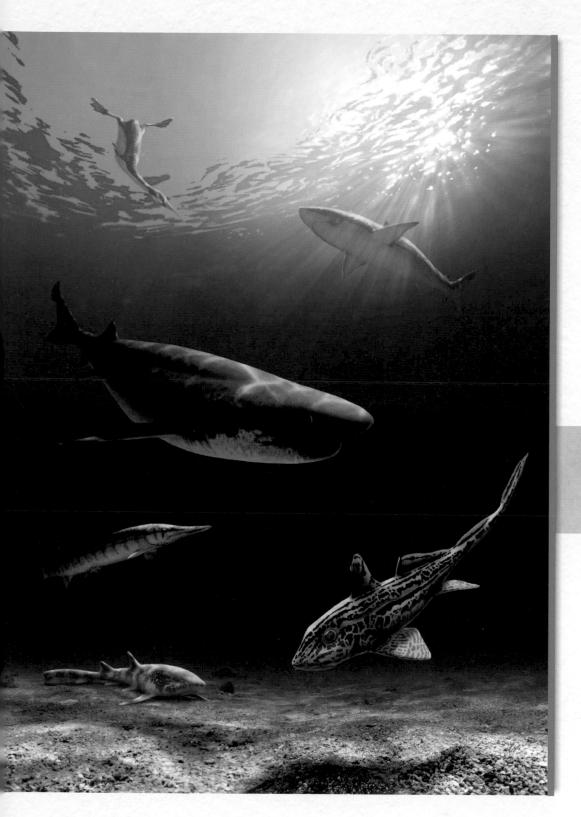

(Above) **Lundbreck Falls Marine Cretaceous Scene.** Digital drawing. Commission: Alberta Fossil Trail signage project, Royal Tyrrell Museum. 2007.
This image depicts *Clidastes propython*, ammonites, a shark, and inoceramid clams.

(Opposite Left) *Polycotylus* **Giving Birth.** Photographic composite. 2011.
Polycotylus latippinus giving birth to live young, from the Western Interior Seaway of Kansas, 78 million years ago.

(Opposite Right) *Polycotylus'* **First Breath.** Digital painting. 2013.
Polycotylus latippinus helping its young to the surface for its first breath after being born, from the Western Interior Seaway of Kansas, 78 million years ago. This image is based on the recent description of a *Polycotylus* specimen discovered with a single fetus found inside the body cavity. The baby was large, 40% the length of the 5m (16ft) adult.

(Left) **Bylot Island Arctic Prehistoric Community.** Digital painting and (some) photographic composite. Commission: Dr. Matthew Vavrek. 2013.
Brand new research being conducted by Dr. Matthew Vavrek on the Bylot Island (far north Appalachia) paleo-community around the end of the Maastrichtian, with marine fauna including (anti-clockwise from top right) a hesperornithid, hexanchiform shark, a gar-like osteichthyan, a synechodontiform shark, a chimaerid, and a lamniform shark.

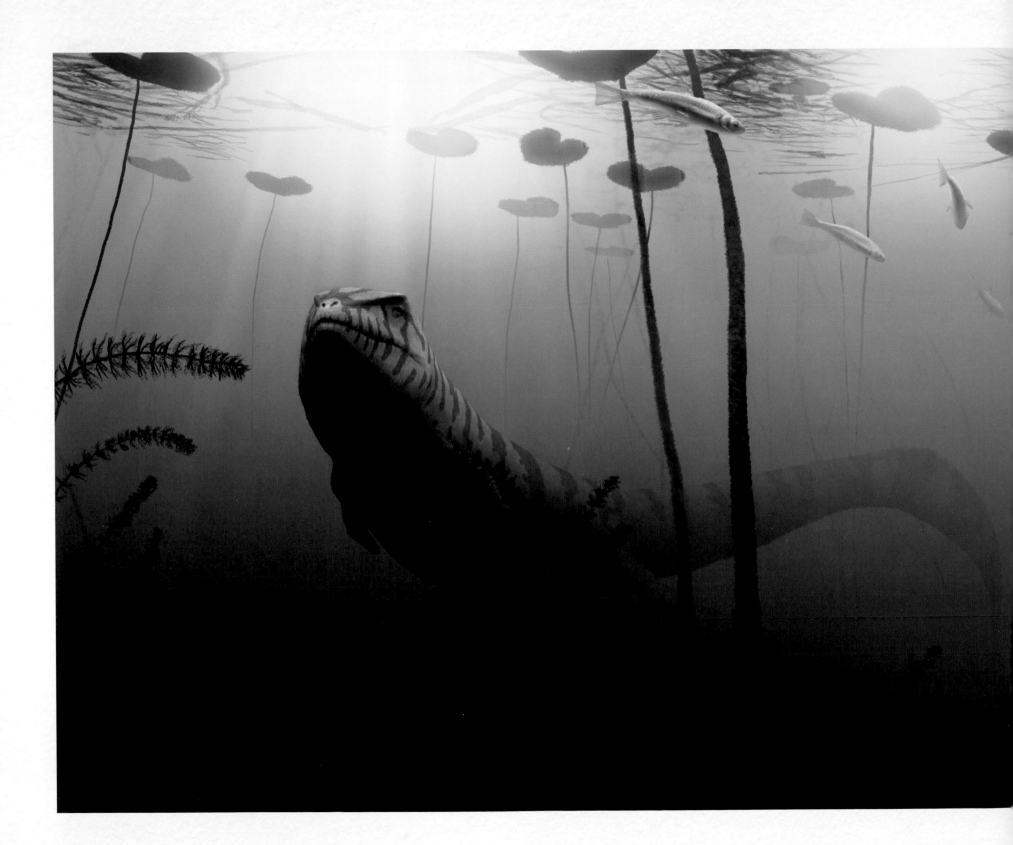

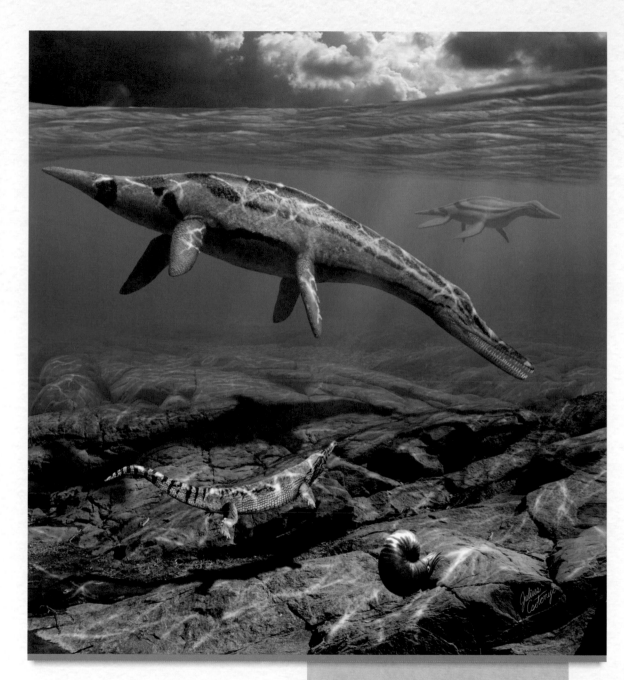

(Left) **Pannoniasaurus inexpectatus.** Digital painting. 2013.
I have depicted this Hungarian mosasaur in a murky, slow flowing portion of river, stealthily stalking the silty green waters. Although the limbs were not recovered, I have sided with the speculation of Makadi, Caldwell, and Osi (2013) that this animal may have possessed limbs like those of terrestrial squamates instead of paddle-like advanced mosasaur limbs, possibly retained for clambering around its freshwater aquatic environment. The tail also lacks the advanced down-turned tip that is characteristic of many marine mosasaurs.

(Right) **Trinacromerum.** Photographic composite. Commission: Cretaceous Life exhibit, Manitoba Museum. 2009.
This restoration of the Western Interior Seaway bisecting North America during much of the Cretaceous features the short-necked plesiosaur *Trinacromerum*, *Champsosaurus*, and the ammonite *Placenticeras*.

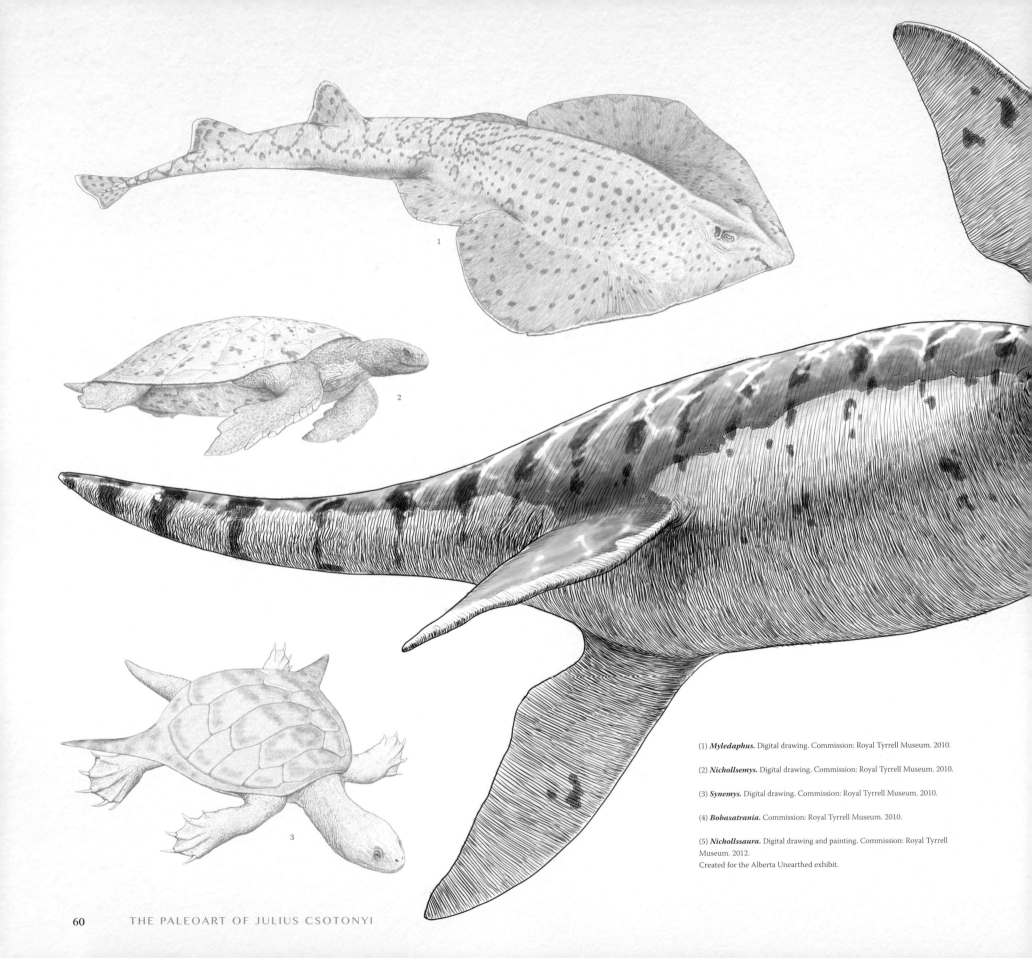

(1) **Myledaphus.** Digital drawing. Commission: Royal Tyrrell Museum. 2010.

(2) **Nichollsemys.** Digital drawing. Commission: Royal Tyrrell Museum. 2010.

(3) **Synemys.** Digital drawing. Commission: Royal Tyrrell Museum. 2010.

(4) **Bobasatrania.** Commission: Royal Tyrrell Museum. 2010.

(5) **Nichollssaura.** Digital drawing and painting. Commission: Royal Tyrrell Museum. 2012.
Created for the Alberta Unearthed exhibit.

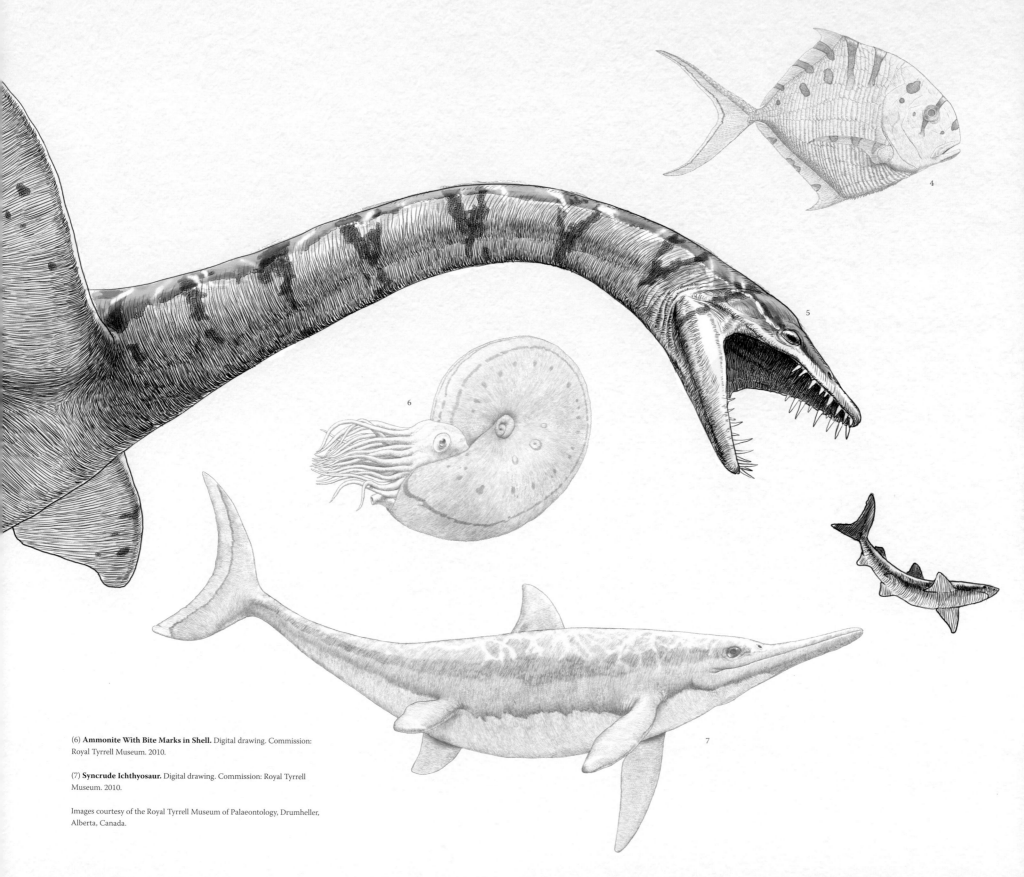

(6) **Ammonite With Bite Marks in Shell.** Digital drawing. Commission: Royal Tyrrell Museum. 2010.

(7) **Syncrude Ichthyosaur.** Digital drawing. Commission: Royal Tyrrell Museum. 2010.

Images courtesy of the Royal Tyrrell Museum of Palaeontology, Drumheller, Alberta, Canada.

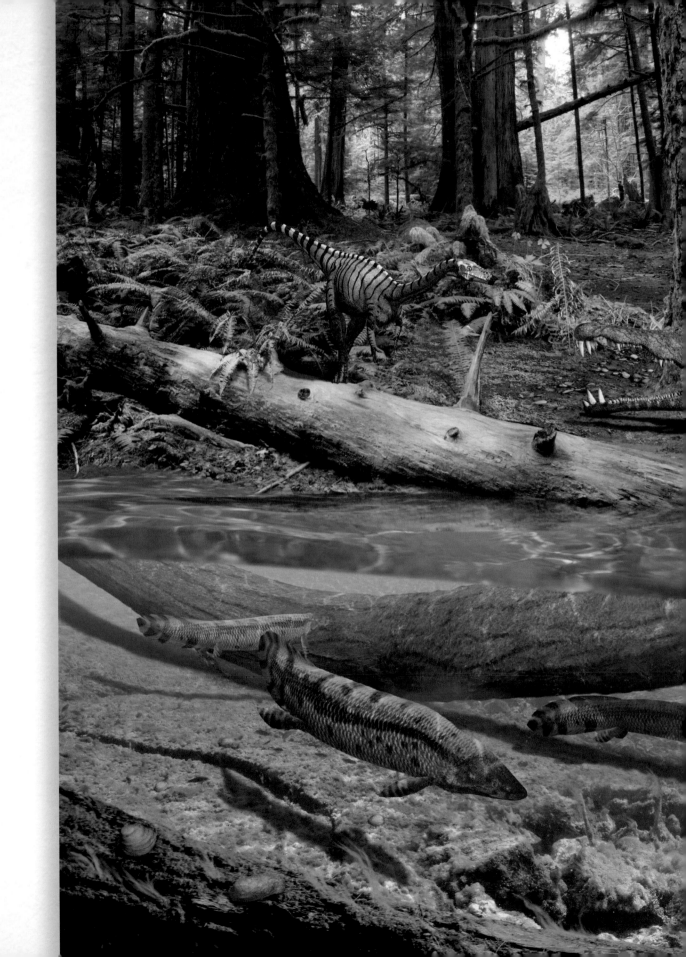

Chinle Formation Paleoenvironment. Photographic composite. Commission: Natural History Museum of Los Angeles County. 2010.

One of three interactive digital displays in the museum's Dinosaur Hall, teaching about the paleoecology of three major Mesozoic formations. This one features the land animals (left to right) *Coelophysis, Leptosuchus, Typthorax, Eucoelophysis* and *w*, and the plants *Clathopteris, Laccopteris,* and *Araucarioxylon,* with (in the water) *Antediplodon* (mussel), *Ceratodus,* and *Buettneria*.

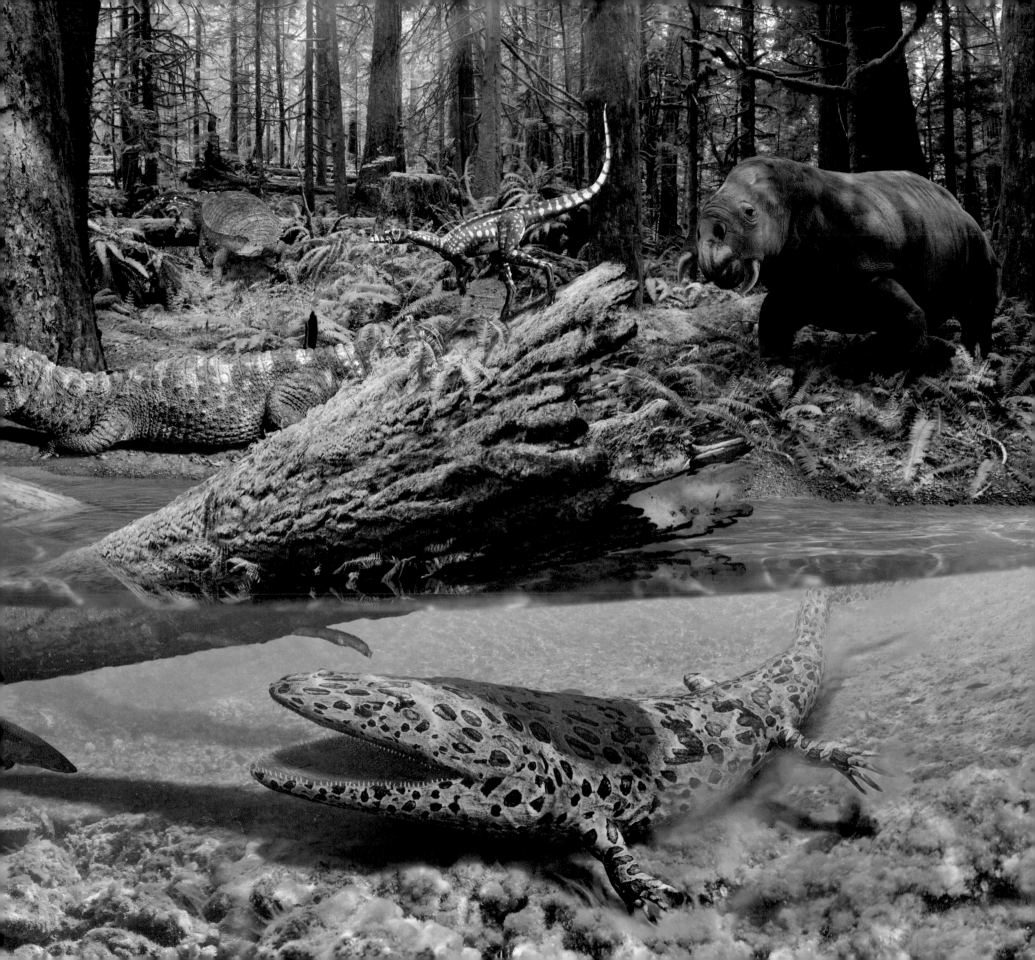

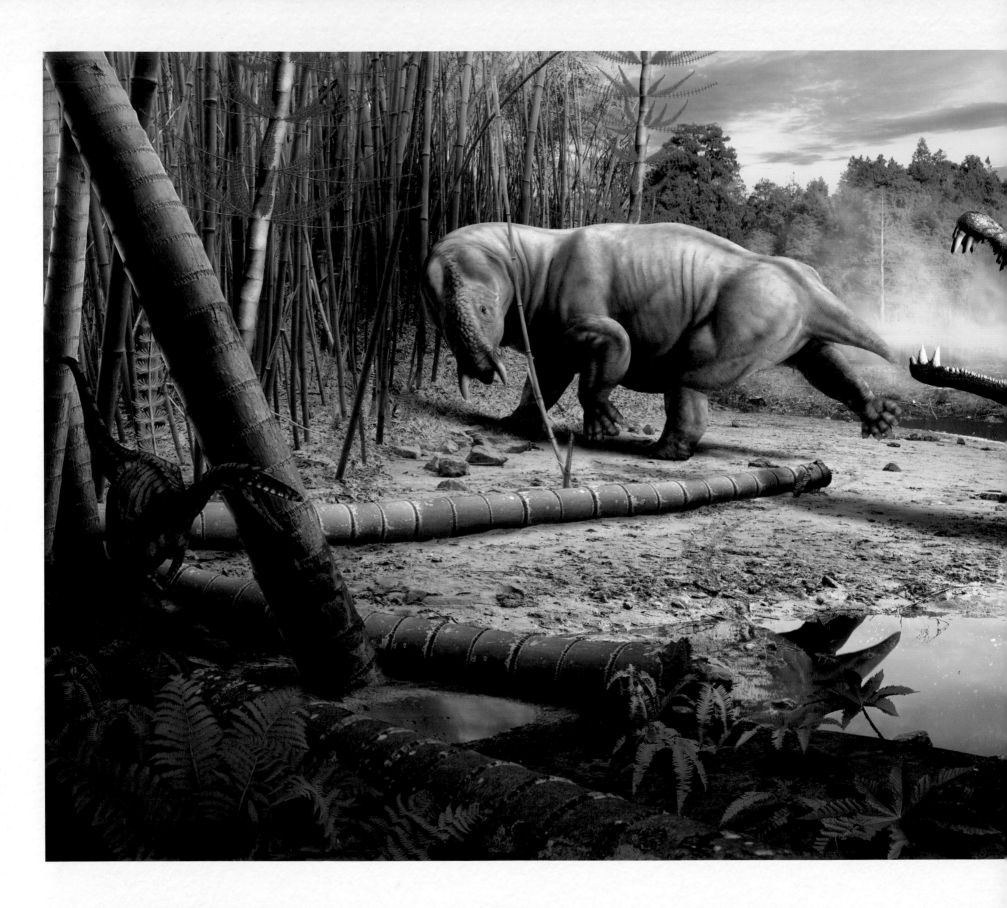

THE PALEOART OF JULIUS CSOTONYI

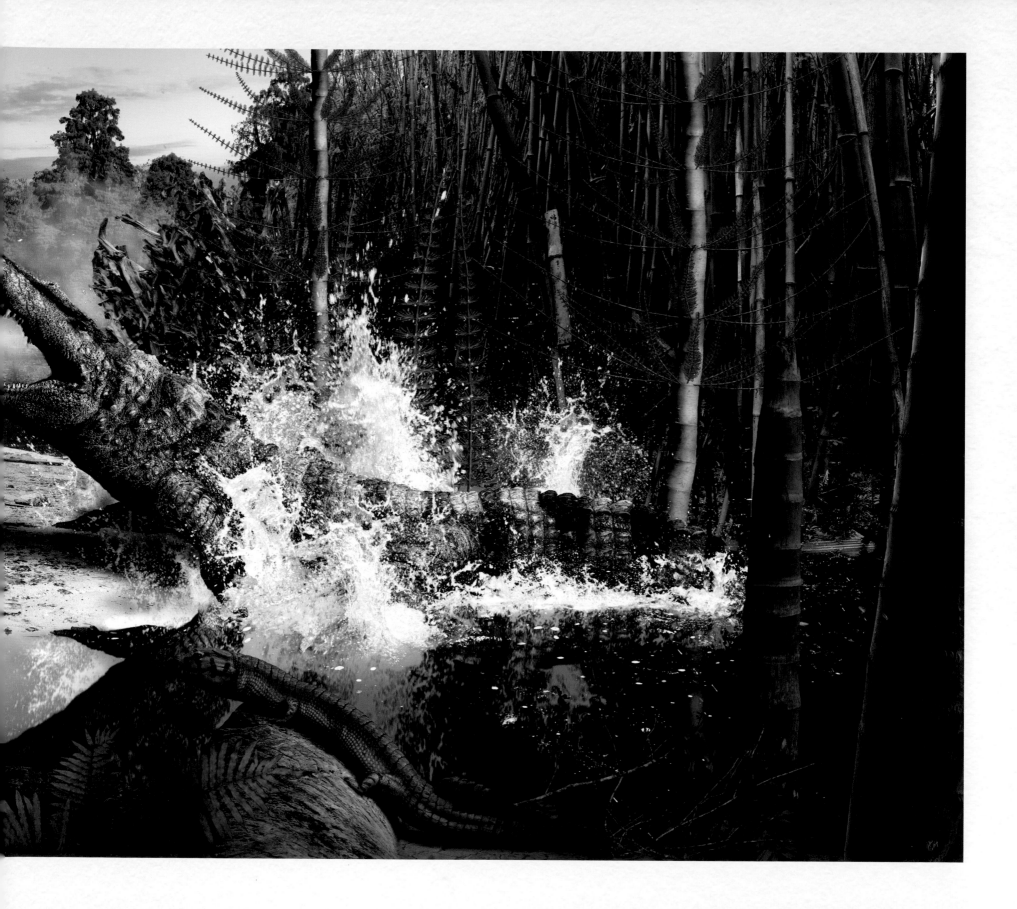

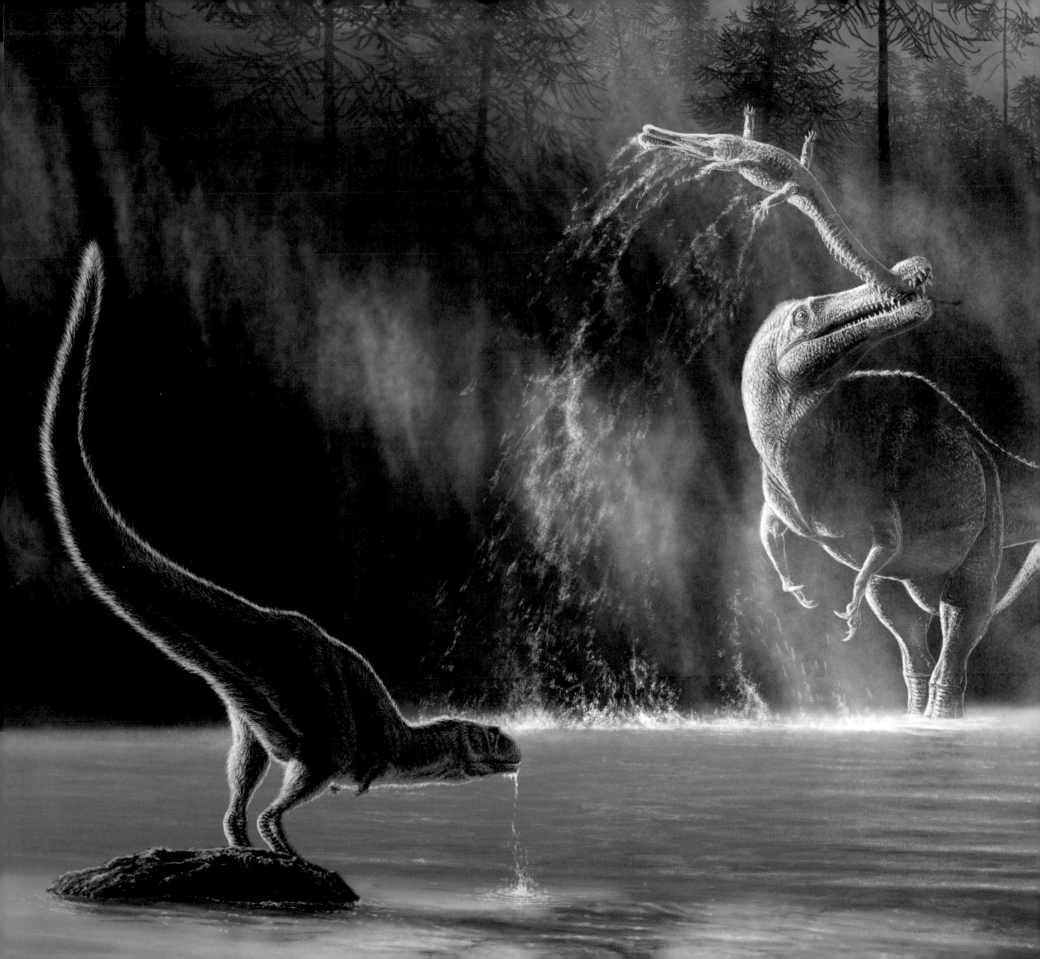

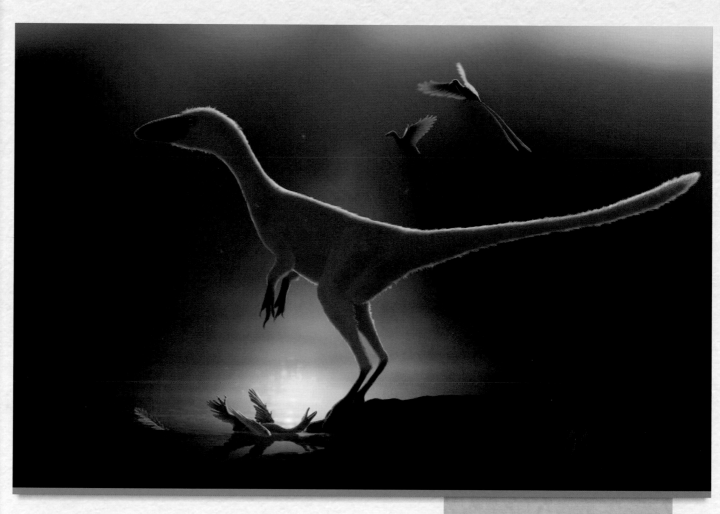

(Previous Spread) ***Smilosuchus* and *Placerias* in the Triassic.** Photographic composite. Commission: Hall of Paleontology at the Houston Museum of Natural Science. 2012. One of fourteen of my images appearing as backlit panels (about four feet tall) in the enormous new Hall of Paleontology at the Houston Museum of Natural Science, this image depicts *Coelophysis*, *Placerias*, *Smilosuchus*, and *Vancleavea*.

(Left) ***Suchomimus* and *Kryptops.*** Digital Painting. 2013.
A Cretaceous Nigerian scene depicting a young (and speculatively feathered) Abelisaurid called *Kryptops* disturbed from its drinking by the commotion caused by a *Suchomimus* plucking a young *Sarcosuchus* from its river habitat. This image was meant to break the unnecessary custom of nearly always showing the crocodilian-like snouted *Suchomimus* hunting fish of one sort or another. I do not see why it could not have hunted anything of about the right size, even a young *Sarcosuchus* (which, in adult form, would turn the tables and pose a greater threat to *Suchomimus* than the other way around).

(Above) ***Sinocalliopteryx, Confuciusornis,* and *Sinornithosaurus.*** Digital painting. 2012.
Based on a recent find by Xing *et al.* (2012) demonstrating that *Sinocalliopteryx* fed on the latter two animals.

"It is very rare to find fossils that preserve actual evidence of dinosaur behavior, so the discovery of not one but two *Sinocalliopteryx* with gut contents was exceptional. The articulated foot of a dromaeosaur, *Sinornithosaurus*, was found in one, and the remains of two primitive birds (*Confuciusornis*) were found in the other. We can perhaps imagine *Sinocalliopteryx* as a stealth hunter, crouching in the foliage at a waterhole waiting for small dinosaurs or birds to come down for a drink, which is exactly what Julius has shown here."
Dr. Phil Bell, University of New England (Australia)

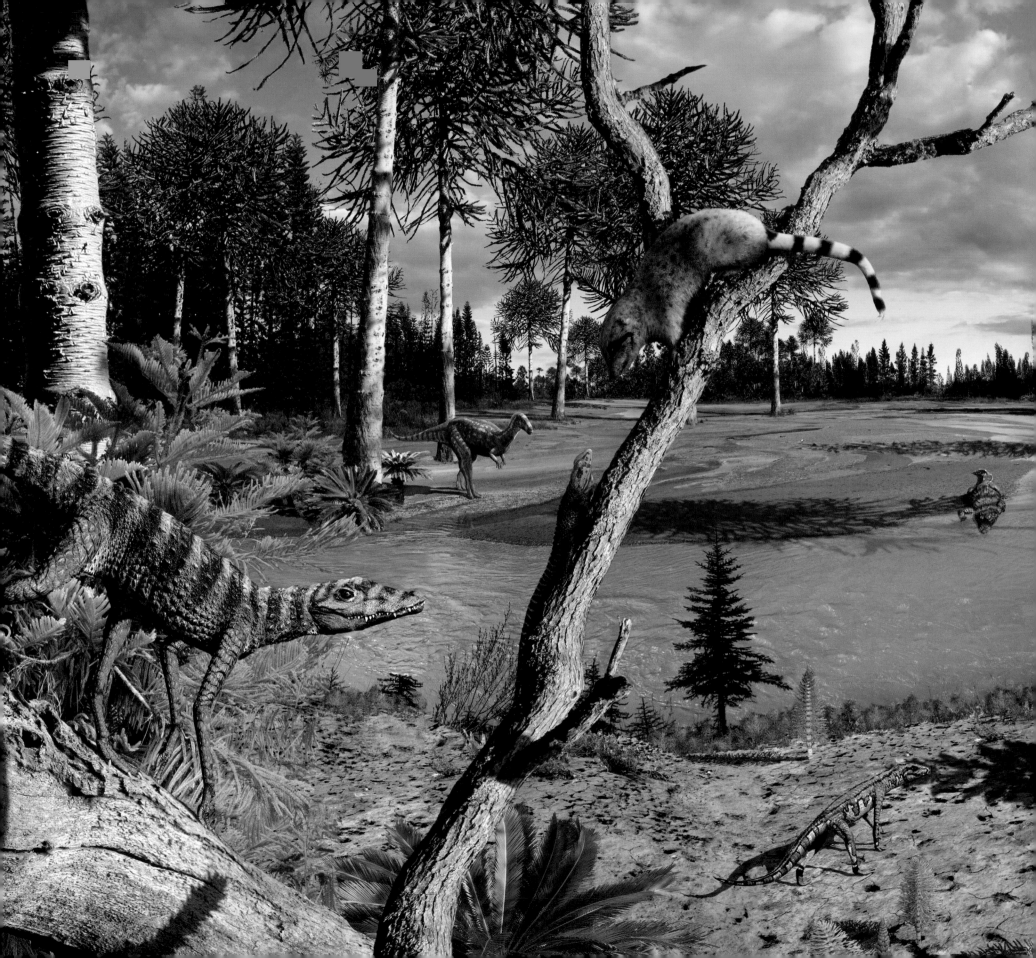

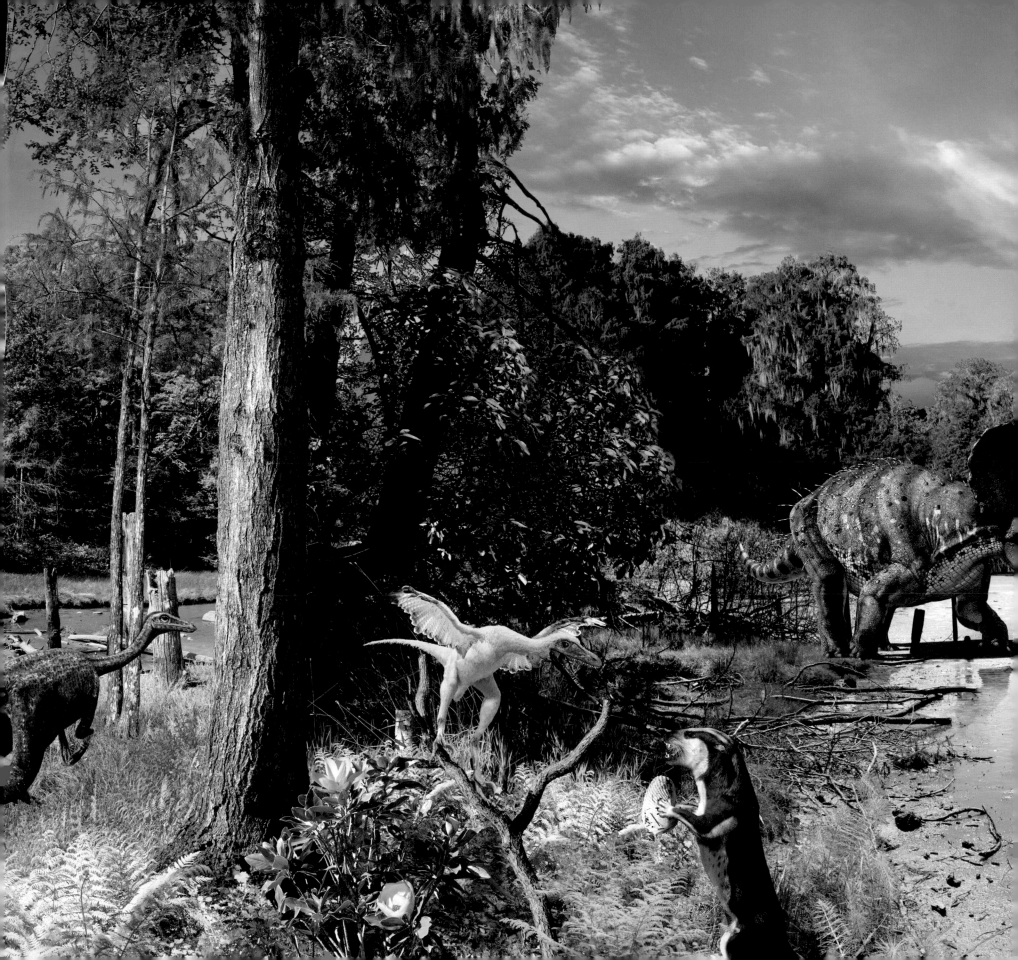

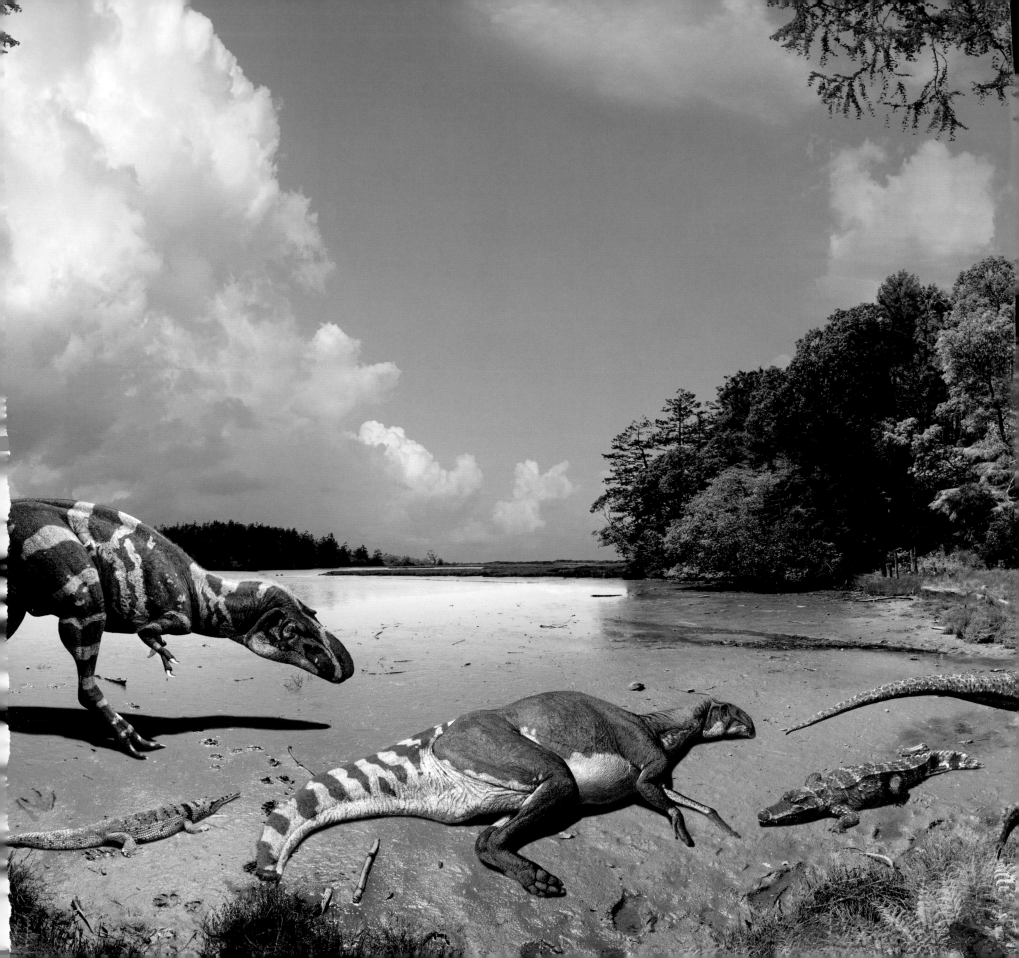

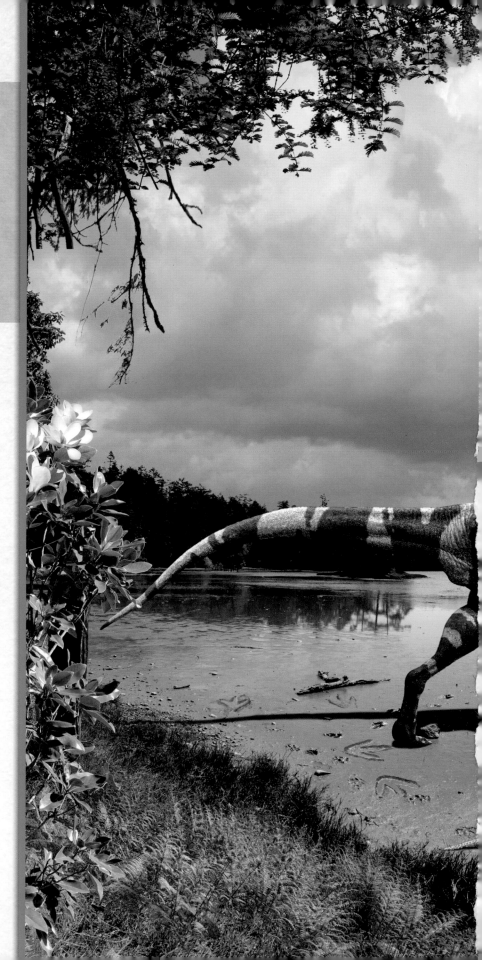

"Julius Csotonyi has a unique way of capturing a snapshot in time. Even the smallest detail has been examined for accuracy in both structure and time. The concept is carried to the level of detail where even the time of day can be estimated! From the appropriate blue coloration of the sky to the recently flooded mudflat, this image captures the realism that is lacking in many dinosaur illustrations. While this panel itself represents serial iterations of the same viewpoint from several different points in time, the rendition's coloration and detail make it appear more like a photograph than an artistic piece. I feel that it is important to place the viewer in a 'real' snapshot in time rather than a mystical, dream world setting, and this image epitomizes realistic depiction.

It is important to notice the types of plants, species of lower vertebrates, and overall topography if one wishes to accurately represent a snapshot in time and space. In this image, we have two such snapshots joined and superimposed. The beauty of this image comes not only from its accuracy in floral, faunal, and topographic detail, but also in its unique presentation. To take the exact same viewpoint forward several million years in time, and pick up the same landscape with appropriate floral and faunal changes provides a unique and pointed exposition on change through time.

From the combination of camouflage and display features represented on the illustrated dinosaurs to the types and density of the included flora, this image captures a reality most cannot imagine. The additional detail needed to create a photographic rendition rather than an artistic rendition is immense. I particularly like the accurate colorations of the land, sky, and flora, and I appreciate the attempt at accurate coloration and patterning for the dinosaurs based on our knowledge of modern vertebrates."
David Trexler, Paleontologist, Two Medicine Dinosaur Center

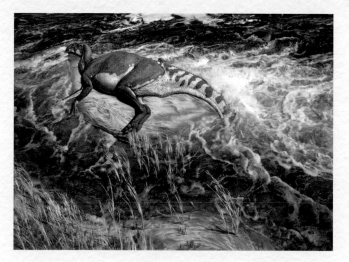

(Left) **Morrison Formation Paleoenvironment.** Photographic composite. Commission: Natural History Museum of Los Angeles County. 2010.
One of three interactive digital displays in the museum's Dinosaur Hall, teaching about the paleoecology of three major Mesozoic formations. This one features (left to right) the animals *Macelognathus* (small running crocodile), *Camptosaurus*, a eupantotherian mammal, *Fruitachampsa* (running crocodile), *Goniopholis*, *Stegosaurus*, *Eilenodon* (sphenodont lizard), a fossorial triconodontid, *Allosaurus*, and (overhead) a pterodactyloid pterosaur; and the plants *Araucaria*, cycads, and sphenophytes.
Courtesy Los Angeles County Museum of Natural History, Dinosaur Hall; all rights reserved (for reproduction of this image, contact Nancy Batlin, Director of Creative Services; nbatlin@nhm.org).

(Right) **Cretaceous Terrestrial Scene.** Photographic composite. Commission: Hall of Paleontology at the Houston Museum of Natural Science. 2012.
One of fourteen of my images appearing as backlit panels (about four feet tall) in the enormous new Hall of Paleontology at the Houston Museum of Natural Science, this image depicts a temporal progression of Late Cretaceous North American environments, from the Campanian (Judith River Formation) to the Maastrichtian (Hell Creek Formation) Stages. Taxa illustrated are *Gorgosaurus* coming across the carcass of *Brachylophosaurus*, *Champsosaurus* (crocodile-like reptile), *Borealosuchus* (crocodilian), *Struthiomimus*, an as-yet-unnamed dromaeosaurid, *Didelphodon* (a mammal), a trionychid turtle, and the 'Lane' specimen of *Triceratops* facing off with 'Stan' the *Tyrannosaurus* while 'Wyrex' the *Tyrannosaurus* hassles a nesting pair of *Quetzalcoatlus*.

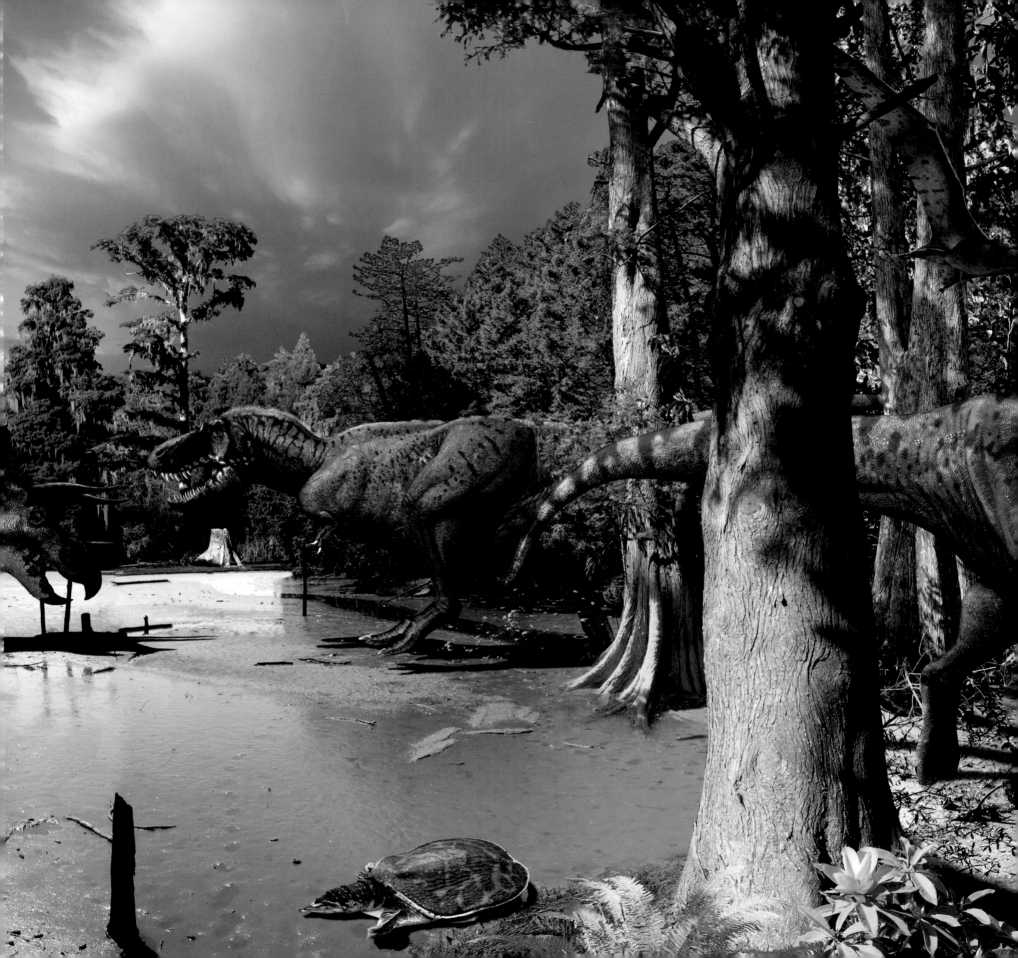

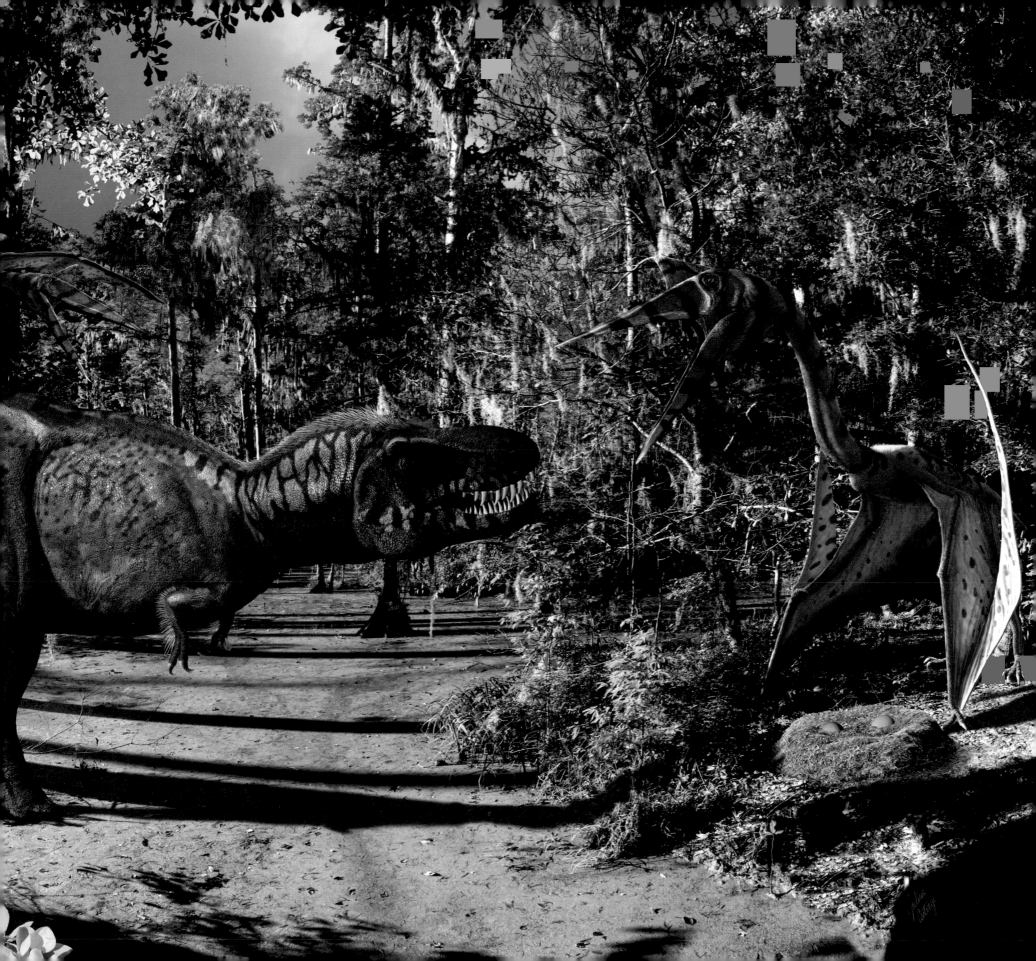

GUANLONG

Genus:	*Guanlong* ('Crowned Dragon' in Hanyu Pinyin)
Species:	*wucaii* ('five colours' in Hanyu Pinyin)
Location:	Shishugou Formation, Xinjiang, China
Named:	2006
Age:	Oxfordian Stage, Late Jurassic approx. 160 million years ago
Length:	3m (9ft)

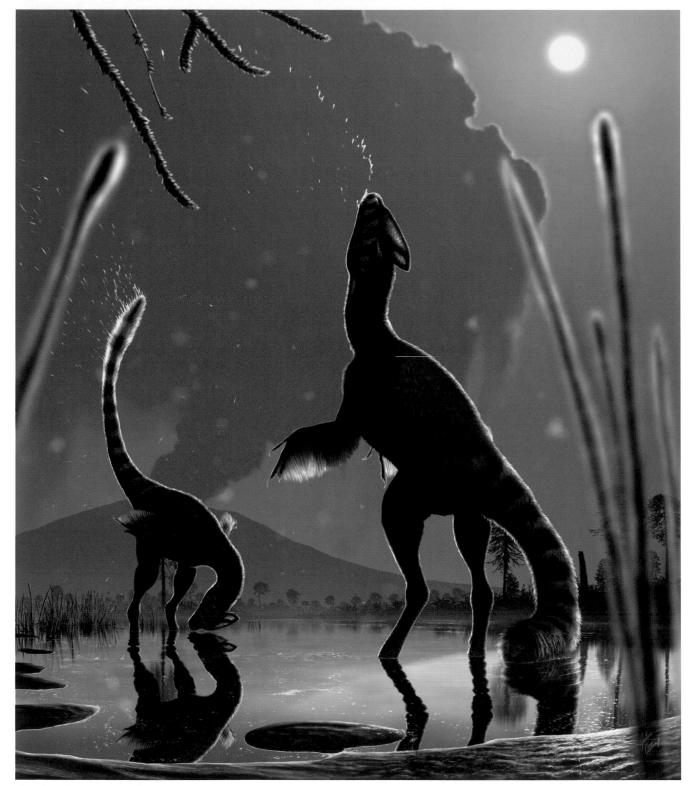

Known from two specimens, a fairly complete adult skeleton and an almost complete articulated immature individual. The crest on the latter was considerably smaller and rose from the forward part of the snout. The larger crests in the adults were thin and delicate; their function may have been as some sort of visual recognition device, perhaps as part of a mating display. Unlike many dinosaurs from this region, *Guanlong* was found without any kind of skin integument and has been illustrated here with a covering of filamentous feathers, similar to its close relative *Dilong*.

In this image, a volcano coughs ash into the Late Jurassic skies of China, but life goes on for a pair of courting early tyrannosauroids* on the shores of a lake. It is uncharacteristically speculative for my work, as there is no direct evidence of such courting behavior in this taxon (though it is certainly plausible), and I have also speculated that the pair of dinosaurs utilize splashes of water in their courtship display.

People often ask me why I do not frequently explore speculative avenues with my illustrations. My answer is always framed in the context of the main driving force of my work: Scientific rigor to the greatest extent possible. I tend to be conservative in my reconstructions, endeavoring to not add much more than current research supports, while still leaving my work open to alteration if and when evidence for a previously unknown idea is presented in the literature. Although I sometimes do let my imagination go beyond the most parsimonious models, I try to keep its flight governed at least reasonably well by science, be it plausible interpretations of paleontological observation, or applications of contemporary ecological principles to paleoenvironments in an effort to fill in the unknown with reasonable modern analogues of processes.

* Some studies put *Guanlong* closer to the maniraptorans.

***Guanlong* Courting.** Digital painting. 2013.

(Far Right) *Eosinopteryx brevipinna.* Digital painting. 2013. Great plausible example of evolutionary divergence, closely related to *Anchiornis* but filling a different, cursorial, niche.

(Right) **Ceratopsian Beak Reconstruction.** Ink. Commission: Royal Tyrrell Museum. 2007. Image courtesy of the Royal Tyrrell Museum of Palaeontology, Drumheller, Alberta, Canada

(Below) *Saurornitholestes.* Digital drawing and painting. Commission: Royal Tyrrell Museum. 2012. Image courtesy of the Royal Tyrrell Museum of Palaeontology, Drumheller, Alberta, Canada.

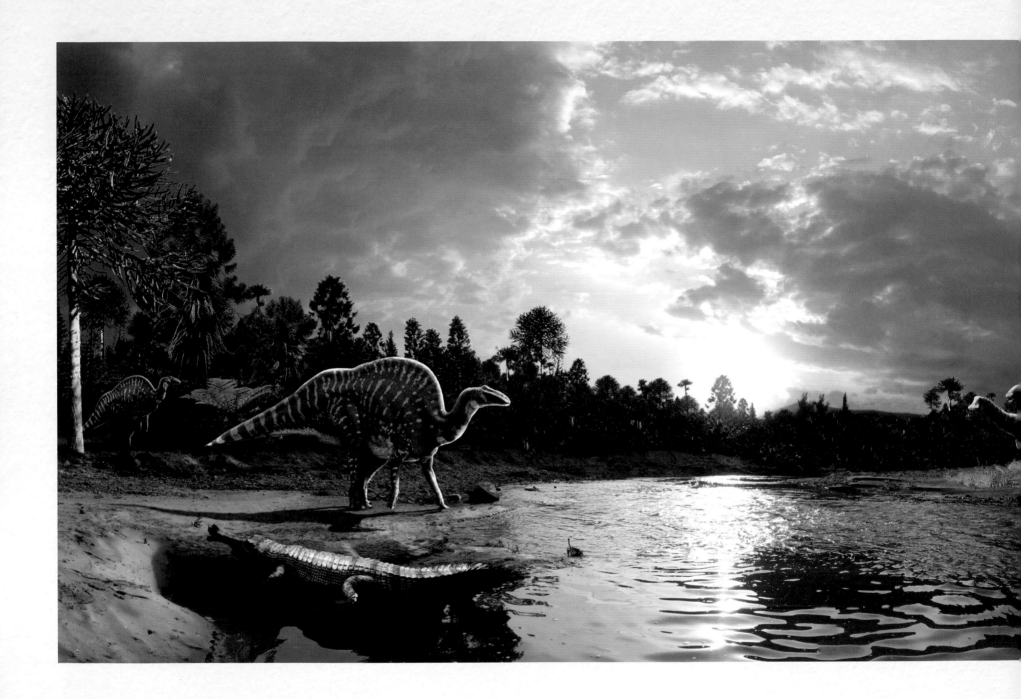

Cretaceous Niger. Photographic composite (32 x 5m). Commission: Royal
Ontario Museum. 2012.
A mural for the Ultimate Dinosaurs: Giants From Gondwana exhibit, this
projected image featured animated clouds and the taxa *Ouranosaurus*,
Sarcosuchus (crocodilian), *Nigersaurus*, *Suchomimus*, and *Onchopristis*
(sawfish).
Courtesy of the Royal Ontario Museum, © ROM, Toronto, Ontario, Canada.

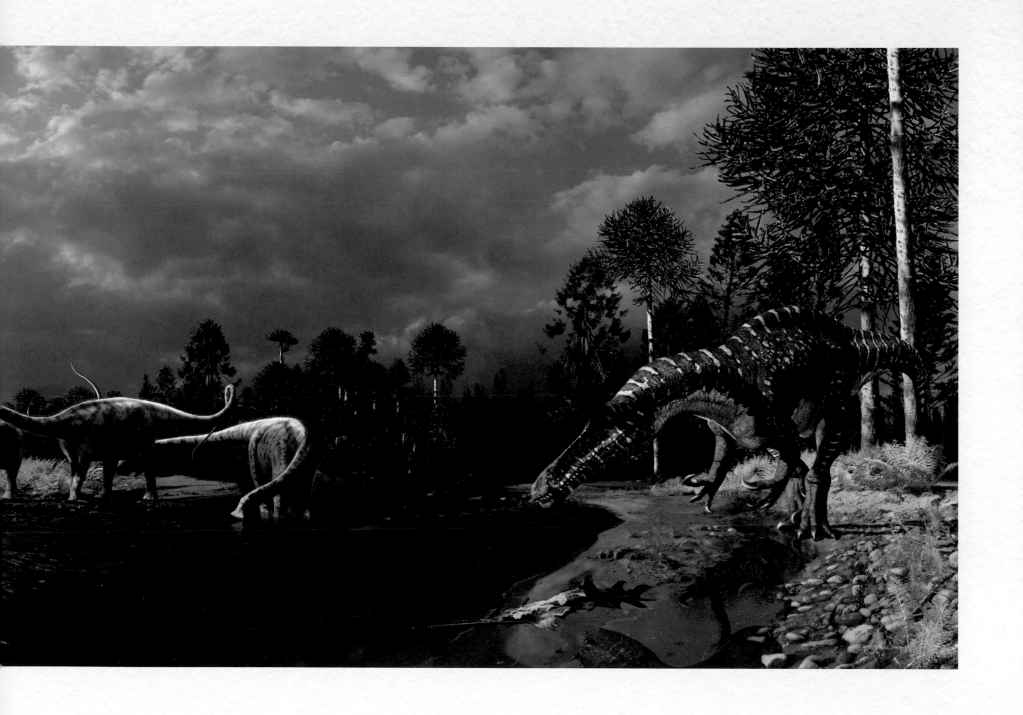

Horseshoe Canyon Cretaceous Scene. Digital drawing. Commission: Alberta Fossil Trail signage project, Royal Tyrrell Museum. 2007.
This paired image depicts the process of climate change during the Maastrichtian of the Horseshoe Canyon Formation, evidenced by the floral and faunal turnover from a relatively arid to a mesic environment. It features *Atrociraptor*, *Saurolophus*, and *Hypacrosaurus* in the lower section of the formation, and *Eotriceratops*, *Albertosaurus*, and a crocodilian in the upper section.

"This illustration is a paleoenvironmental reconstruction of the lower Horseshoe Canyon Formation (approx. 72-71 million years ago). Best exposed in the Drumheller area, the coal beds and fossils preserved in that rock unit reveal that a highly diverse fauna, consisting of dinosaurs, turtles, and crocodiles, populated subtropical wetlands that developed in the coastal lowlands near the Western Interior Seaway."
Dr. Francois Therrien, Curator of Dinosaur Palaeoecology, Royal Tyrrell Museum

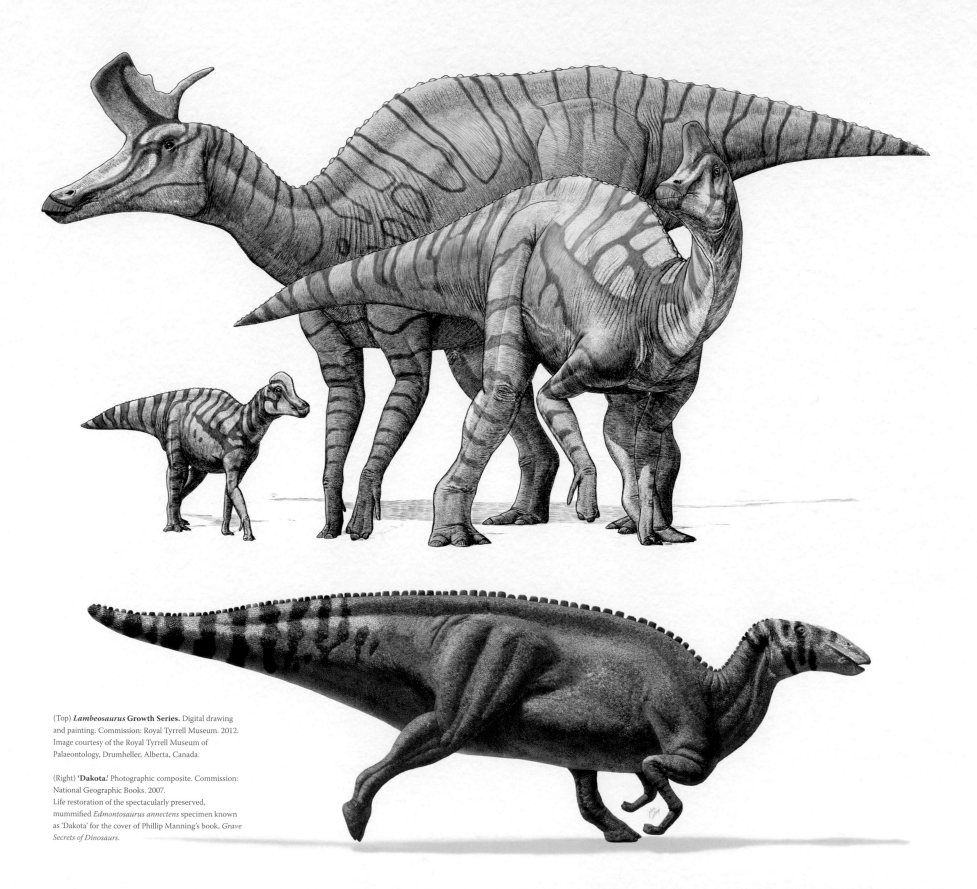

(Top) **Lambeosaurus Growth Series.** Digital drawing and painting. Commission: Royal Tyrrell Museum. 2012. Image courtesy of the Royal Tyrrell Museum of Palaeontology, Drumheller, Alberta, Canada.

(Right) **'Dakota.'** Photographic composite. Commission: National Geographic Books. 2007.
Life restoration of the spectacularly preserved, mummified *Edmontosaurus annectens* specimen known as 'Dakota' for the cover of Phillip Manning's book, *Grave Secrets of Dinosaurs.*

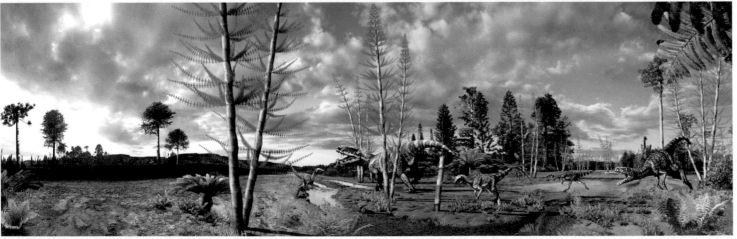

Triassic Scene. Photographic composite (16 x 5m). Commission: Royal Ontario Museum. 2012. A mural for the Ultimate Dinosaurs: Giants From Gondwana exhibit at the museum from June 2012 to March 2013, after which it went on tour, beginning with the Cincinnati Museum Center. This image features *Eoraptor*, *Prestosuchus*, *Pisanosaurus*, and *Herrerosaurus*. Courtesy of the Royal Ontario Museum, © ROM, Toronto, Ontario, Canada.

(Above) **Albertosaurus** and **Euoplocephalus.**
Digital drawing and painting. Commission: Royal Tyrrell Museum. 2012.
One of about ten images created for the Royal Tyrrell Museum for marketing and museum displays.

(Right) **Albertosaurus.** Digital drawing and painting. Commission: Royal Tyrrell Museum. 2012.

(Far Right) **Young Albertosaurus.** Digital drawing and painting. Commission: Royal Tyrrell Museum. 2012.

Images courtesy of the Royal Tyrrell Museum of Palaeontology, Drumheller, Alberta, Canada.

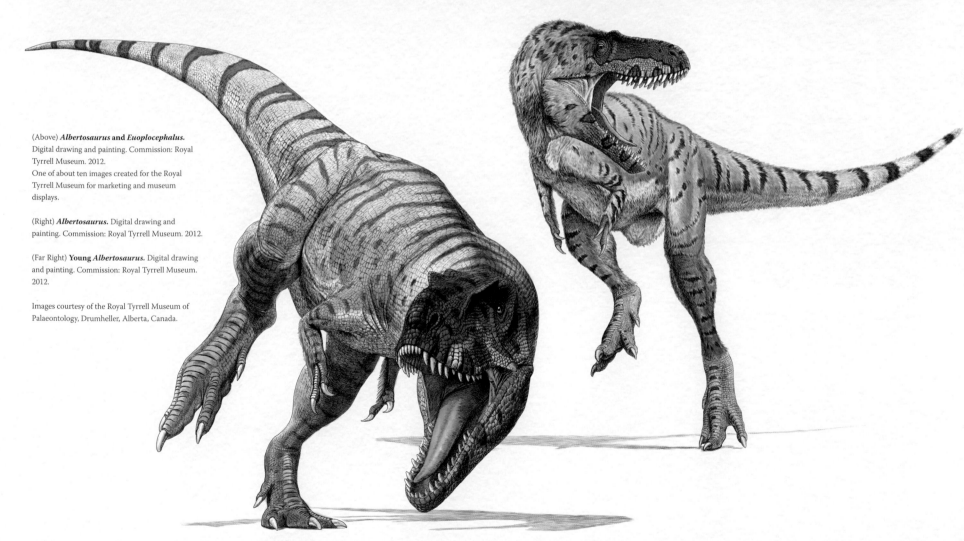

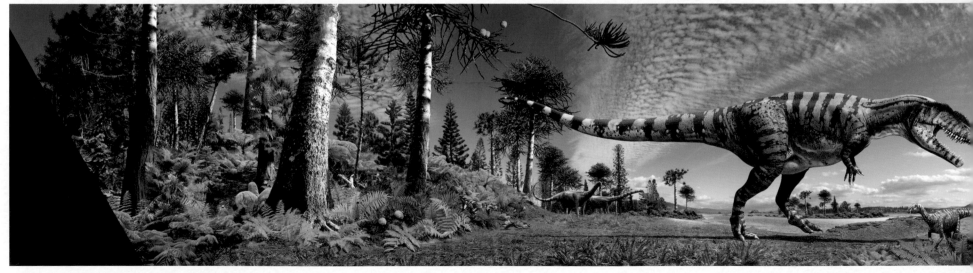

THE PALEOART OF JULIUS CSOTONYI

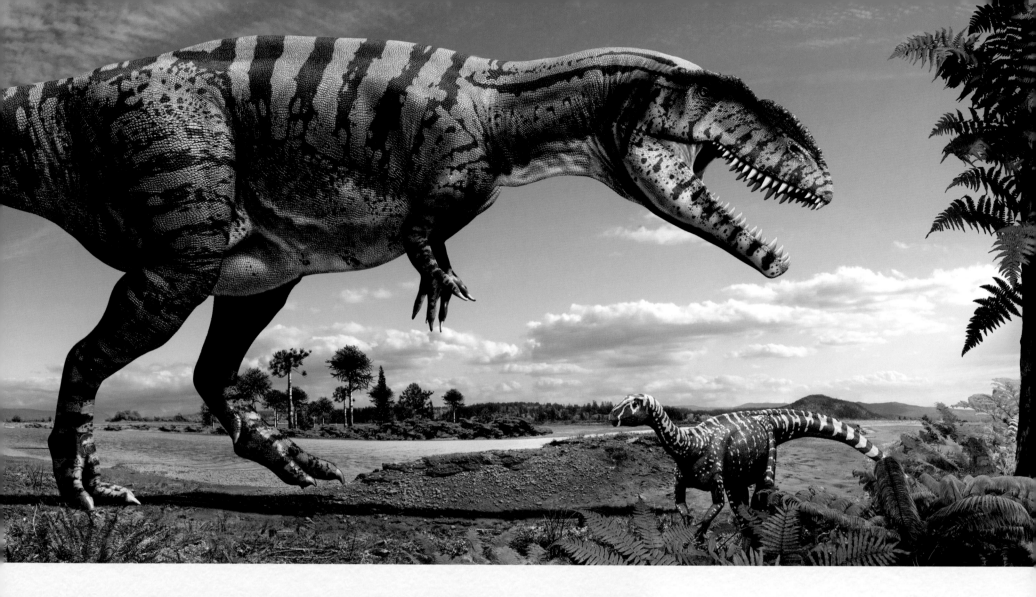

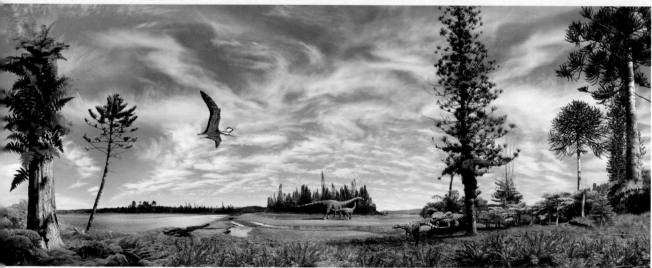

Cretaceous Patagonia. Photographic composite (32 x 5m). Commission: Royal Ontario Museum. 2012.

A mural for the Ultimate Dinosaurs: Giants From Gondwana exhibit, this image features *Araripesuchus* (running crocodile), *Neuquenornis* (birds), *Andesaurus*, *Giganotosaurus*, *Anabisetia*, and *Tupuxuara* (pterosaur).

Courtesy of the Royal Ontario Museum, © ROM, Toronto, Ontario, Canada.

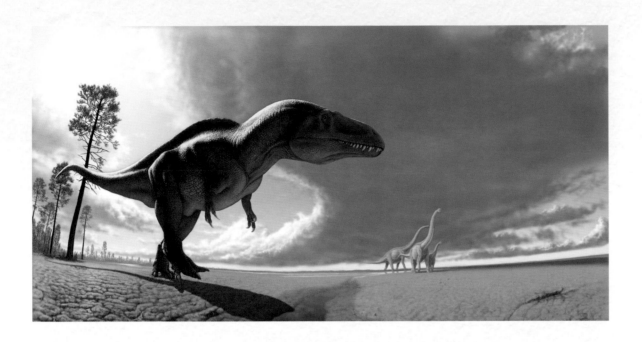

(Left) **Acrocanthosaurus atokensis.** Digital painting. Commission: Museum of the Red River. 2007.

This is the second paleoart piece that I completed digitally, inspired by an art competition hosted by the Museum of the Red River in celebration of the recent naming of *Acrocanthosaurus atokensis* as the state dinosaur of Oklahoma. The month-and-a-half that it took me to paint it using a newly acquired tablet and stylus, in the same fashion as traditional acrylic painting, paid off: the painting was awarded first prize as Best in Show for the newly installed exhibit featuring the splendidly preserved fossil remains of this dinosaur. The painting shows *Acrocanthosaurus* eyeing a trio of the huge *Sauroposeidon* ambling along the eastern shore of the great Western Interior Seaway during the Early Cretaceous, with a stand of *Frenelopsis* conifers back of the intertidal flats to the left.

(Below) **Edmontosaurus herd.** Digital painting (11 x 3m). Commission: Natural History Museum of Los Angeles County. 2010.

One of four nearly life-sized murals, this one features *Edmontosaurus*, of which the keratinous beak was preserved.

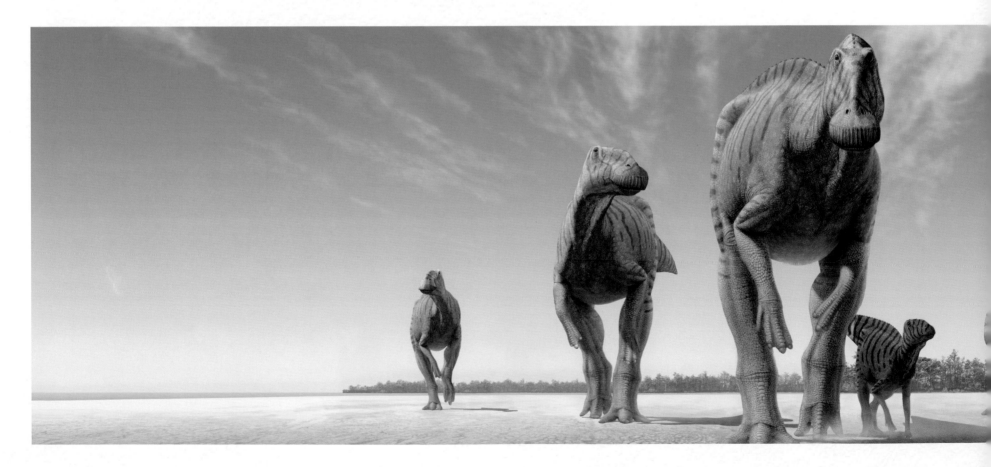

Carcharodontosaurus saharicus. Colored
pencils. 2005.
The mid-Cretaceous North African
Carcharodontosaurus was one of the largest
theropods known (around 12m long), with
serrated teeth reminiscent of lamniform
sharks' teeth, hence the name (*Carcharodon* is
the genus name of the great white shark).

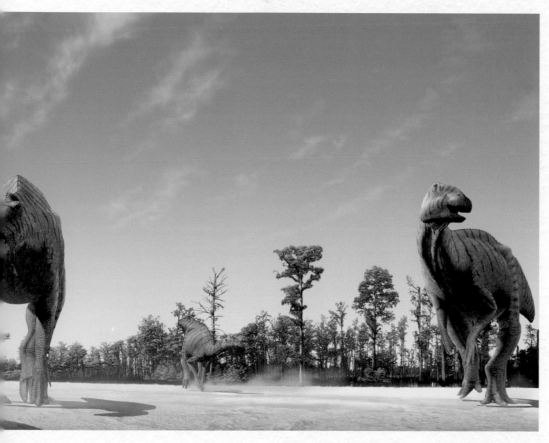

***Cunninghamia* sp. (Conifer).** Digital
drawing. Commission: Royal Tyrrell
Museum. 2010.
Created for the Alberta Unearthed
exhibit.
Image courtesy of the Royal Tyrrell
Museum of Palaeontology, Drumheller,
Alberta, Canada.

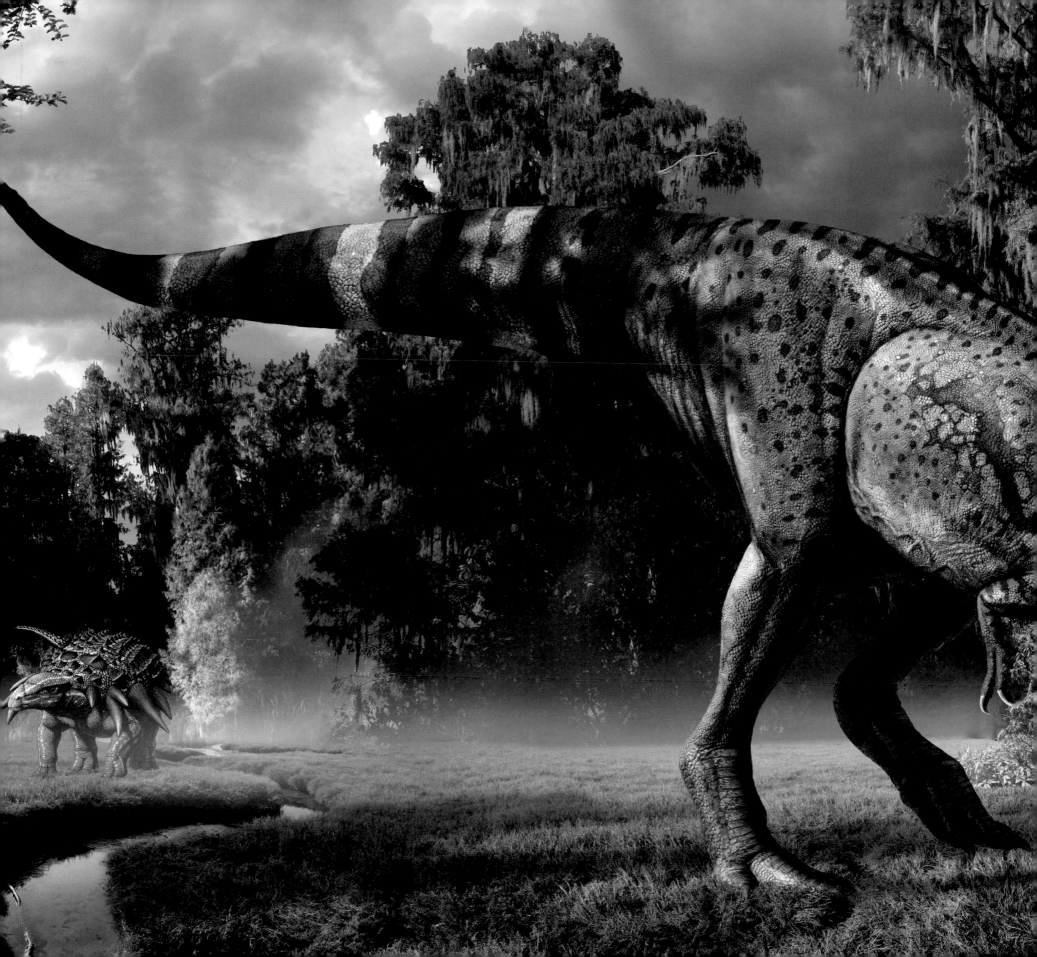

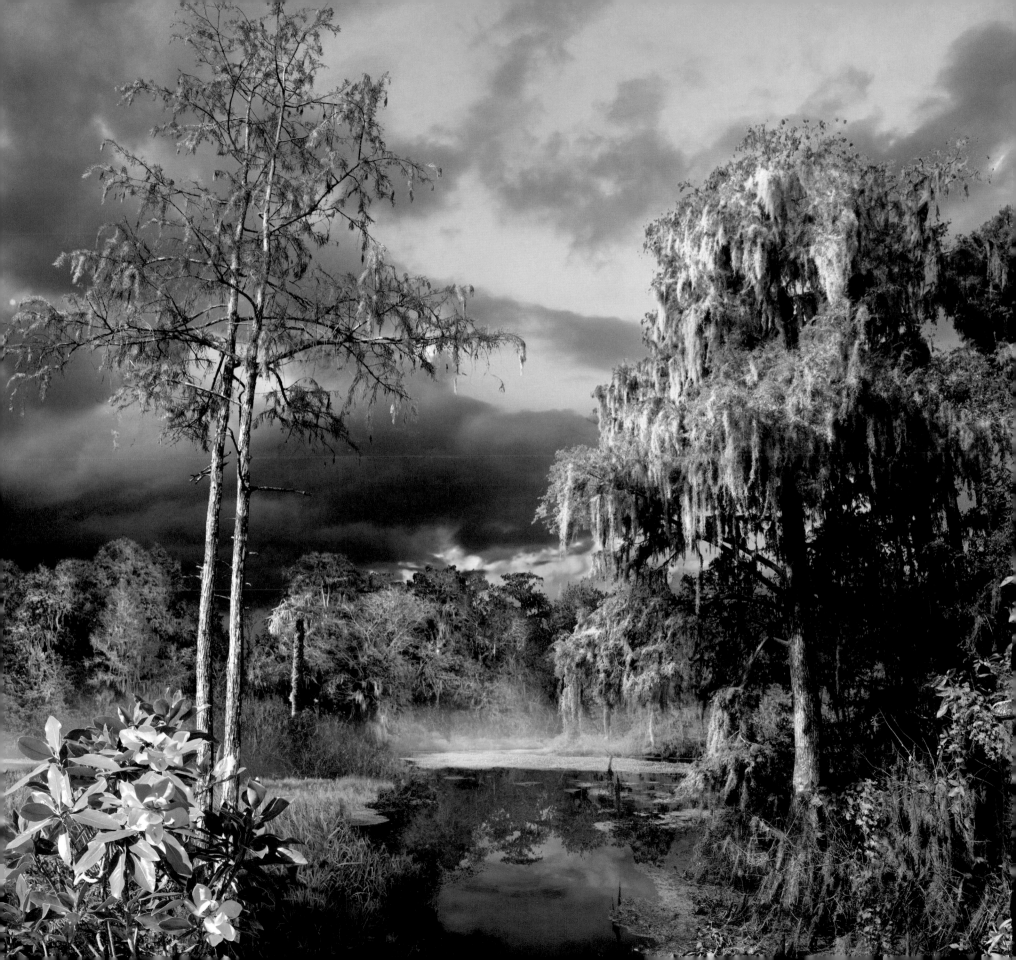

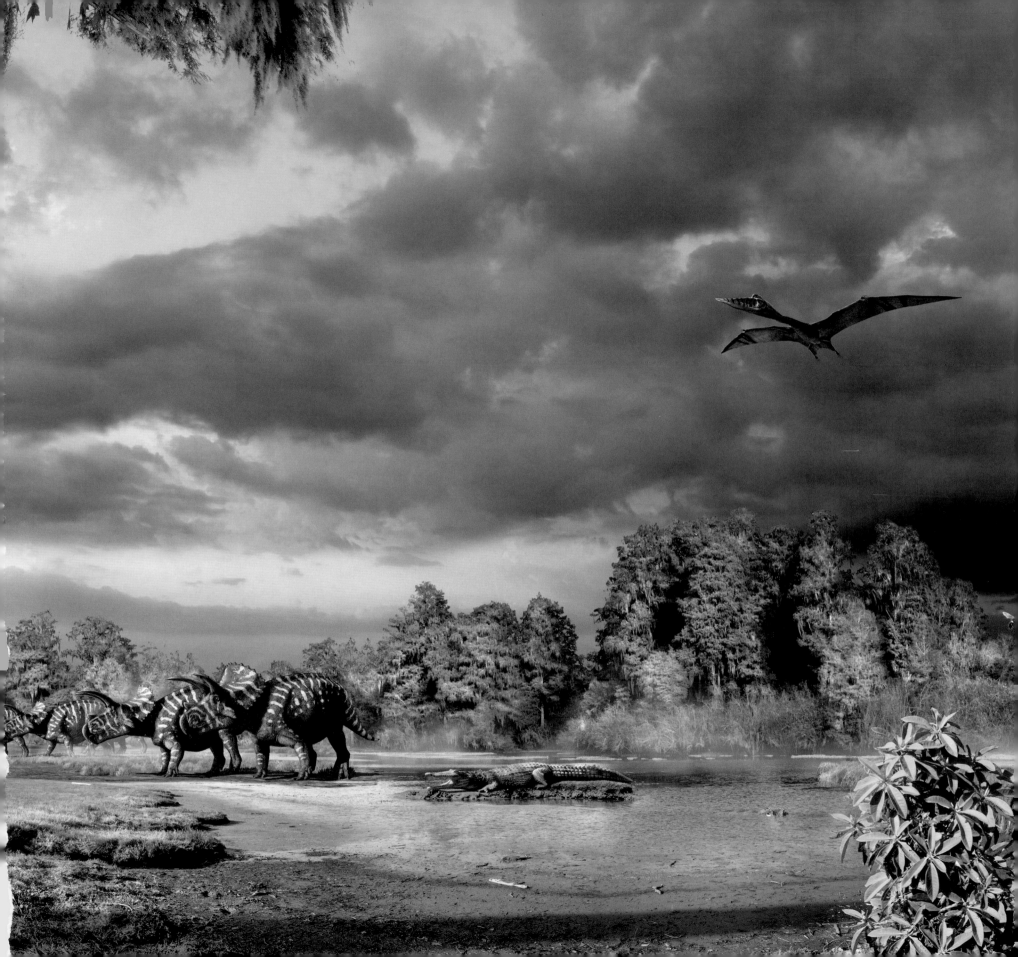

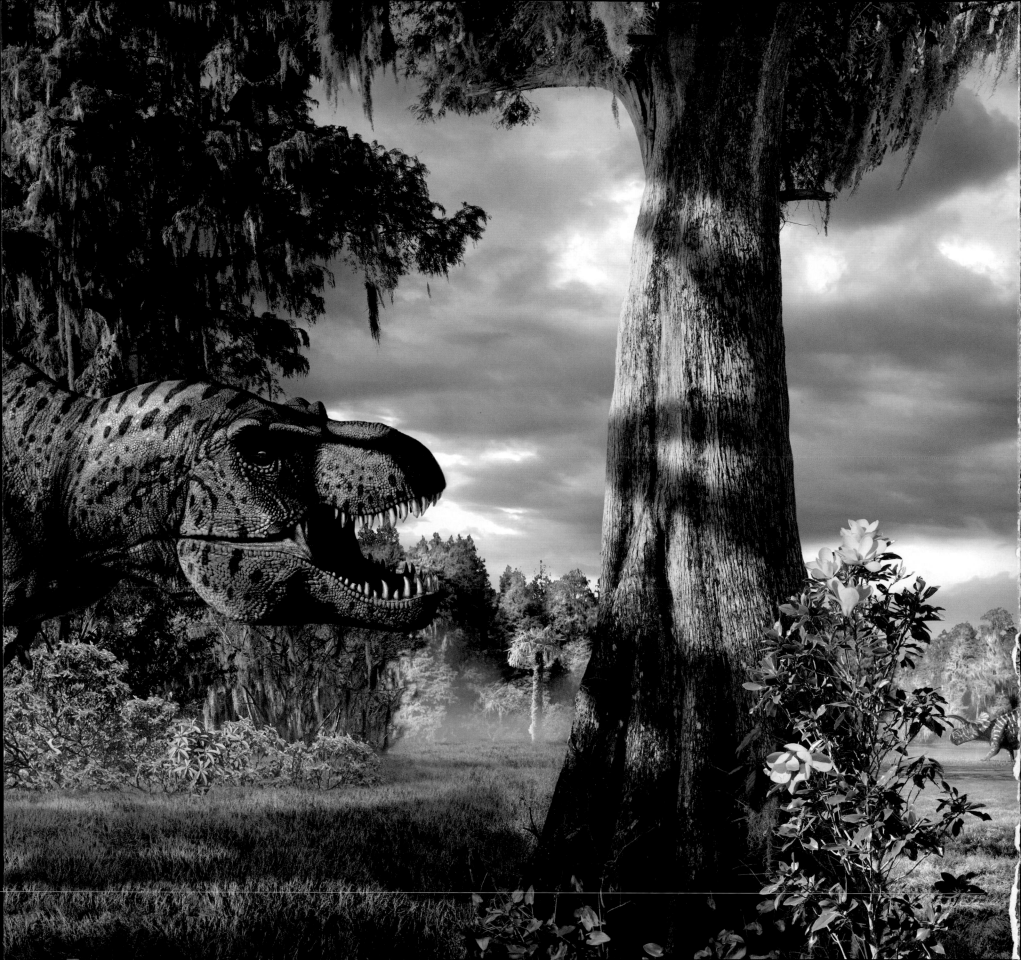

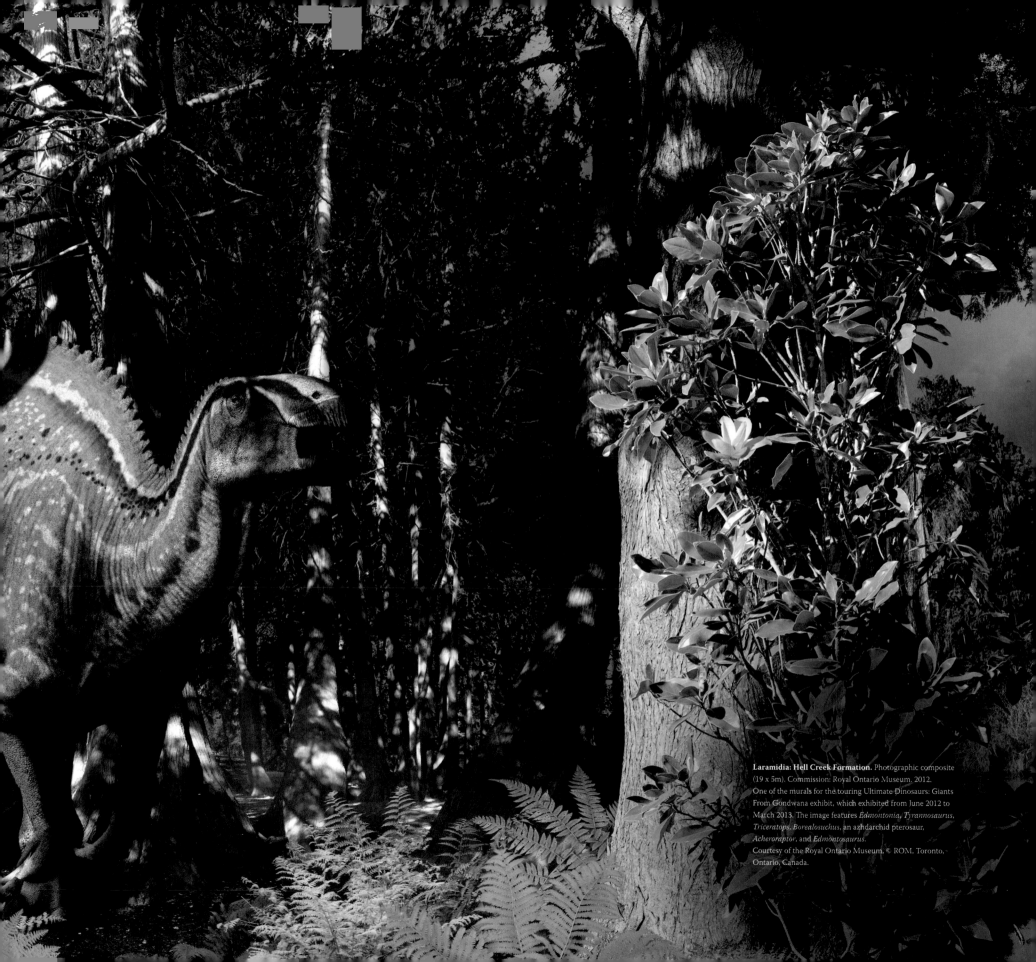

Laramidia: Hell Creek Formation. Photographic composite (19 x 5m). Commission: Royal Ontario Museum, 2012. One of the murals for the touring Ultimate Dinosaurs: Giants From Gondwana exhibit, which exhibited from June 2012 to March 2013. The image features *Edmontonia*, *Tyrannosaurus*, *Triceratops*, *Borealosuchus*, an azhdarchid pterosaur, *Acheroraptor*, and *Edmontosaurus*. Courtesy of the Royal Ontario Museum, © ROM, Toronto, Ontario, Canada.

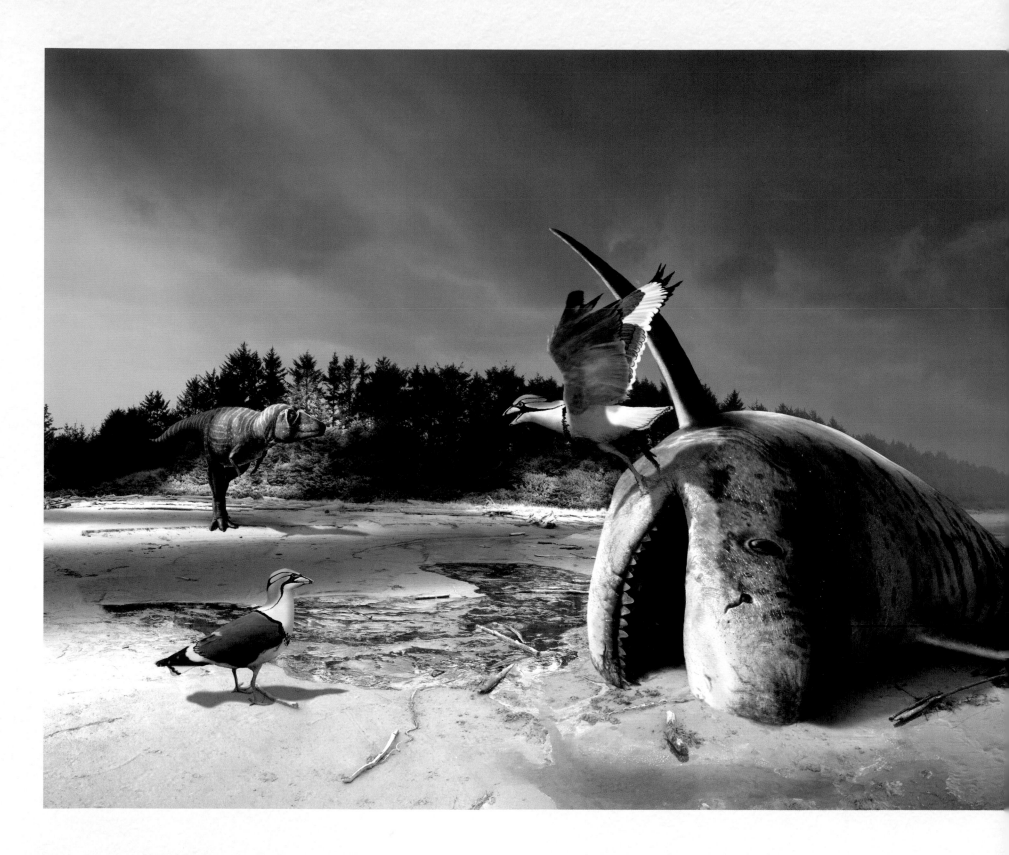

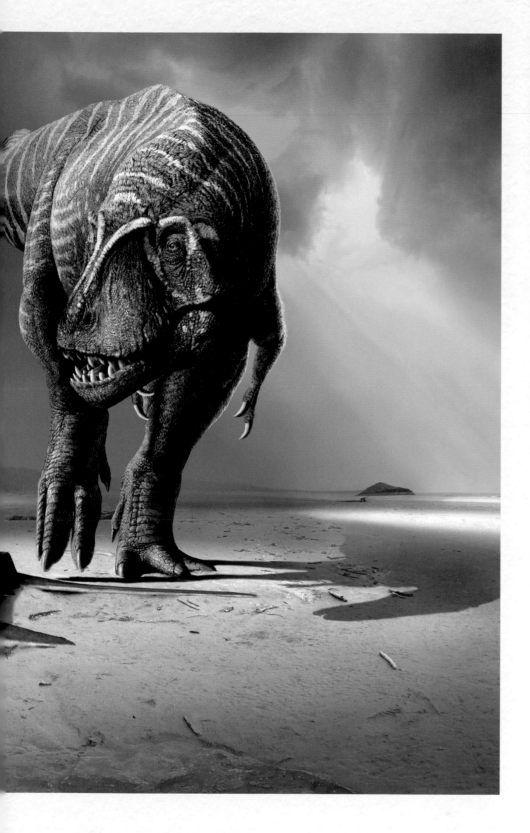

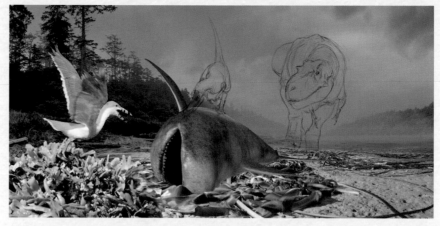

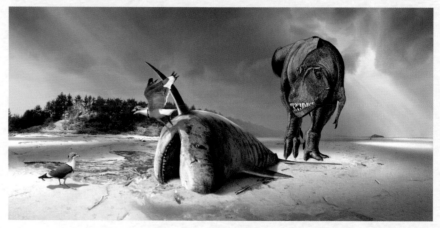

***Lythronax* Investigating *Squalicorax*.** Photographic composite. 2013.

On a beach in Laramidia during the Cretaceous, in what is now Utah, a pair of *Lythronax argestes* moves in to investigate the stranded carcass of a large *Squalicorax* shark, which is already being picked at by a pair of enantiornithine birds. As can be seen in the intermediate stages of the image (above), the identity of the theropod in this artwork changed during the course of its creation. I had initially planned to depict the tyrannosaurid *Teratophoneus*, which lived three to four million years later. The more recent discovery of *Lythronax* (Loewen *et al.*, 2013), an interesting early North American tyrannosaurid with stereoscopic forward-pointing eyes more similar to those of the advanced *Tyrannosaurus*, offered the opportunity to illustrate a discovery that reaches even further back into the depths of tyrannosaurid prehistory. This change in scope required revision of the skull morphology from the initial sketch. Although protofeathers are not known from *Lythronax*, phylogenetic bracketing suggests their presence in tyrannosaurids in general, so I chose to give *Lythronax* a stubble of filaments. I also decided to open up the shoreline for a broader, more sweeping panorama to make better use of the dappled light with which I wished to illuminate the scene, much like spotlights but in a natural setting. The general enantiornithine identity of the birds was based on the fact that, thus far, bird remains are unknown from the Wahweap Formation, and since incomplete remains ascribed to the enantiornithine *Avisaurus* are known from the overlying Kaiparowits Formation, it isn't altogether unreasonable to expect something related to be present a hair earlier. Also, further research and discussions with paleontologists about the evolution and biogeography of large kelp such as those visible on the beach in the first draft of the image (top) led me to remove these masses of huge washed-up algae, since the fossil evidence for their presence in subtropical Mesozoic seas seems questionable.

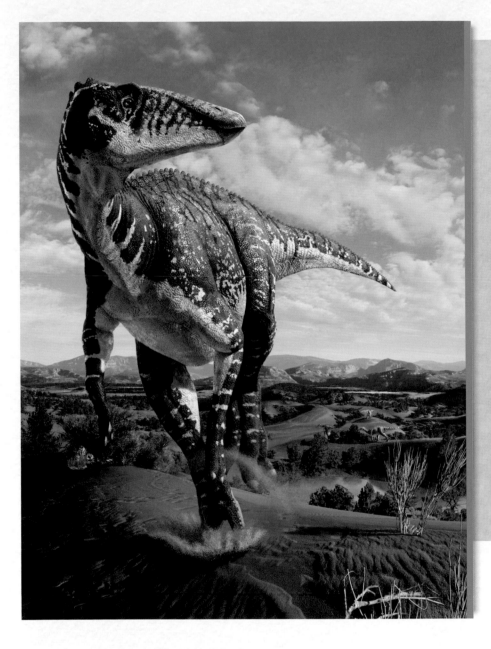

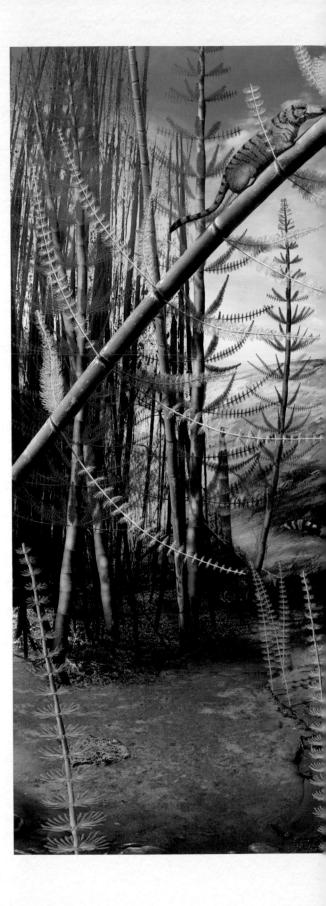

"Djadokhtan paleoenvironments of Mongolia and China are classically portrayed as arid, eolian dune fields where dinosaurs are buried by sand storms or sand slides from nearby dunes. Sedimentological evidence, however, suggests that these paleoenvironments were climatically variable over many thousands of years, and ranged from arid, sandy deserts to more mesic settings that experienced seasonal rainfall. In this reconstruction of a new hadrosauroid from the Alag Teeg locality of south-central Mongolia (Tsogtbaatar *et al.*, in press), we decided to portray, for the first time, a Djadokhtan environment in the process of shifting toward more mesic conditions. At Alag Teeg such conditions are not difficult to imagine; the hadrosauroid was collected from mudstones indicative of a wetland. In the reconstruction, normally high-relief eolian dunes are becoming deflated with each rainfall, and wetlands and streams are gradually expanding from the uplands into the former eolian setting. As plant communities extend their reach and begin to stabilize the dune field, the hadrosauroid extends its range in search of food."
Dr. David A. Eberth, Senior Research Scientist, Royal Tyrrell Museum

(Above) **Djadochta Hadrosaur.** Photographic composite. Commission: Dr. David A. Eberth, Dr. David Evans. 2013.
Cover image of forthcoming book *Hadrosaurs* (Indiana University Press).

(Opposite) **_Postosuchus_ and _Desmatosuchus_ in the Triassic.** Photographic composite. Commission: Hall of Paleontology at the Houston Museum of Natural Science. 2012.
One of fourteen of my images appearing as backlit panels (about four feet tall) in the enormous new Hall of Paleontology at the Houston Museum of Natural Science, this image depicts *Dromatherium* (mammal), *Chinesaurus*, *Hyposgnathus* (in hole), and *Desmatosuchus* being attacked by *Postosuchus* and *Eudimorphodon* (pterosaur).

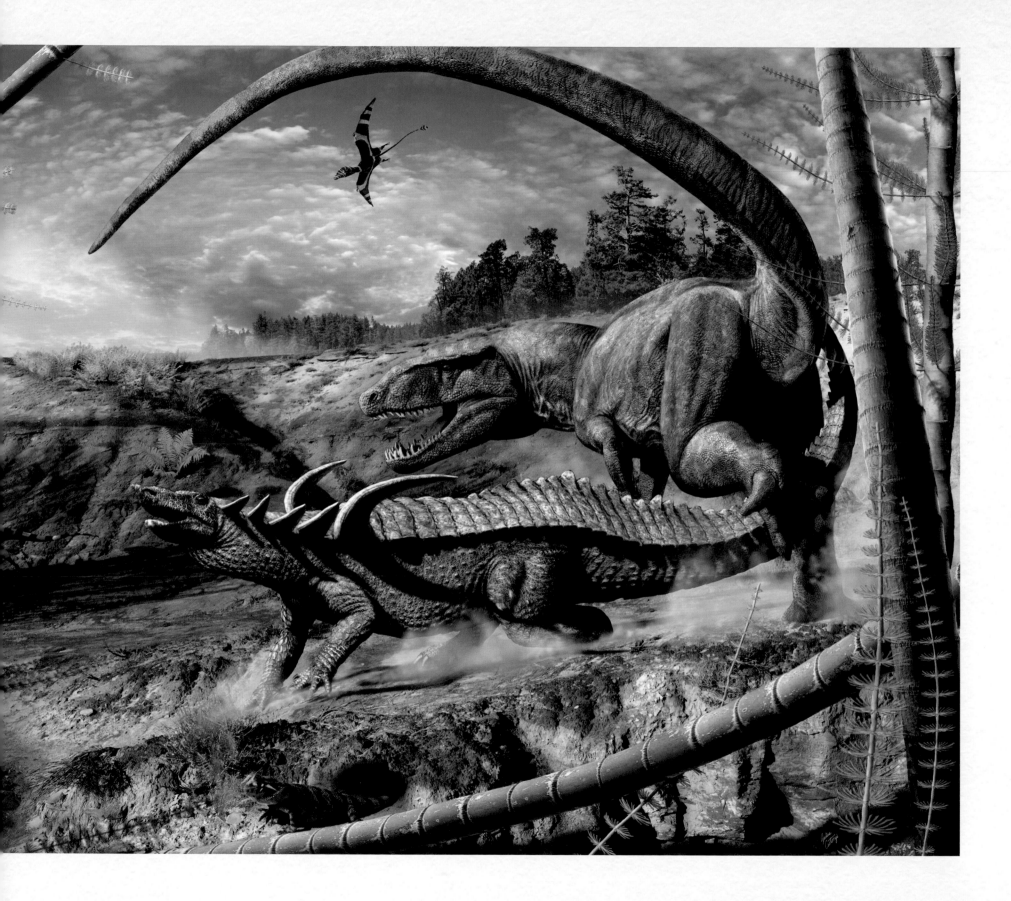

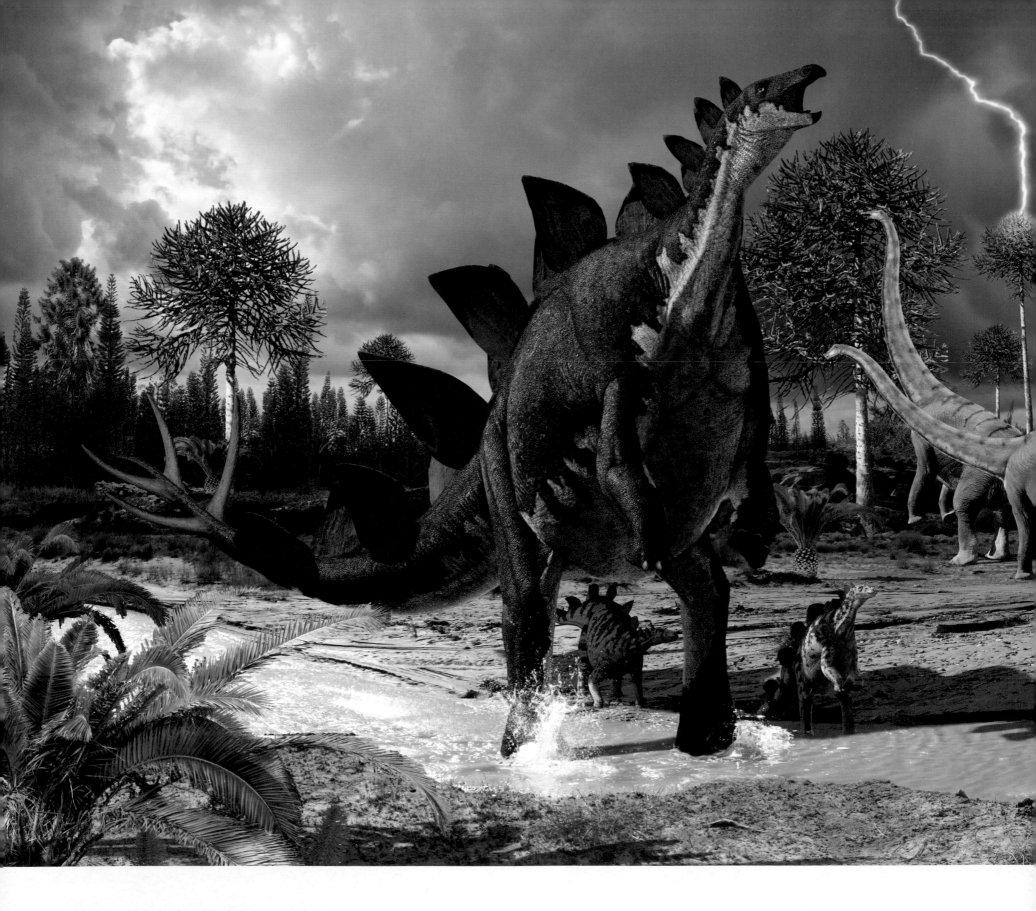

THE PALEOART OF JULIUS CSOTONYI

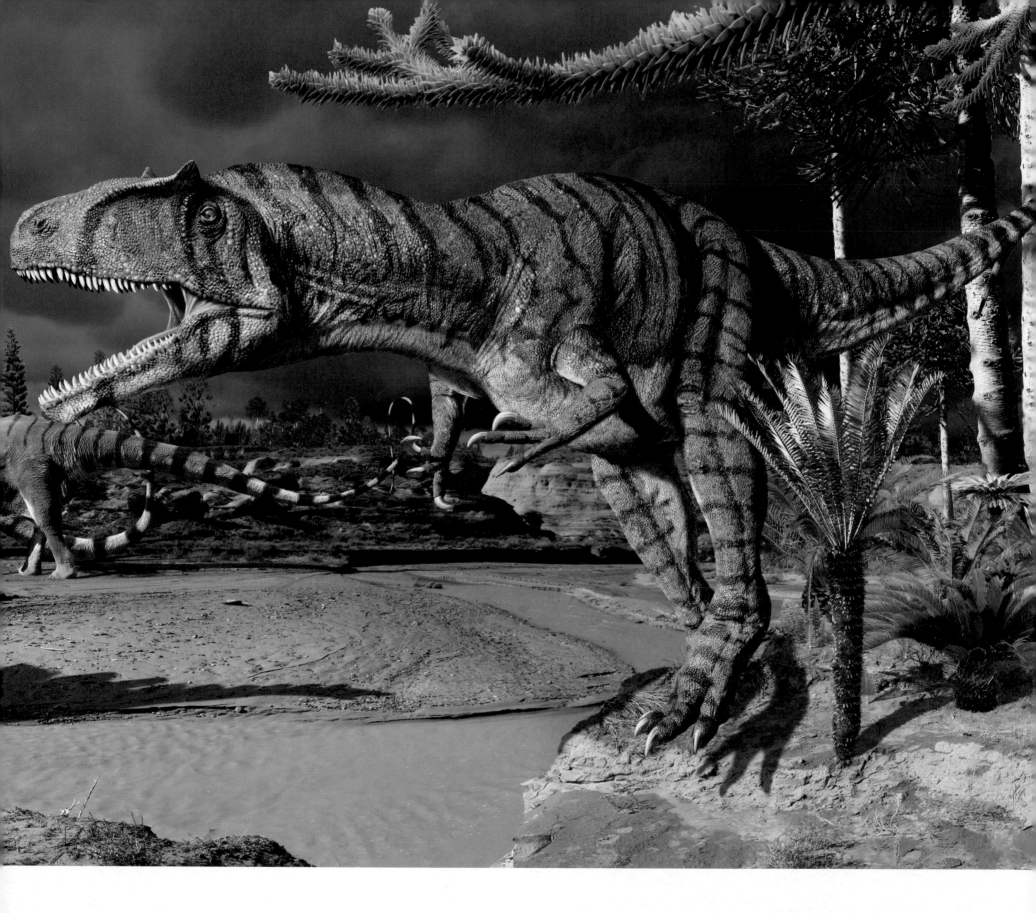

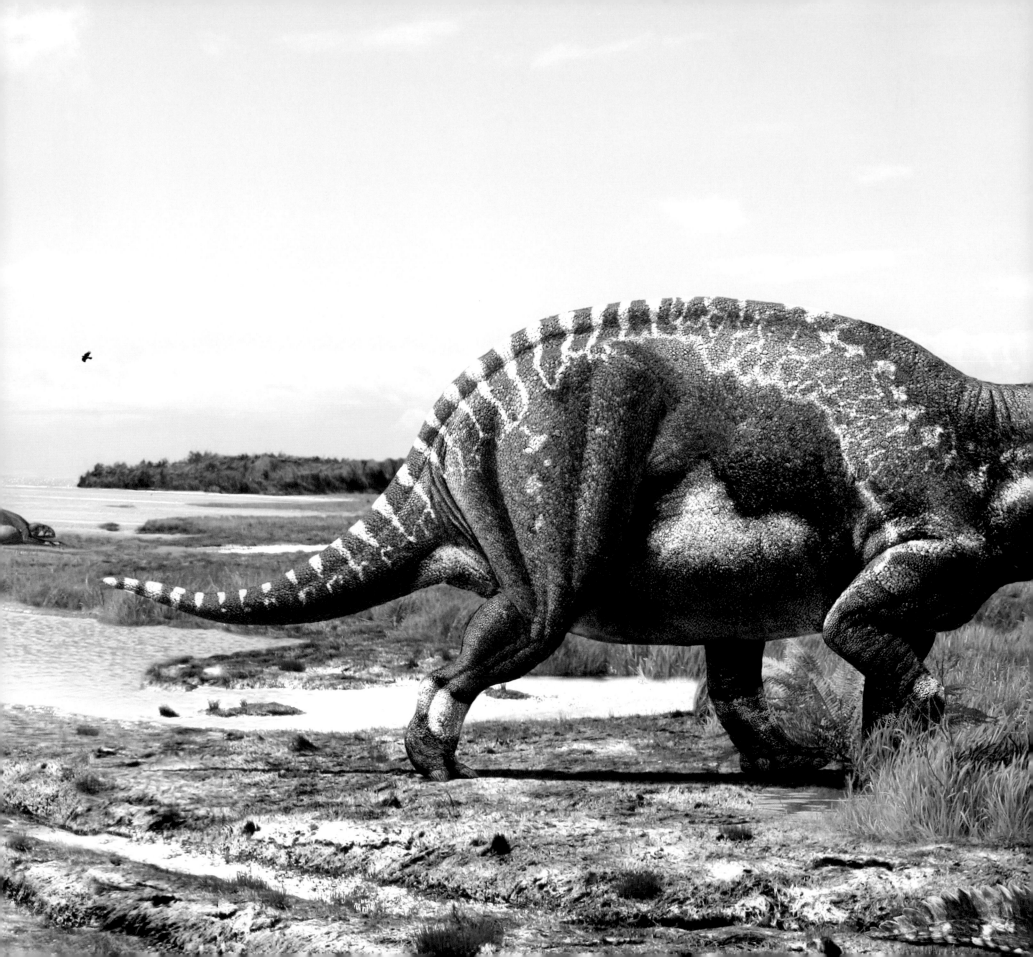

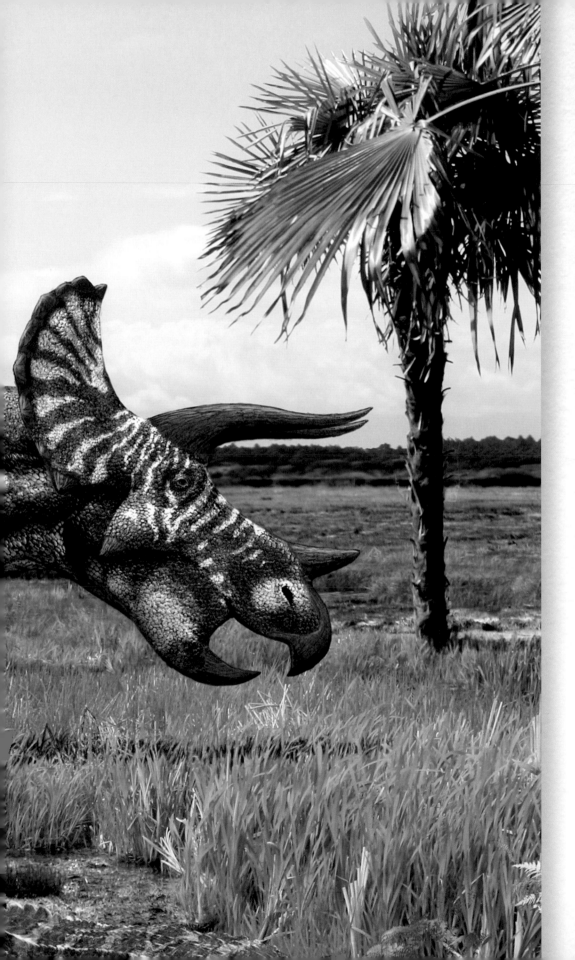

(Previous Spread) **Jurassic (Morrison Formation) Terrestrial Scene.** Photographic composite. Commission: Hall of Paleontology at the Houston Museum of Natural Science. 2012.
One of fourteen of my images appearing as backlit panels (about four feet tall) in the enormous new Hall of Paleontology at the Houston Museum of Natural Science, this image depicts a rearing mother *Stegosaurus* in a threat display to ward off a curious *Allosaurus* from its young, while a pair of *Diplodocus* browse in the background.

(Left) *Triceratops.* Photographic composite. Commission: College of Charleston. 2010.
Completed prior to the unveiling of the 'Lane' specimen of *Triceratops*, bearing the gigantic plate-sized knobby scutes.

(Top) *Eotriceratops* **Skull.** Ink. Commission: Royal Tyrrell Museum. 2007.
One of about forty drawings completed for the museum's ceratopsian exhibit in the Dinosaur Hall.
Image courtesy of the Royal Tyrrell Museum of Palaeontology, Drumheller, Alberta, Canada.

(Above) *Triceratops.* Ink. Commission: Royal Tyrrell Museum. 2007.
Image courtesy of the Royal Tyrrell Museum of Palaeontology, Drumheller, Alberta, Canada.

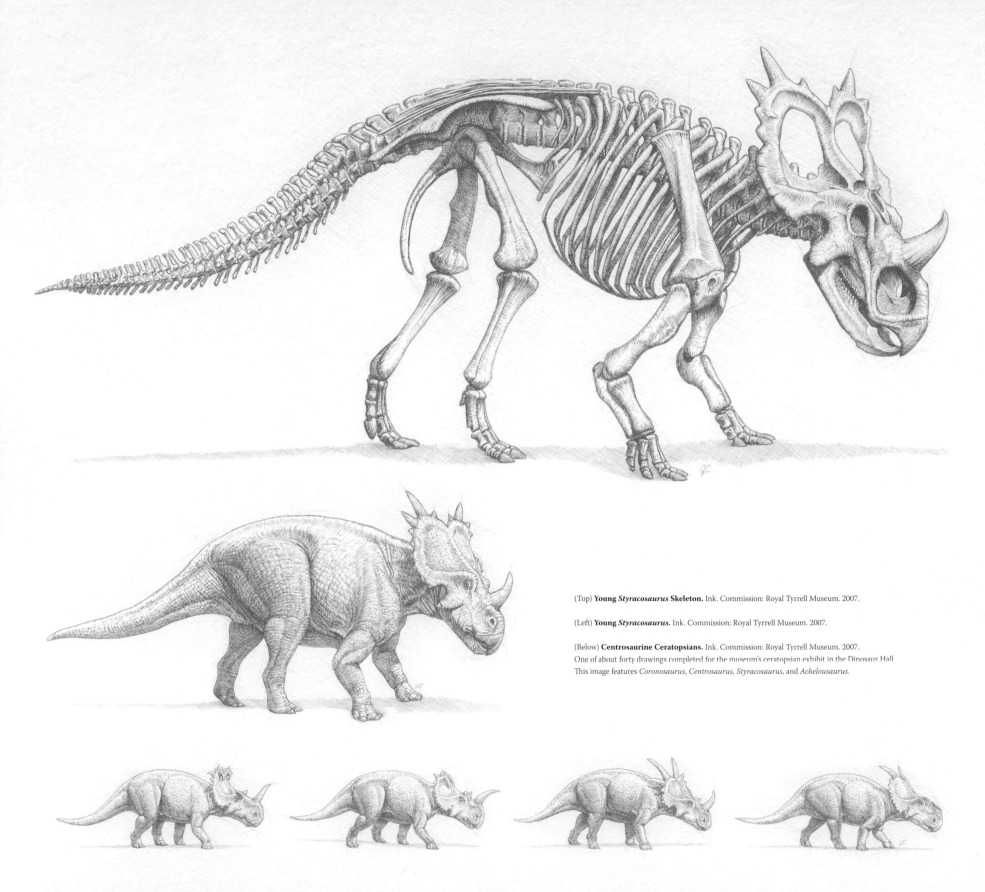

(Top) **Young *Styracosaurus* Skeleton.** Ink. Commission: Royal Tyrrell Museum. 2007.

(Left) **Young *Styracosaurus*.** Ink. Commission: Royal Tyrrell Museum. 2007.

(Below) **Centrosaurine Ceratopsians.** Ink. Commission: Royal Tyrrell Museum. 2007.
One of about forty drawings completed for the museum's ceratopsian exhibit in the Dinosaur Hall.
This image features *Coronosaurus*, *Centrosaurus*, *Styracosaurus*, and *Achelousaurus*.

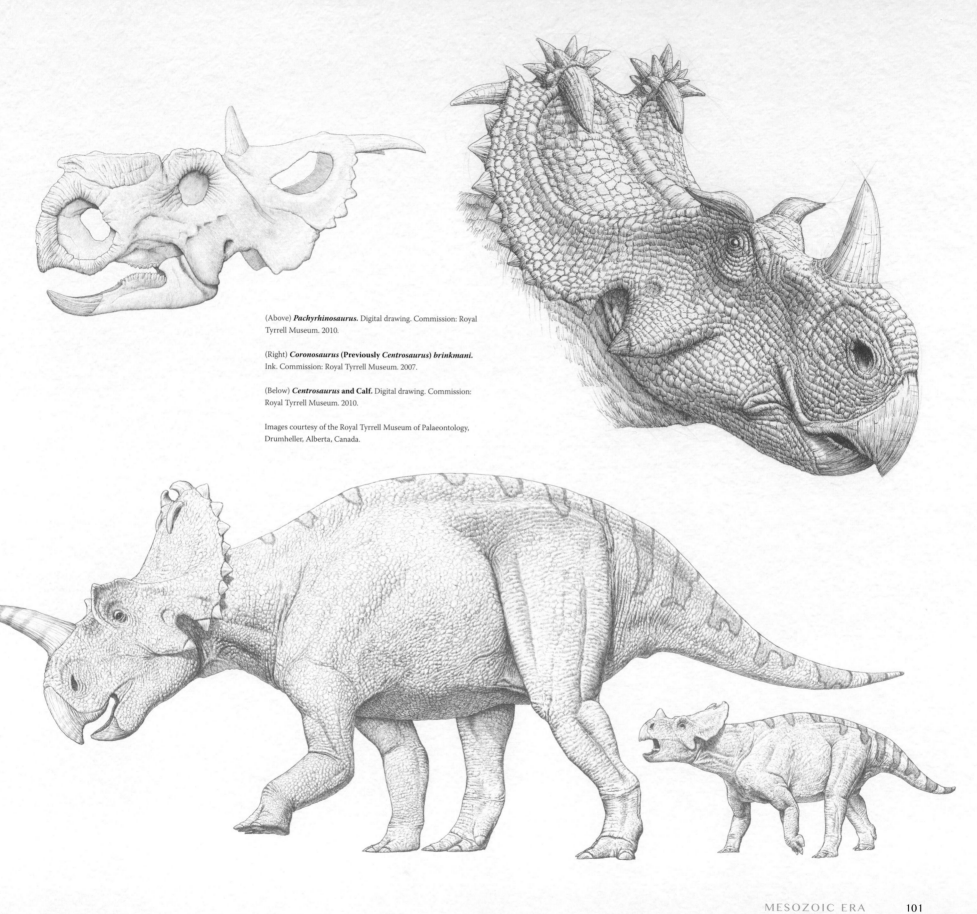

(Above) **Pachyrhinosaurus.** Digital drawing. Commission: Royal Tyrrell Museum. 2010.

(Right) **Coronosaurus (Previously** *Centrosaurus*) *brinkmani.* Ink. Commission: Royal Tyrrell Museum. 2007.

(Below) **Centrosaurus and Calf.** Digital drawing. Commission: Royal Tyrrell Museum. 2010.

Images courtesy of the Royal Tyrrell Museum of Palaeontology, Drumheller, Alberta, Canada.

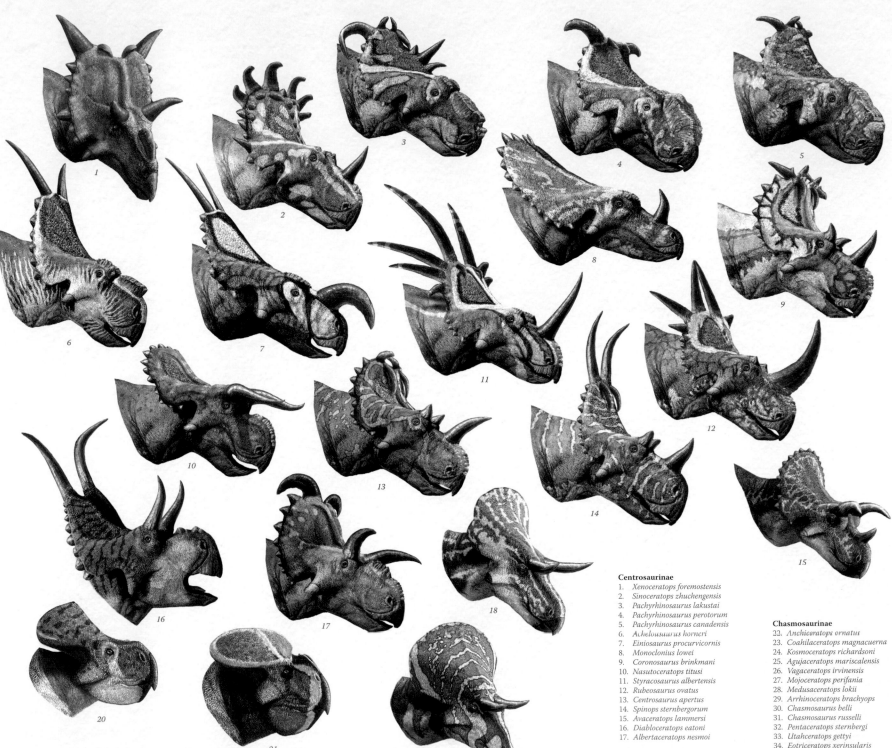

Centrosaurinae

1. *Xenoceratops foremostensis*
2. *Sinoceratops zhuchengensis*
3. *Pachyrhinosaurus lakustai*
4. *Pachyrhinosaurus perotorum*
5. *Pachyrhinosaurus canadensis*
6. *Achelousaurus horneri*
7. *Einiosaurus procurvicornis*
8. *Monoclonius lowei*
9. *Coronosaurus brinkmani*
10. *Nasutoceratops titusi*
11. *Styracosaurus albertensis*
12. *Rubeosaurus ovatus*
13. *Centrosaurus apertus*
14. *Spinops sternbergorum*
15. *Avaceratops lammersi*
16. *Diabloceratops eatoni*
17. *Albertaceratops nesmoi*

Ceratopsoidea

18. *Turanoceratops tardabilis*
19. *Zuniceratops christopheri*

Protoceratopsidae

20. *Protoceratops andrewsi*
21. *Protoceratops hellenikorhinus*

Chasmosaurinae

22. *Anchiceratops ornatus*
23. *Coahuilaceratops magnacuerna*
24. *Kosmoceratops richardsoni*
25. *Agujaceratops mariscalensis*
26. *Vagaceratops irvinensis*
27. *Mojoceratops perifania*
28. *Medusaceratops lokii*
29. *Arrhinoceratops brachyops*
30. *Chasmosaurus belli*
31. *Chasmosaurus russelli*
32. *Pentaceratops sternbergi*
33. *Utahceratops gettyi*
34. *Eotriceratops xerinsularis*
35. *Triceratops horridus*
36. 'Yoshi's Trike'
37. *Judiceratops tigris*
38. *Titanoceratops ouranos*
39. *Triceratops prorsus*
40. *Torosaurus latus*
41. *Bravoceratops polyphemus*

Ceratopsian Cornucopia. Photographic composite. 2013.
Some of these represent distinct species or genera, others are part of
ontogenetic sequences.

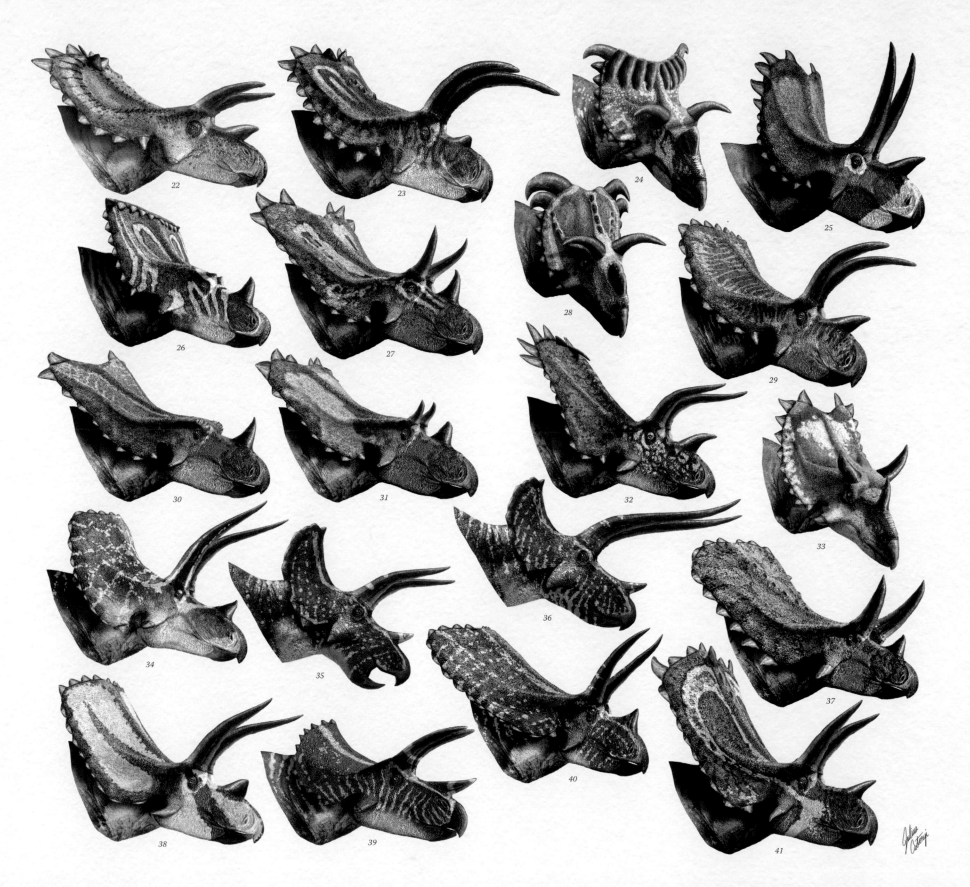

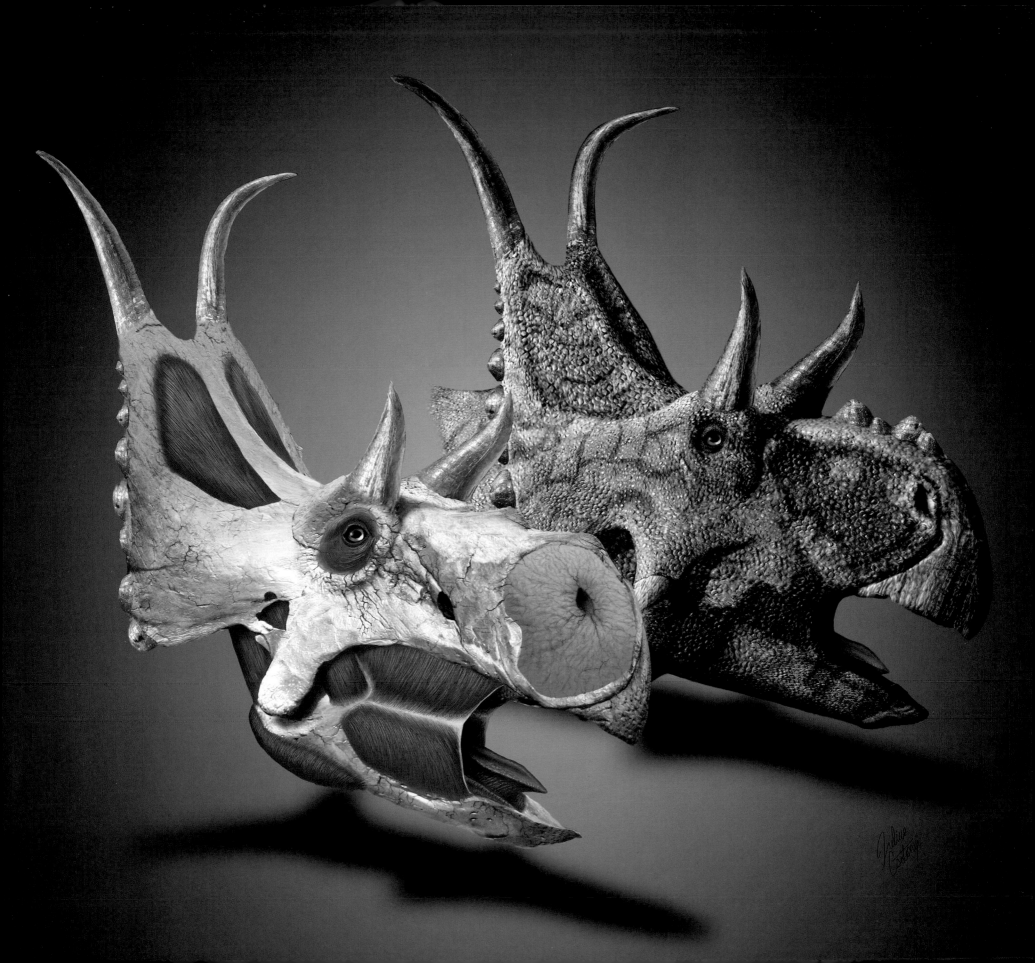

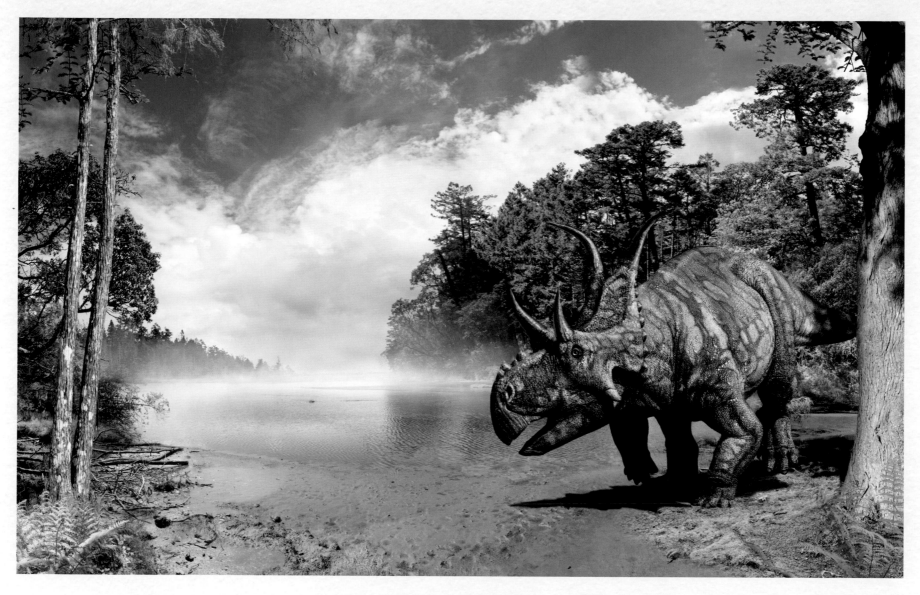

(Opposite) *Diabloceratops* **Head Restoration Sequence.** Photographic composite. Commission: Lanzenby Design for Gondwana – Das Praehistorium. 2013.
One of a set of images created to demonstrate the process of making a fleshed-out life restoration from fossilized remains.

(Above) *Diabloceratops* **in Its Environment.** Photographic composite. Commission: Lanzenby Design for Gondwana – Das Praehistorium. 2013.
One of a set of images created to demonstrate the process of making a fleshed-out life restoration from fossilized remains.

(Right) *Albertaceratops.* Ink. Commission: Royal Tyrrell Museum. 2007.
Image courtesy of the Royal Tyrrell Museum of Palaeontology, Drumheller, Alberta, Canada.

"Long brow horns were an important feature in the evolution of the early centrosaurs, like *Xenoceratops*, yet they were later 'traded off' for short brow horns but elongate nasal horns. Figuring out why this happened will give us a clue into the behavior and lifestyles of these ornate dinosaurs."
Dr. Michael Ryan, Coordinator of Research & Curator and Head of Vertebrate Paleontology, Cleveland Museum of Natural History

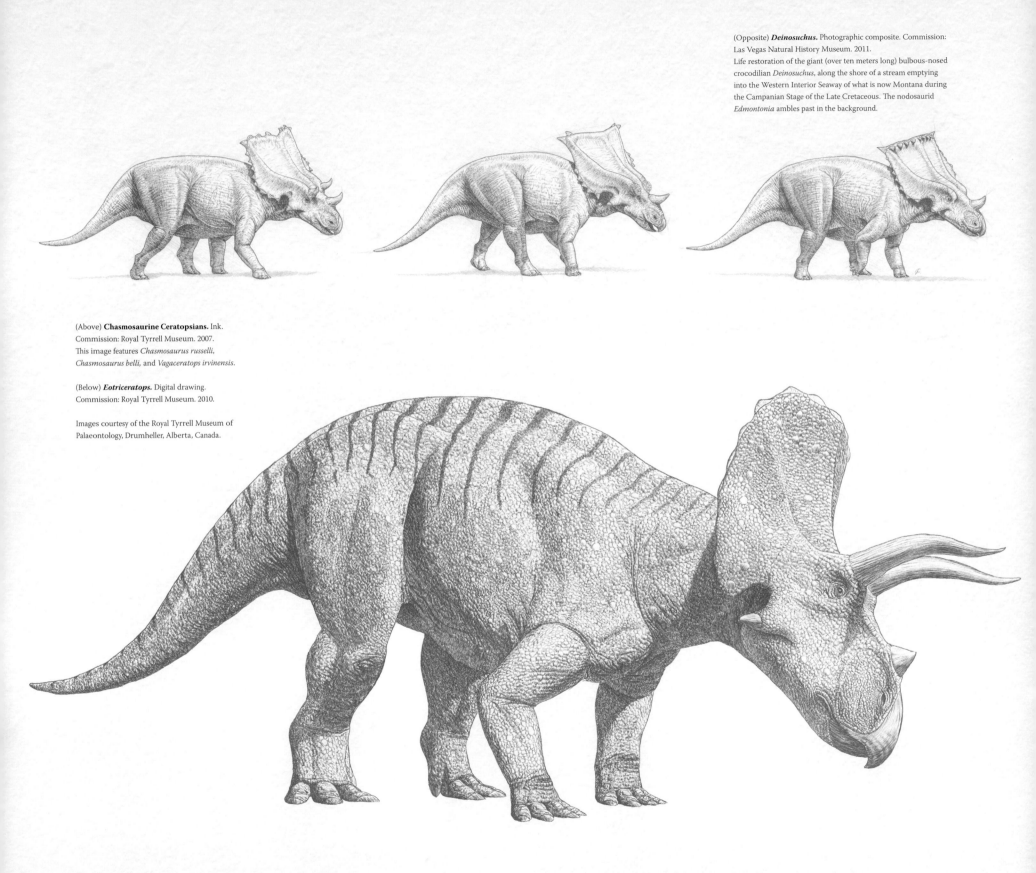

(Opposite) *Deinosuchus.* Photographic composite. Commission: Las Vegas Natural History Museum. 2011.
Life restoration of the giant (over ten meters long) bulbous-nosed crocodilian *Deinosuchus*, along the shore of a stream emptying into the Western Interior Seaway of what is now Montana during the Campanian Stage of the Late Cretaceous. The nodosaurid *Edmontonia* ambles past in the background.

(Above) **Chasmosaurine Ceratopsians.** Ink.
Commission: Royal Tyrrell Museum. 2007.
This image features *Chasmosaurus russelli,* *Chasmosaurus belli,* and *Vagaceratops irvinensis.*

(Below) *Eotriceratops.* Digital drawing.
Commission: Royal Tyrrell Museum. 2010.

Images courtesy of the Royal Tyrrell Museum of Palaeontology, Drumheller, Alberta, Canada.

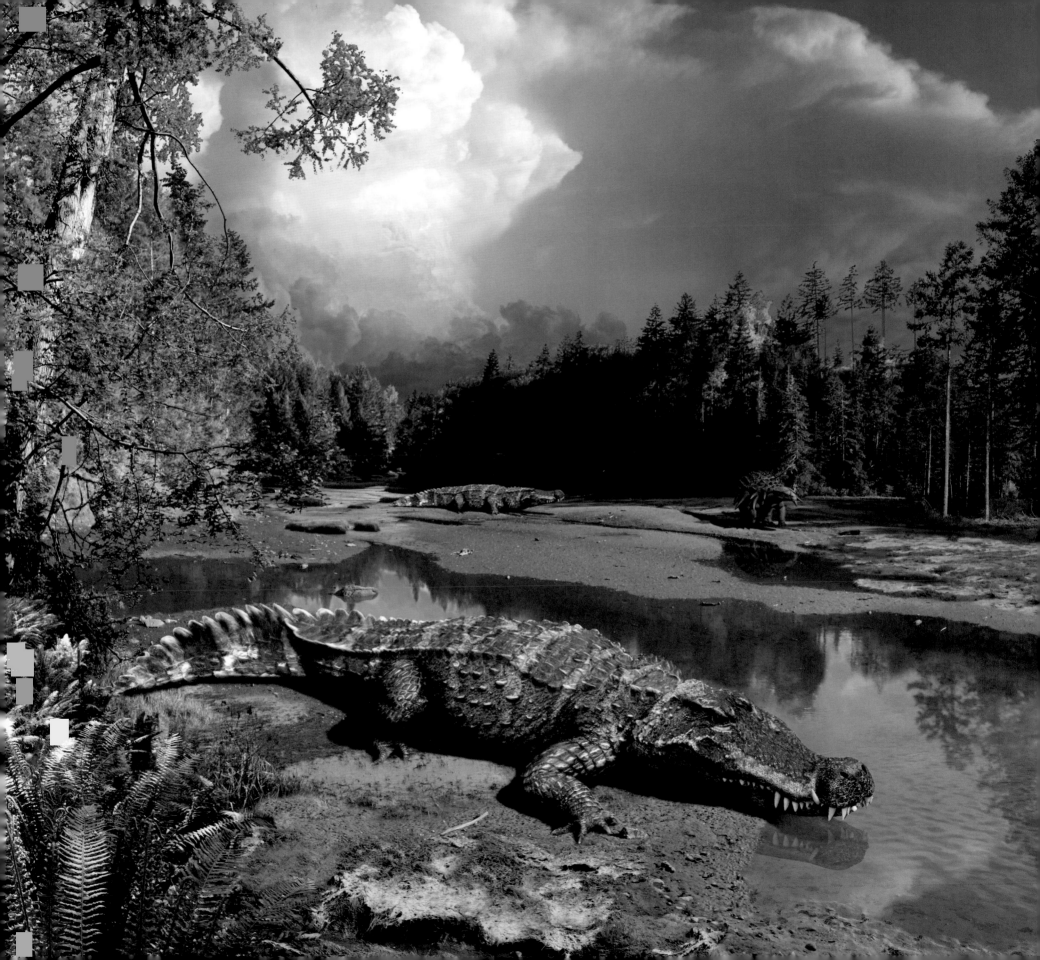

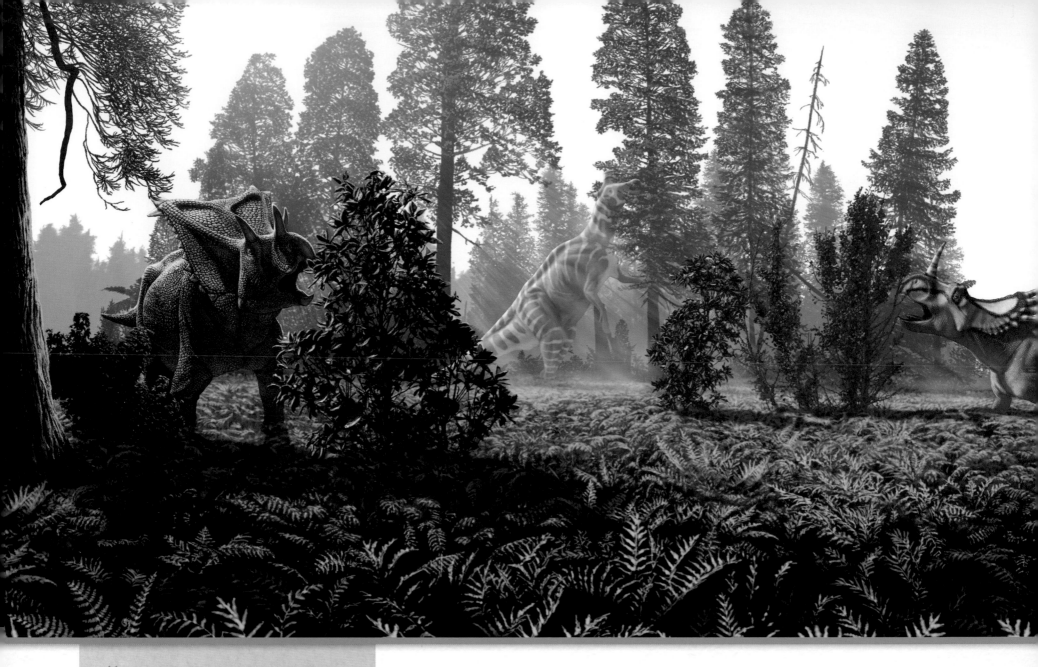

" This scene beautifully depicts my findings on the dietary adaptations of the large herbivorous dinosaurs that lived in Alberta approximately 75 million years ago. Julius's masterful handle on color, texture, and form is on full display. Most of our collaboration was spent deliberating the positions of individual trees!"
Dr. Jordan Mallon, Canadian Museum of Nature

(Above) **Niche Partitioning Among Dinosaur Park Formation Dinosaurs.** Digital painting. Commission: Dr. Jordan Mallon, Canadian Museum of Nature. 2013.
For a paper published in *PLOS One* by Mallon and Anderson (2013), this image demonstrates the concept of niche partitioning to help explain high species diversity during the Campanian Stage of the Late Cretaceous, showing different feeding guilds of dinosaurs, exemplified by *Lambeosaurus* and *Saurolophus* (high browsers), *Chasmosaurus* and *Styracosaurus* (low browsers), and *Euoplocephalus* and *Panoplosaurus* (grazers).

(Left) **Neck Frills of Ceratopsians** *Chasmosaurus, Centrosaurus, and Styracosaurus.* Ink. Commission: Royal Tyrrell Museum. 2007.
Image courtesy of the Royal Tyrrell Museum of Palaeontology, Drumheller, Alberta, Canada.

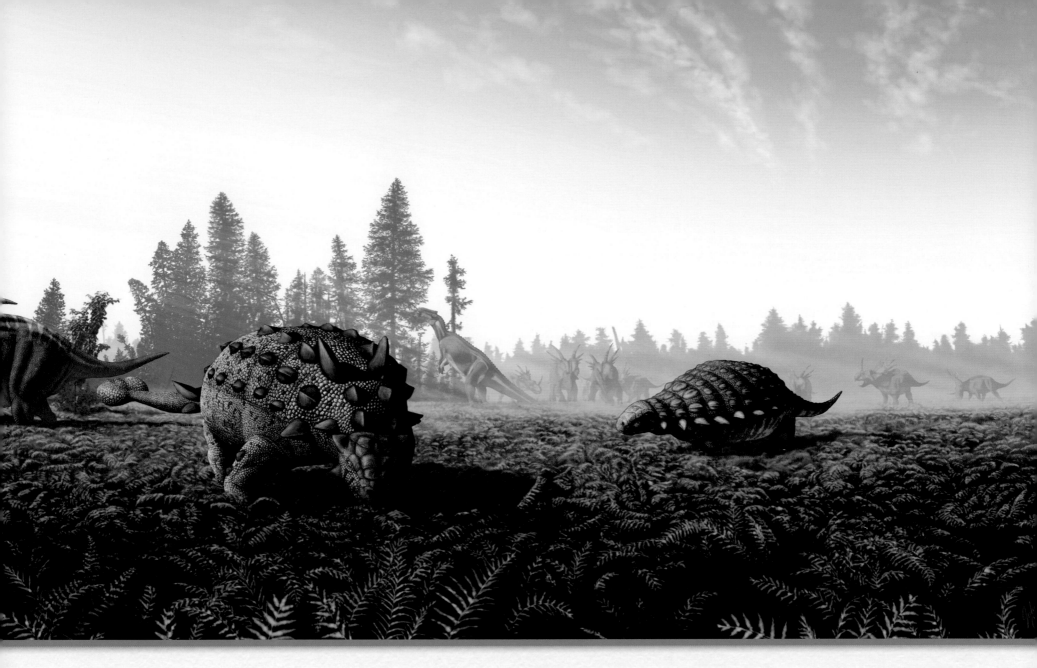

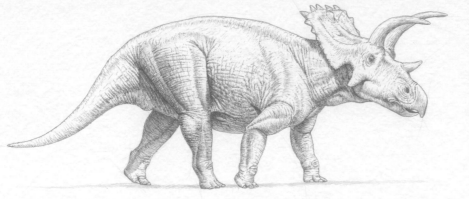

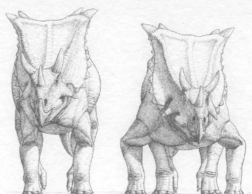

(Right) *Anchiceratops.* Ink.
Commission: Royal Tyrrell
Museum. 2007.

(Far Right) **Alternative
Postures For** *Chasmosaurus.*
Ink. Commission: Royal Tyrrell
Museum. 2007.

Images courtesy of the Royal
Tyrrell Museum of Palaeontology,
Drumheller, Alberta, Canada.

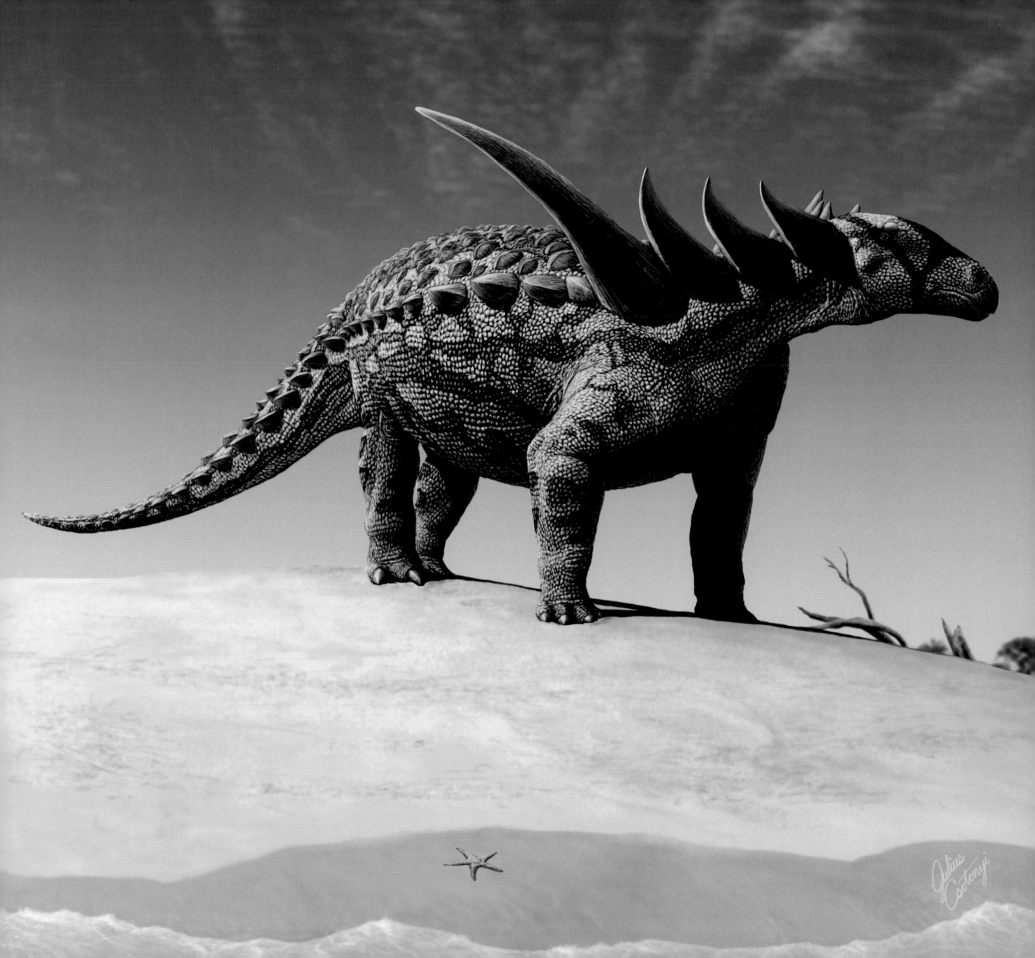

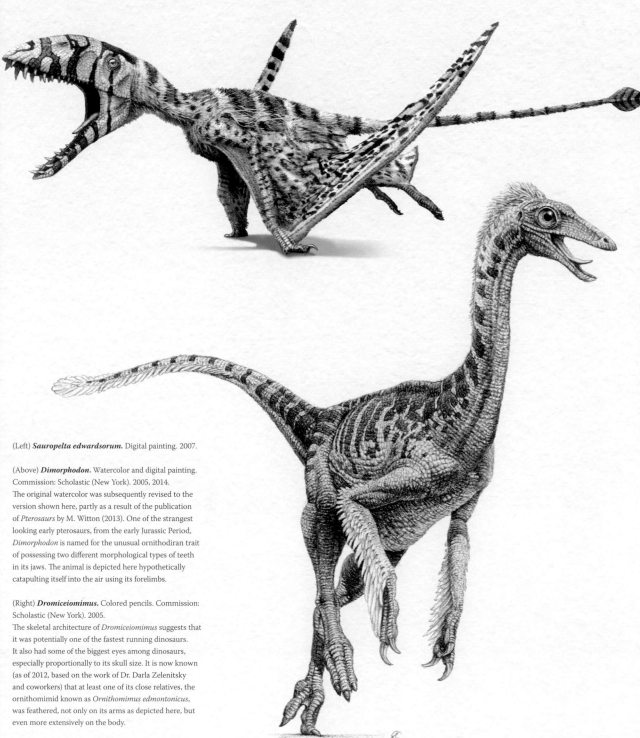

(Left) *Sauropelta edwardsorum.* Digital painting. 2007.

(Above) *Dimorphodon.* Watercolor and digital painting.
Commission: Scholastic (New York). 2005, 2014.
The original watercolor was subsequently revised to the
version shown here, partly as a result of the publication
of *Pterosaurs* by M. Witton (2013). One of the strangest
looking early pterosaurs, from the early Jurassic Period,
Dimorphodon is named for the unusual ornithodiran trait
of possessing two different morphological types of teeth
in its jaws. The animal is depicted here hypothetically
catapulting itself into the air using its forelimbs.

(Right) *Dromiceiomimus.* Colored pencils. Commission:
Scholastic (New York). 2005.
The skeletal architecture of *Dromiceiomimus* suggests that
it was potentially one of the fastest running dinosaurs.
It also had some of the biggest eyes among dinosaurs,
especially proportionally to its skull size. It is now known
(as of 2012, based on the work of Dr. Darla Zelenitsky
and coworkers) that at least one of its close relatives, the
ornithomimid known as *Ornithomimus edmontonicus*,
was feathered, not only on its arms as depicted here, but
even more extensively on the body.

Edmontonia. Digital drawing. Commission: Royal Tyrrell Museum. 2010.
Created for the Alberta Unearthed exhibit.
Image courtesy of the Royal Tyrrell Museum of Palaeontology, Drumheller, Alberta, Canada.

Fossil Trackway Makers. Digital drawing. Commission: Royal Tyrrell Museum. 2010.
Created for the Alberta Unearthed exhibit.
Image courtesy of the Royal Tyrrell Museum of Palaeontology, Drumheller, Alberta, Canada.

Mural Work in Progress. Photographic composite. Commission: Houston Museum of Natural Science. 2008.
An example of what part of a photorealistic-style paleoecological restoration looks like before it is complete. This image features *Dromaeosaurus* (foreground) and *Edmontonia*, and is a small part of the long Judithian Montana mural for the Dinomummy CSI: Cretaceous Science Investigation exhibit.

"Almost by definition, most animals within an evolutionary group look a lot like one another; all dogs, wolves, and foxes look like each other because they are closer relatives than to, say, bears or hyenas. Still, there are always some real oddities and for the ankylosaurs that is *Liaoningsaurus*. A fraction of the size of other members of the group and with relatively little armor, this is quite a different sight to its evolutionary kin. It would presumably have been relatively vulnerable to predators and in a wooded environment there is always the potential of danger from above as well as on the ground.

In this case a lone *Sinornithosaurus* is perched just off the forest floor and considering a strike on the tough little herbivore. While lacking the tail club or extensive bony armor of other ankylosaurs, it still has some protection and there was plenty of smaller and more amenable prey out there – the Jehol fossil record is replete with other small dinosaurs, amphibians, reptiles, and insects."
Dr. Dave Hone, Queen Mary, University of London

(Right) **Liaoningosaurus** and **Sinornithosaurus.** Digital painting. 2013.
Inspired by conversations with Dr. David Hone, the tiny size of the Chinese ankylosaurid *Laioningosaurus* provides a rare opportunity to show an ankylosaurid being attacked by a dromaeosaurid.

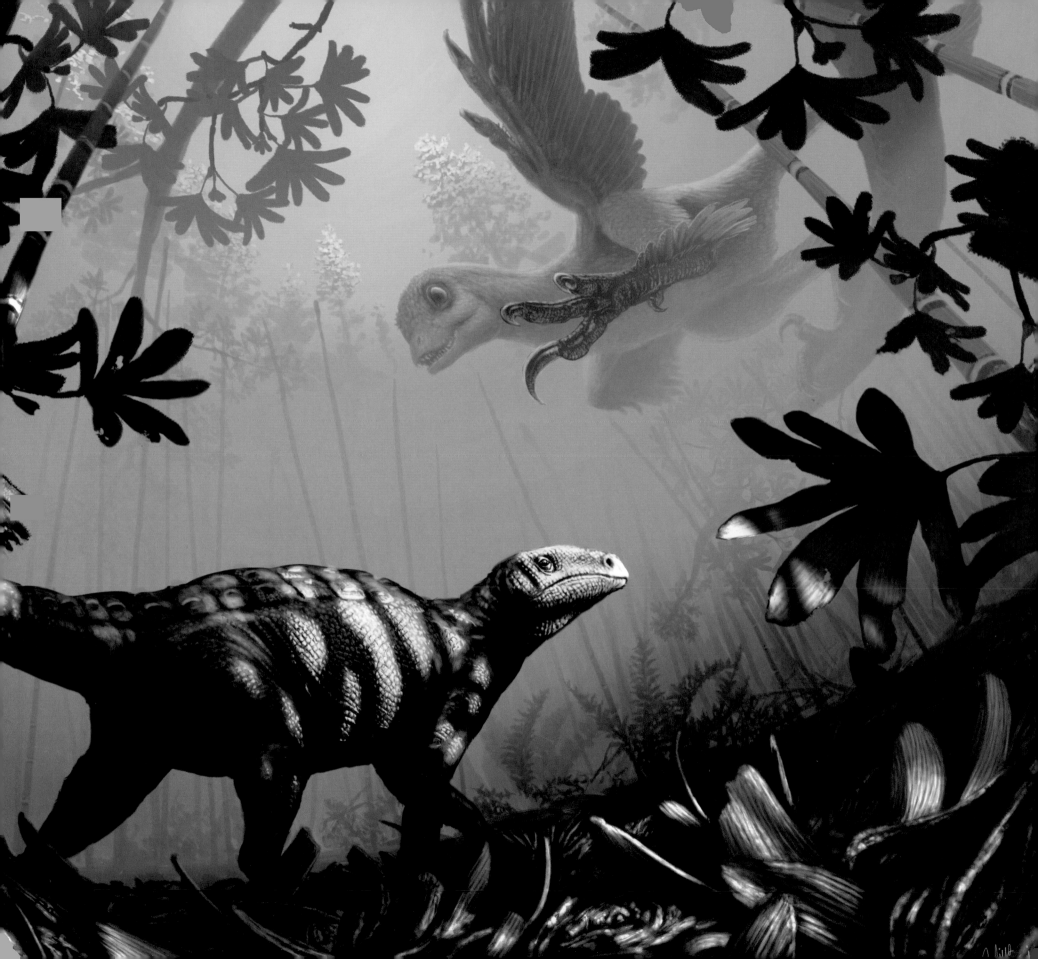

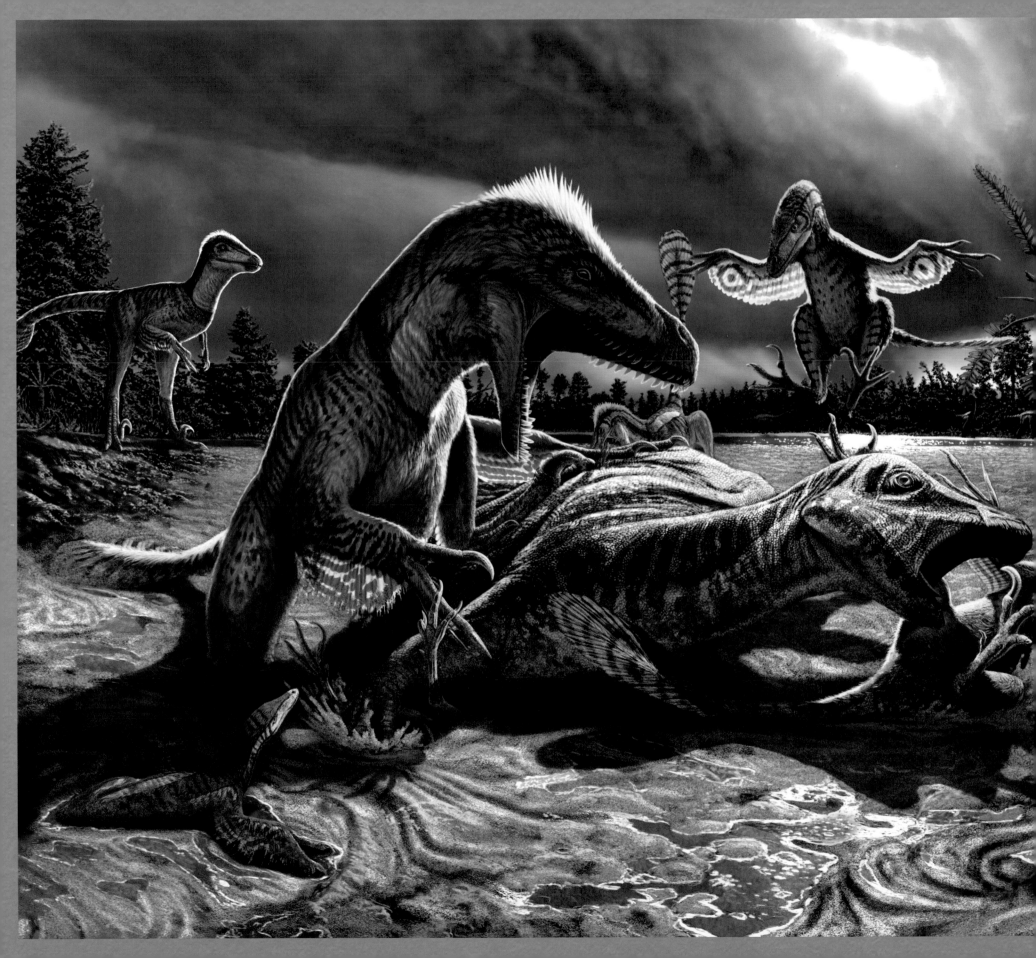

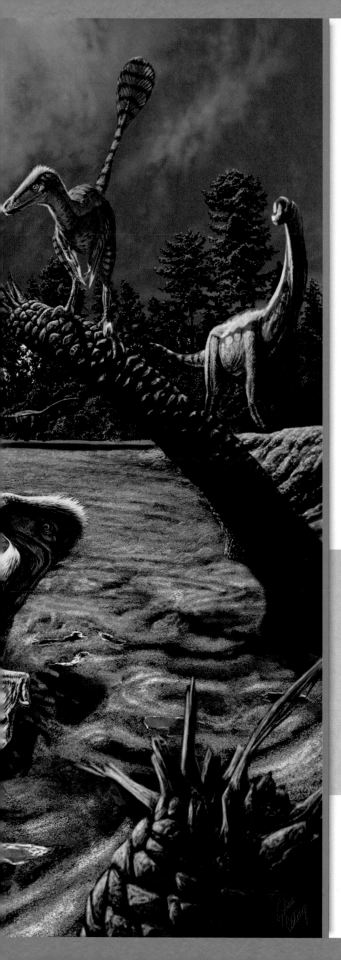

UTAHRAPTOR

Genus:	*Utahraptor* ('Utah hunter')
Species:	*ostrommaysorum* (named after renowned paleontologist, John Ostrom, and dinosaur animatronic pioneer, Chris Mays)
Location:	Utah, USA
Named:	1993
Age:	Barremian Stage, Early Cretaceous approx. 125 million years ago
Length:	approx. 7m (24ft)

The largest known member of the Dromaeosauridae (the famous 'raptors'), *Utahraptor* retains features similar to its small relatives, including *Deinonychus*, with whom it shared its American home. The telltale second claw so well known in the dromaeosaurs is particularly large, the longest measuring 22cm (8.5in), indicating that *Utahraptor* was a major predator. Not built for speed, it probably utilized ambush tactics to take down prey. While many raptors have been discovered with a covering of protofeathers in various forms, it remains unknown if *Utahraptor* had such an integument.

This image attempts to restore some of the events leading to the creation of a large block of highly fossiliferous (mainly *Utahraptor* over a range of ontogenetic stages) sandstone from the Cretaceous in what is now Utah.

"The Utah Geological Survey has been excavating a Lower Cretaceous dinosaur site high on a cuesta north of Arches National Park in eastern Utah. The site consists of blobs of fine sandstone packed with skeletons incased in unfossiliferous mudstone. We have interpreted that the skeletons are incorporated into a large-scale dewatering feature on the side of a lake. The largest blob is filled with *Utahraptor* skeletons, including at least one baby, several juveniles, and at least one adult (based on fully toothed jaws observed from edges of the blob), packed around an iguanodont skeleton (possibly *Hippodraco*). Basically, our hypothesis is that a pack (family group) of *Utahraptors* was trapped in quicksand while taking advantage of a trapped iguanodont. The bone density is so great that you cannot stick in an ice pick without hitting bone, and taking out the resulting intact blob of approximately three-by-three-by-one meters (nine cubic meters) will require the use of a skycrane. As this is probably the single most significant block of fossils our team has ever collected, we do not want to screw it up. Julius painted an interpretation of our hypothesis that we could use as we try to raise funds to extract the block properly and test this hypothesis."

Dr. James Kirkland, State Paleontologist, Utah Geological Survey

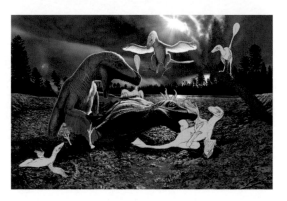

***Utahraptor* Attacking *Hippodraco* in Sand Dewatering Feature.** Digital painting. Commission: Dr. James Kirkland. 2013.

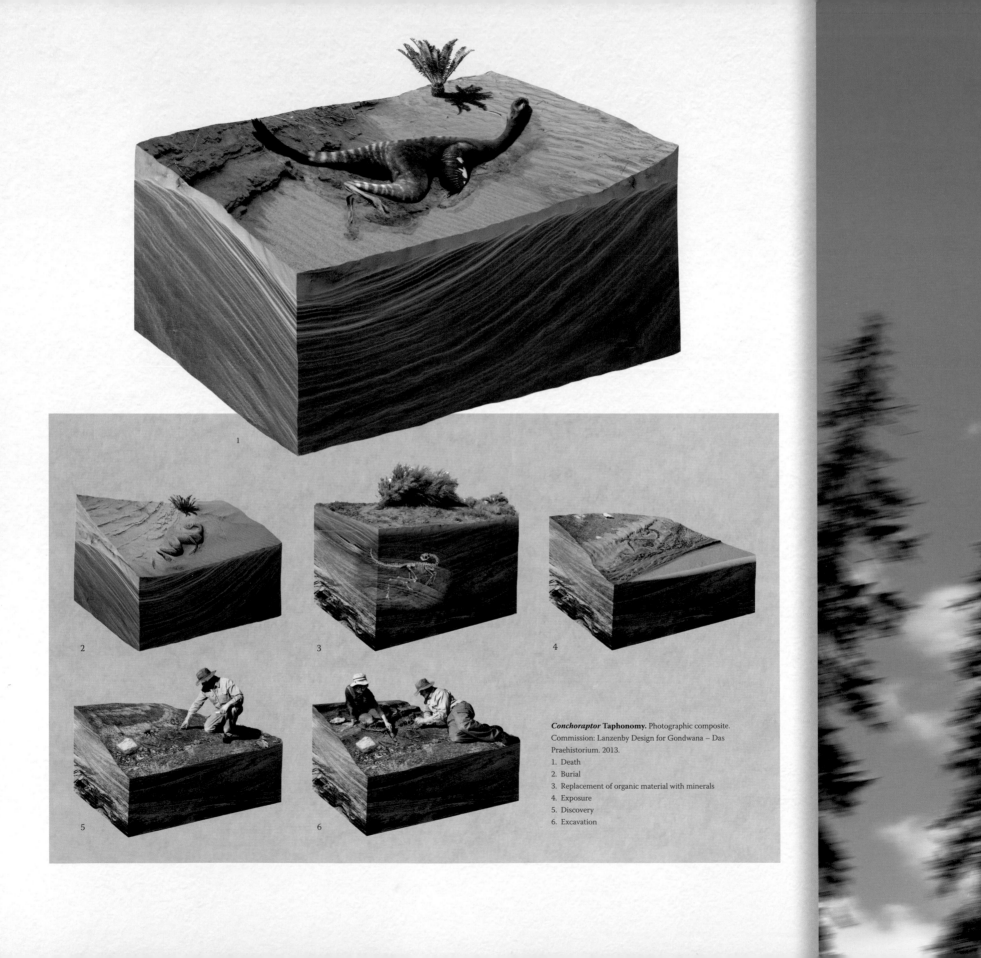

***Conchoraptor* Taphonomy.** Photographic composite.
Commission: Lanzenby Design for Gondwana – Das
Praehistorium. 2013.

1. Death
2. Burial
3. Replacement of organic material with minerals
4. Exposure
5. Discovery
6. Excavation

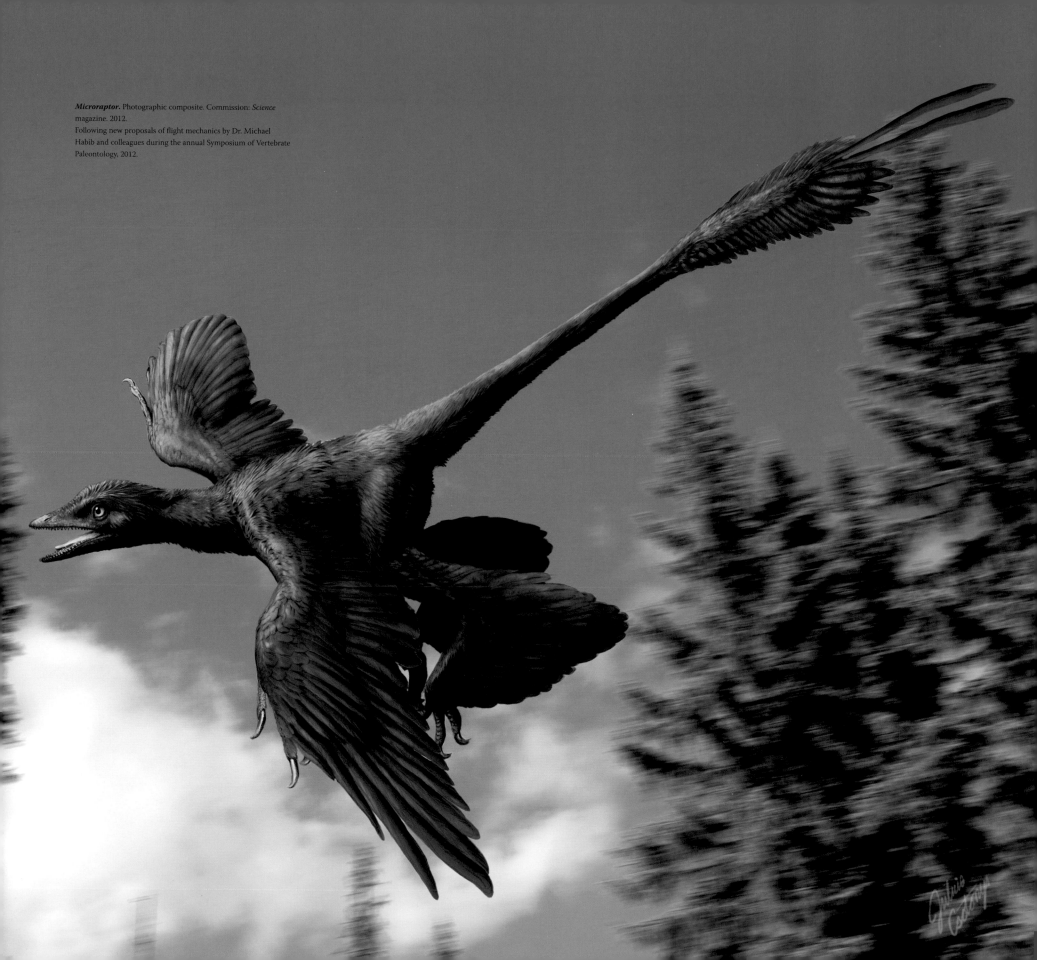

Microraptor. Photographic composite. Commission: *Science* magazine. 2012.
Following new proposals of flight mechanics by Dr. Michael Habib and colleagues during the annual Symposium of Vertebrate Paleontology, 2012.

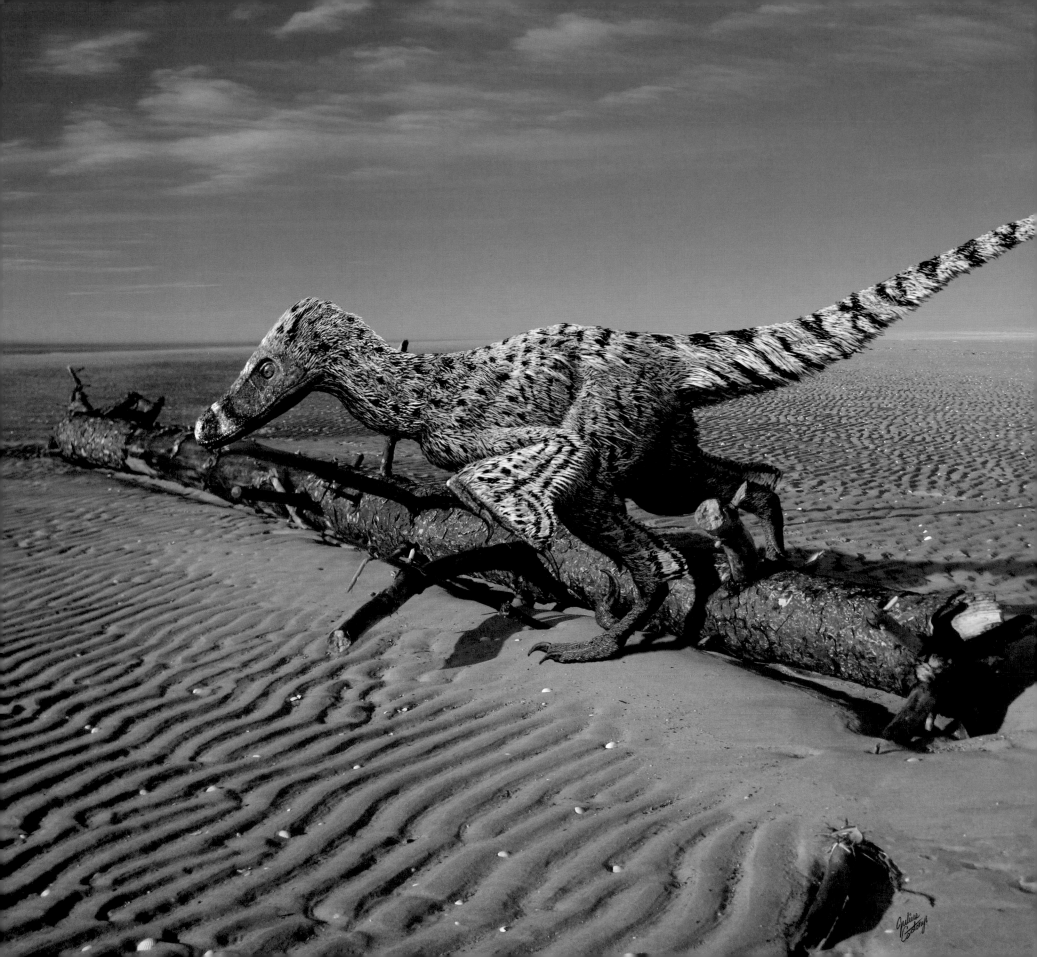

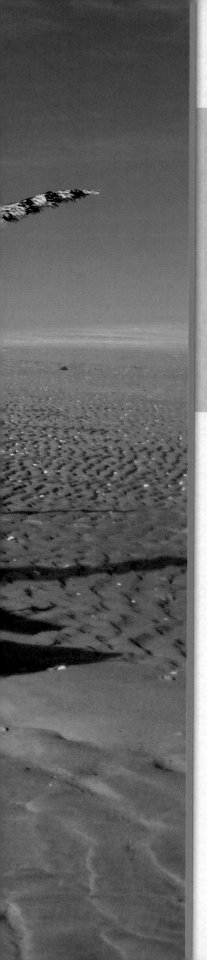

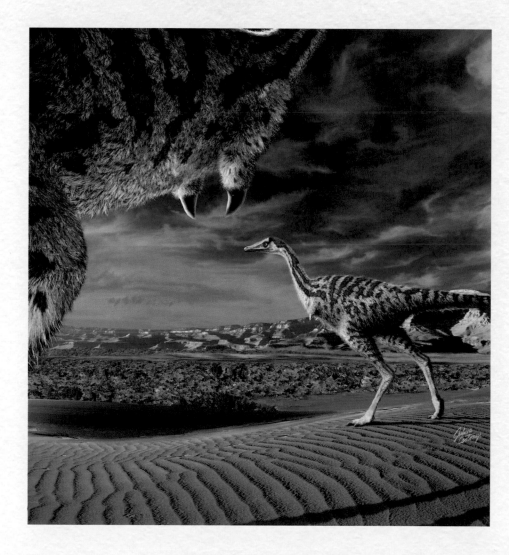

(Left and Top) **Linheraptor exquisitus.** Photographic composite. 2010.
A derived dromaeosaurid with features resembling *Velociraptor* from Late Cretaceous Mongolia was described by Xu *et al.* (2010). The exquisite state of preservation of its remains makes it live up to its specific epithet. This is another example of a piece that I completed in response to the recent publication of its description in the literature.

(Right) **Linhenykus monodactylus.** Photographic composite. Commission: Dr. Michael Pittman and Dr. Xing Xu for Xu *et al.* (2011). 2011.
The first truly monodactylic dinosaur, with no additional vestigial manual digit bones.

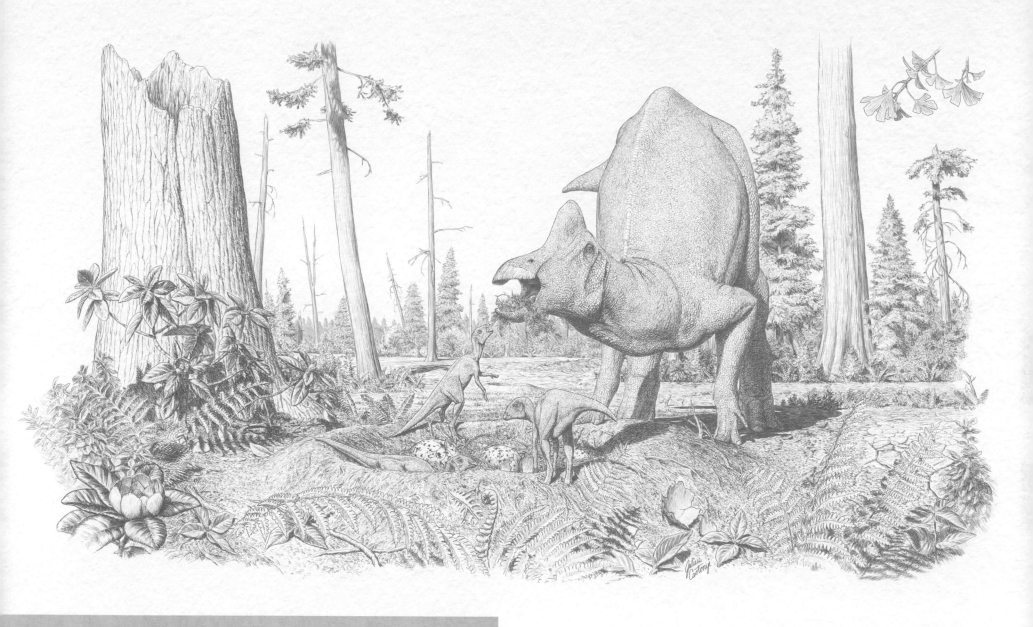

(Left) *Edmontosaurus regalis* **With a Fleshy Crest.** Photographic composite. Commission: Dr. Phil Bell. 2013.
A version of the restoration appeared in the article (Bell *et al.*, 2014) and was selected for the cover of the journal *Current Biology* (Volume 24, Issue 1; 6 January, 2014).

(Above) **Devil's Coulee Cretaceous Scene.** Digital drawing. Commission: Alberta Fossil Trail signage project, Royal Tyrrell Museum. 2007.
One of nine drawings of prehistoric life featured on educational signs in paleontologically strategic locations in Alberta to promote tourism. This image features a nest and the young of the hadrosaur *Hypacrosaurus altispinus*.

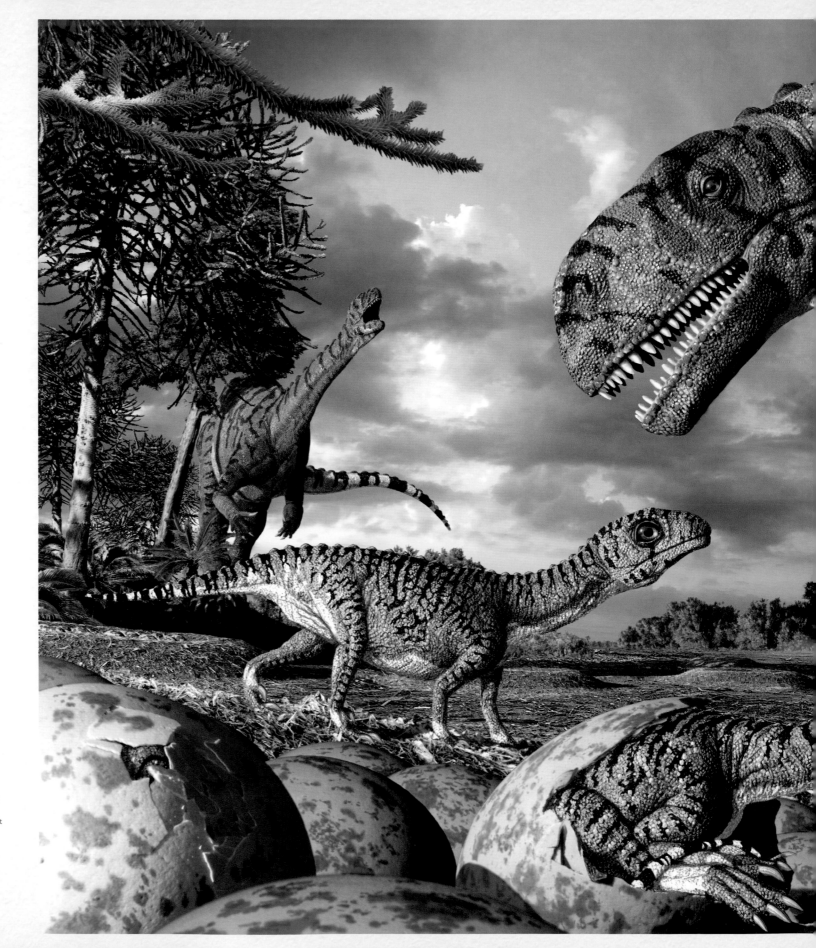

***Massospondylus* Nest Site.** Photographic composite. Commission: Royal Ontario Museum. 2010.
Created for the Dinosaur Eggs and Babies: Remarkable Fossils from South Africa exhibit. The image features hatchling to adult *Massospondylus carinus*, and *Tritylodon*. Courtesy of the Royal Ontario Museum, © ROM, Toronto, Ontario, Canada.

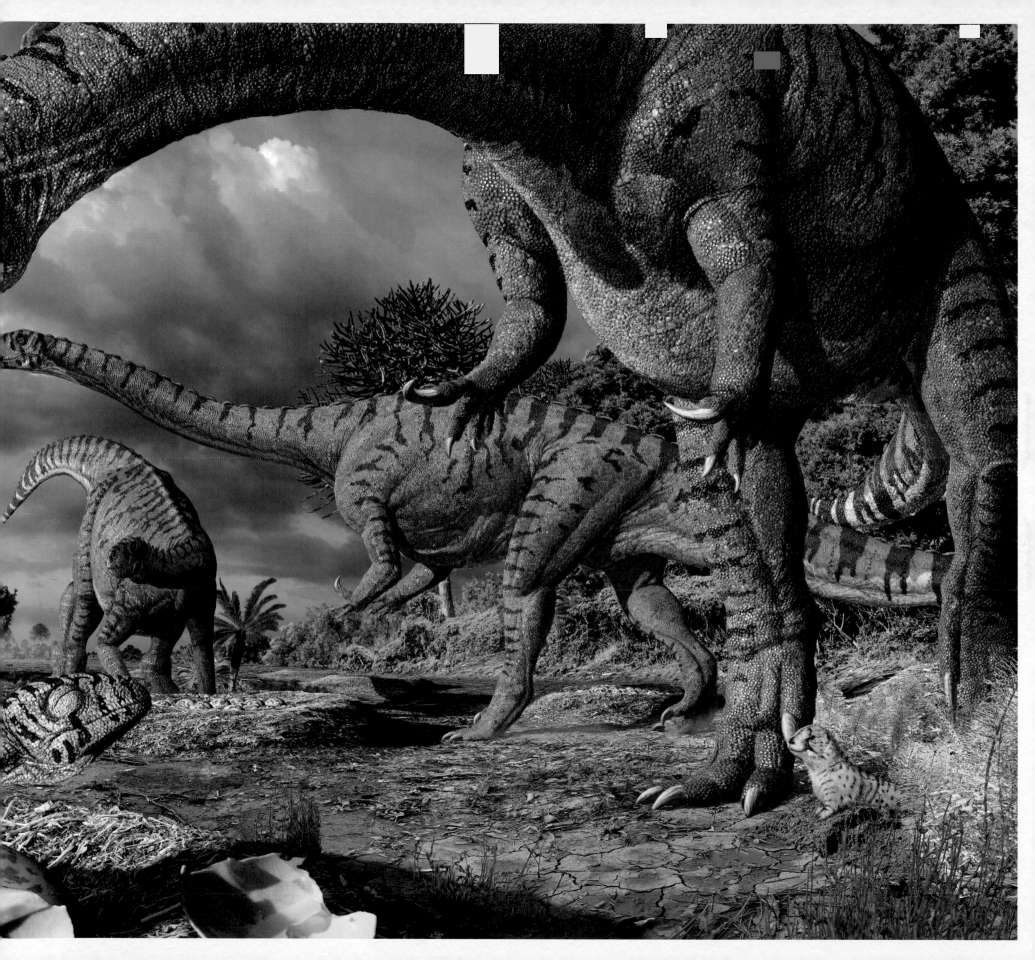

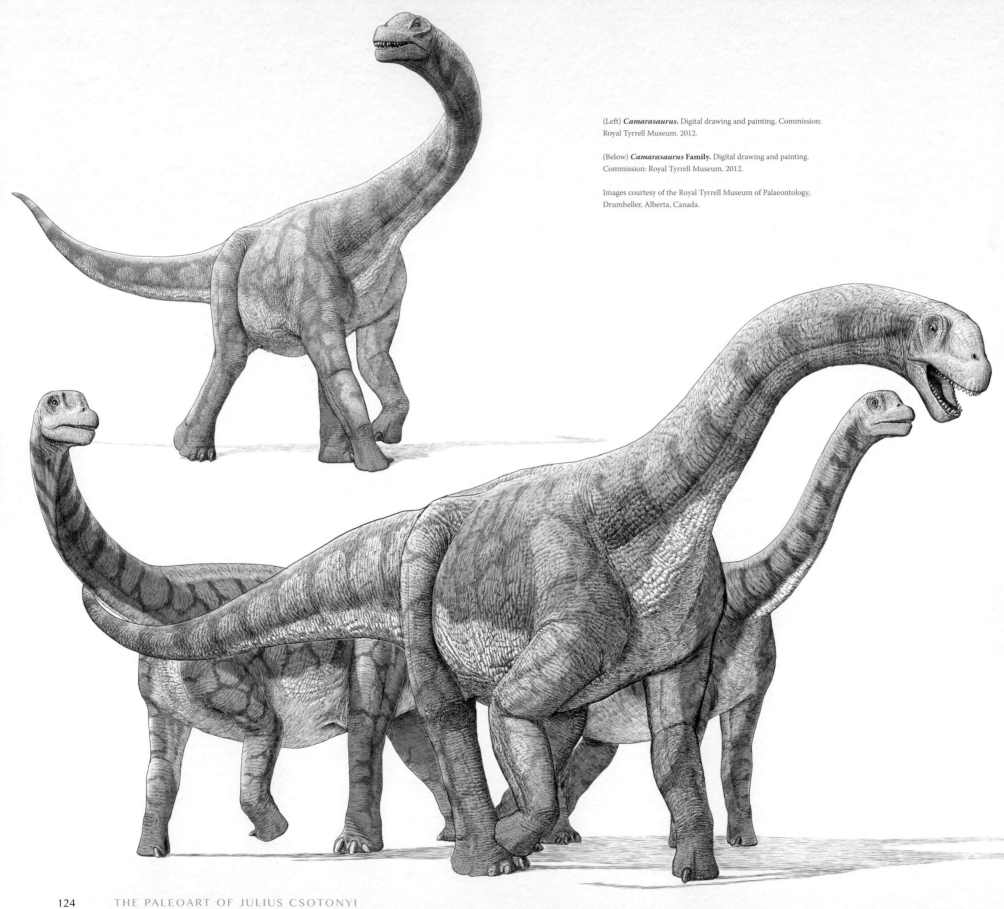

(Left) **Camarasaurus.** Digital drawing and painting. Commission: Royal Tyrrell Museum. 2012.

(Below) **Camarasaurus** Family. Digital drawing and painting. Commission: Royal Tyrrell Museum. 2012.

Images courtesy of the Royal Tyrrell Museum of Palaeontology, Drumheller, Alberta, Canada.

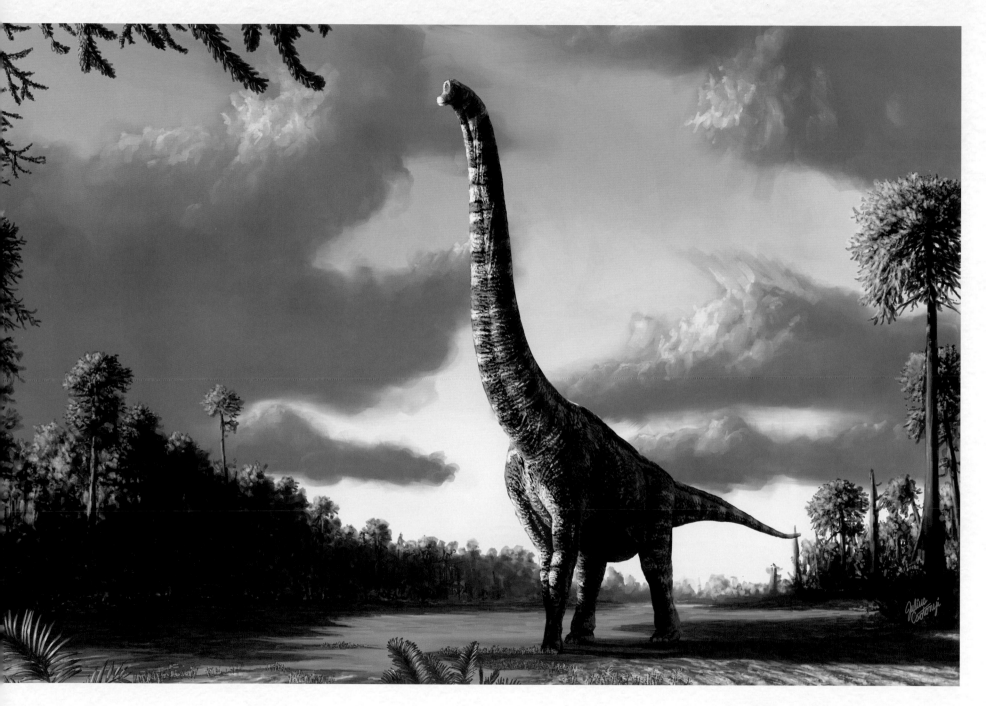

Brachiosaurus. Digital painting. 2009.
Brachiosaurus is a well-known dinosaur from the Jurassic Morrison Formation of North America, though only about a tenth as abundant in fossil material as *Apatosaurus. Brachiosaurus* was one of the most vertically extended sauropods, as well as one of a handful of the largest dinosaurs. Here it is reconstructed on a coniferous forest-lined flood plain that characterized some of its native environment.

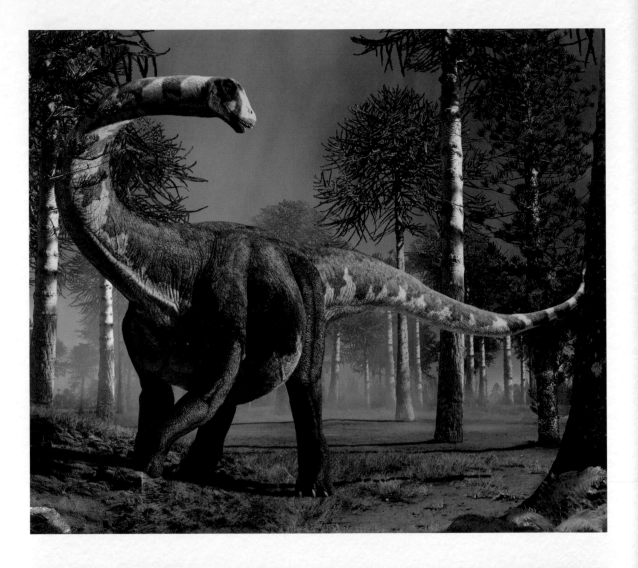

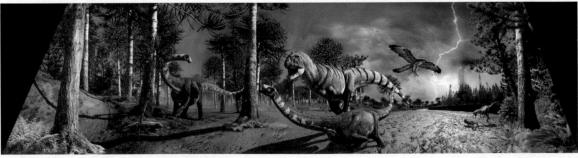

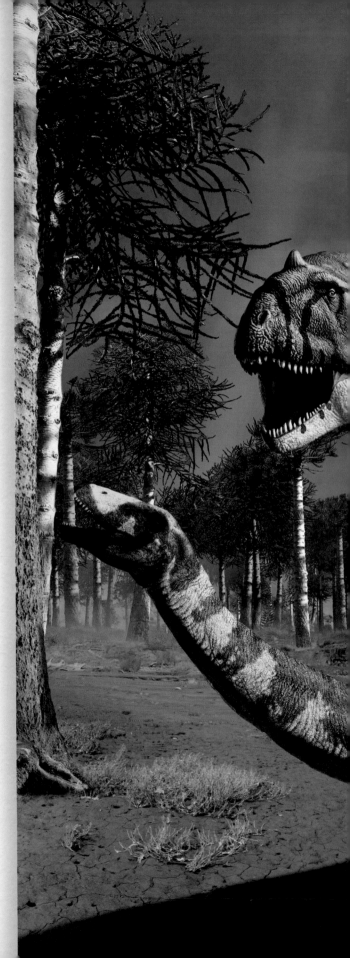

Madagascar Cretaceous Scene. Photographic composite (19 x 5m). Commission: Royal Ontario Museum. 2012.
A mural for the Ultimate Dinosaurs: Giants From Gondwana exhibit, this image features *Simosuchus*, *Rapetosaurus*,
Majungasaurus, *Rahonavis*, *Masiakasaurus*, and *Beelzebufo* (toad).
Courtesy of the Royal Ontario Museum, © ROM, Toronto, Ontario, Canada.

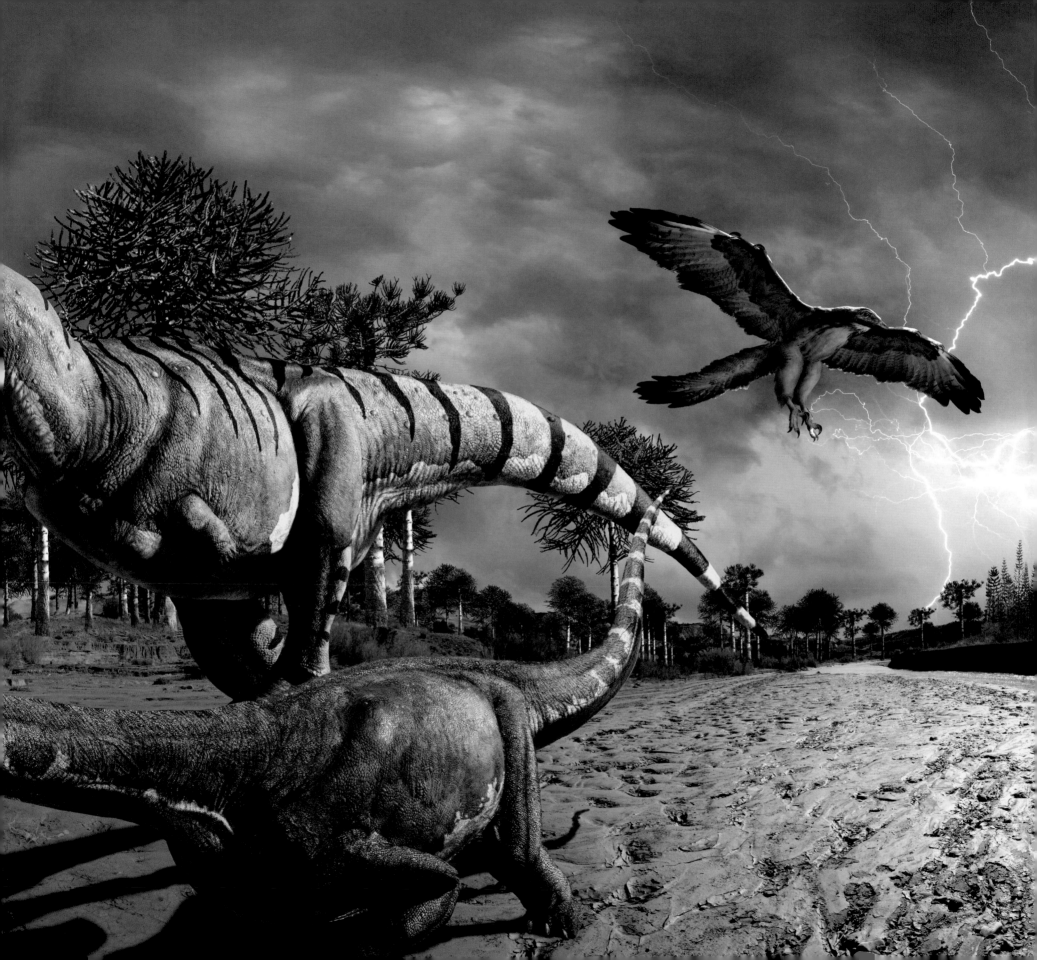

AN ODD PERSPECTIVE

Have you ever gazed into a spherical mirror at the distorted reflection of the surroundings? That was the idea behind this piece; it's what a bead of mercury would reflect, were it sitting on the tip of the stem of a horsetail plant in the Jurassic landscape that generated the Morrison Formation. Back in April 2013, while attending the Royal Tyrrell Museum's hosting of the sixth annual Fossil Preparation and Collections Symposium, I was chatting with Dr. Dave Hone about paleoart subjects while touring the museum's exhibits. He suggested that it would be neat to do another depiction of massive sauropods such as *Apatosaurus* taking the easy route to feeding by using their bulk to tip over trees instead of rearing up to feed on upper branches. John Sibbick has done a wonderful rendition of a herd of *Apatosaurus* stampeding destructively through an araucarian forest, viewed from an escarpment above. I wanted to do something very different, so spurred by a conversation with Dr. Hone about unusual artwork formats, I thought that portraying the animals from below would help to effectively convey how their massive size would facilitate tree felling, much as it does with African elephants today. Of course, the problem with sauropods is that they are so very long, so a wide-angle depiction is almost a necessity to portray them from close range. So I carried the resulting spherical distortion just a little bit farther and abandoned any attachment to an angular painting surface.

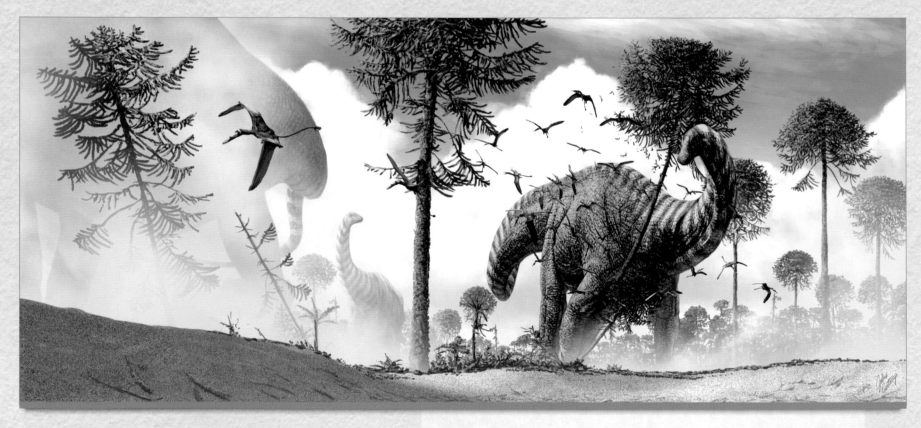

***Apatosaurus* Tree Tipping.** Digital painting. 2013.
Based on discussions with Dr. David Hone, who suggested depicting *Apatosaurus* pushing down trees with their massive torsos, like elephants do today.

"There are plenty of illustrations of sauropods reaching up into trees with their long necks, and some are even shown rearing onto two legs to reach higher branches, but another option may have been available to them. Just like elephants today, the sheer mass of some sauropods might have been more than enough to bend over or break smaller trees, making the higher branches more accessible. Here the large *Apatosaurus* from North America uses its bulk to bend and splinter a tree, bringing down the food to a more manageable level. In the process, small pterosaurs are sent scattering from their resting places, though the effect of the passing giants might well have also thrown plenty of insects into a similar response and made for a superb foraging opportunity for the flying reptiles as well as the huge dinosaurs."
Dr. Dave Hone, Queen Mary, University of London

The most challenging part of setting up a scene like this is ensuring the appropriate amount of distortion. Dinosaurs such as *Apatosaurus* already possessed a very nonlinear outline. Depicting them under conditions photographically analogous to those that generate humorous big-nosed dog portraits required quite a few rough drafts before settling on one that looked right and that also worked compositionally to convey great weight (*Fig. 1*). Although the scene is equally viewable from any angle, placing the nearest foot at the bottom and the sun near the top in the default configuration was intended to instill a sense of gravity. To establish the distortion properly, I marked the zenith position with a dot, lined up all vertical objects with lines connecting their bases to the zenith, and kept in mind that all horizontal lines are represented as curves (e.g. the horizon line is a ring).

The environmental setting of the scene is near the margin of an *Araucaria*-dominated woodland (visible as an increasing density of trees to the right) in a seasonally arid open environment rich in ferns (opening up to the left). It is not far from a river, with locally abundant sphenophytes, and the fern field is dotted with bennettites in the background.

Once the sky and clouds were painted to set up the general brilliance and color temperature of the scene, the second biggest challenge was determining the proper placement of light and shadow. Not only are objects distorted, but so are beams of light. However, once the position of the sun is

established, the beams can be represented as paths similar to the lines of magnetic force around the pole of a magnet (arrows in *Fig. 2*). To aid in quickly and conveniently determining which are the illuminated and shaded sides of objects, I also created a series of spheres at regularly distributed intervals over the painting, each rendered in the phase that it would show based on its position (*Fig. 2*). I could turn this phase layer on and off as needed for reference.

At this point, I blocked in the initial base coat of the subject

elements, starting dark. The hue does not matter much at this point because I can always digitally alter it later. The pattern of scales was then applied as a mid-tone beige layer, with sunlit sides placed according to the pattern of illumination indicated by the paths of sunbeams and the phase diagram. Fossilized impressions of integument indicate that except for the armored scutes of certain species, sauropod scales were especially small compared to the size of the animal, so there were a great many scales to emplace. This part usually takes the

Fig 1.

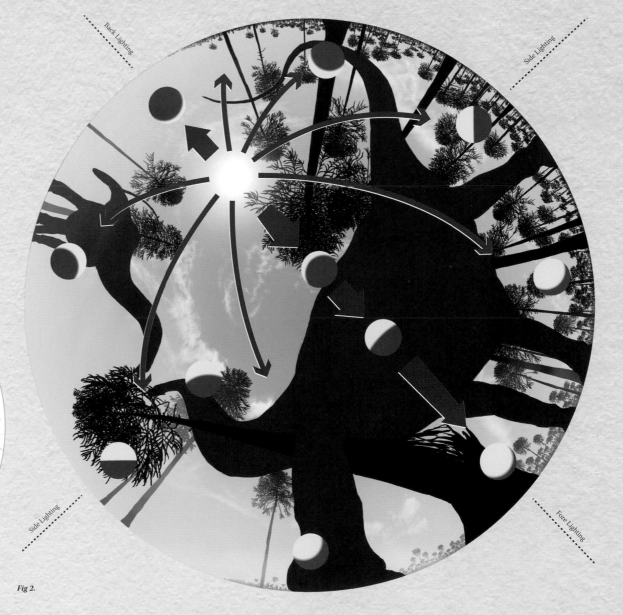

Fig 2.

longest to accomplish when painting an animal. Of course, it's not always necessary to paint all the scales, because an image looks most realistic and harmonious when the animals blend with the rest of their environment in terms of their level of detail and sharpness of features.

As a general trend, the greater number of layers of application into which the highlights and shadows are distributed, the more realistic an image tends to look, so I applied about four layers of highlights progressively to generate the animal's scales, in ever smaller zones representing increasingly more intense highlights. Similarly for the shadows, I apply them over the initial layer of scales in several layers, and I also selectively apply a mask layer with a brush to the base scale layer to partially or completely remove scales from visibility in the deepest zones of shade. The aim was to generate a relatively tough hide, using photographs of elephants for reference, the small scales of the dinosaur embedded in a matrix that itself has been worked over years into a pattern of folds due to repeated compression and extension in a set regime of movement.

Just prior to adding these animal integumentary details, I decided to widen the view from one that ended at the level of the horizon to one that incorporated some foreground

soil as well (*Fig. 3*). The under painting of the soil consisted of first mesh warping a blotchy two-toned cloud rendering into a narrow ring shape, whose patchiness became more compressed toward the inner (horizon representing) margin of the ring, and then applying a similarly mesh-warped photograph of soil using a darkening blending mode, and finally preferentially lightening the side opposite the sun and darkening the side that would be effectively backlit by the sun. To this latter sunward side, I then painted narrow rims of highlights to represent backlit small-scale relief as well as plant litter, and I then subjected the entire semi-photographic underpainting to a brushing of paint of appropriate hue and value, using the photographic layer for reference, followed by the addition of more plant litter.

Once most of the scene was finished, I colorized the *Apatosaurus*. Although I often choose relatively showy markings for dinosaurs when their patterns are not known from research (they are related to birds, after all), I added only subtle hues to these large sauropods. We rarely see very large animals today in similar niches that display gaudy color patterns. Markings are less needed for crypsis when large size (and potentially gregariousness) becomes a means of escape

from predation, and it is uncertain to what extent color vision was present in non-avian dinosaurs anyway.

Finally, I added several layers of foreground plants, multiplying some groups of painted plants to populate the scene, and applied the highlights to the trees, relying heavily on the phase diagrams that I had established earlier for direction of illumination. Placing shadows on the ground is not straightforward under the amount of distortion present in this image. Shadows of tree trunks are not straight, but rather appear to describe arcs on the ground as the perspective shifts gradually around the panorama. The last task was to enrich the species diversity a bit, by adding a pair of *Stegosaurus* to the fern prairie, a *Ceratosaurus* to the forest margin, and a flock of *Harpactognathus* pterosaurs that have been driven from their perch atop an *Araucaria* tree that is being toppled by a third *Apatosaurus* in the distance. Another difference between digital and traditional media became apparent while painting the *Stegosaurus* (at about the 11 o'clock position) and the *Ceratosaurus* (at 2:30): the digital display is less capable of rotation than is a canvas, introducing a bit of a challenge in painting some of the animals on their sides or completely inverted.

Fig 3.

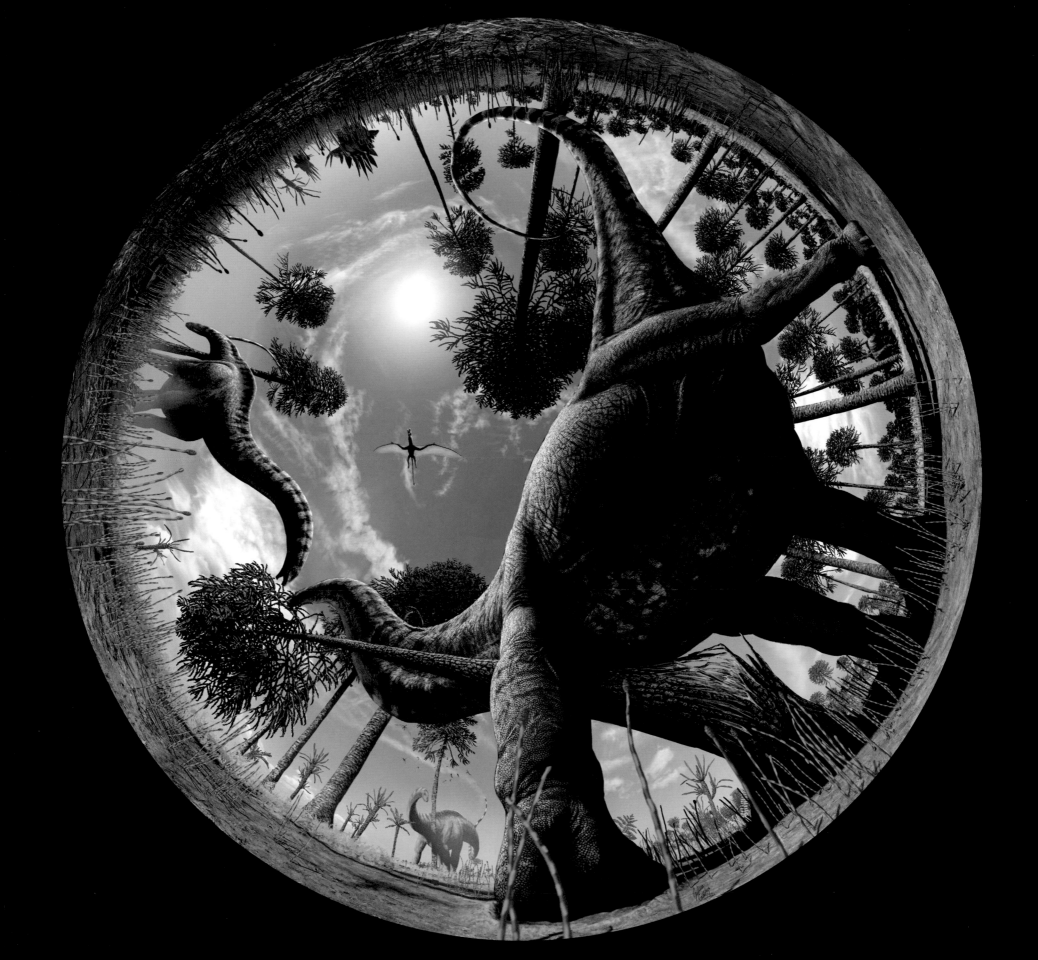

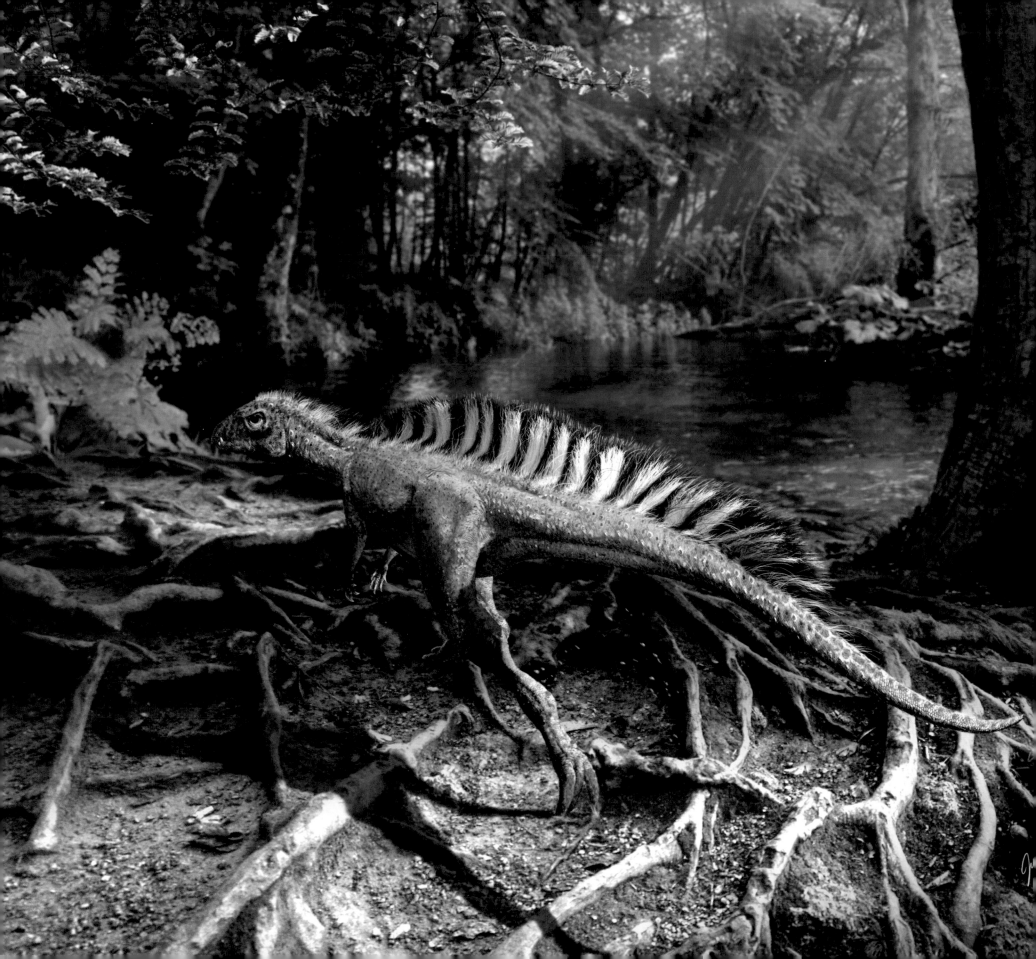

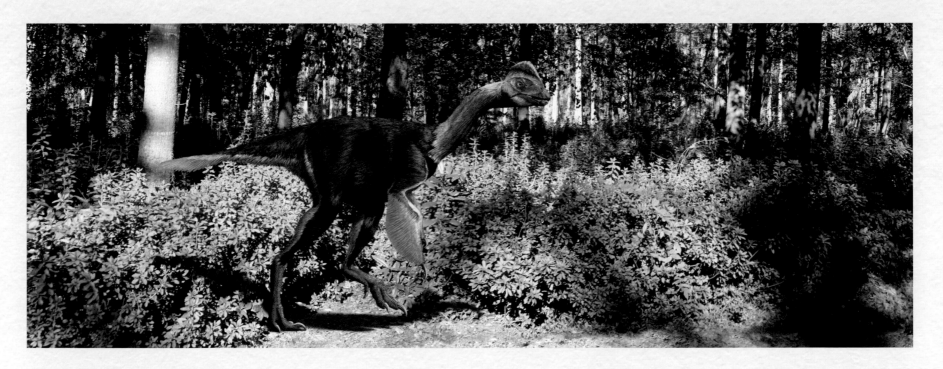

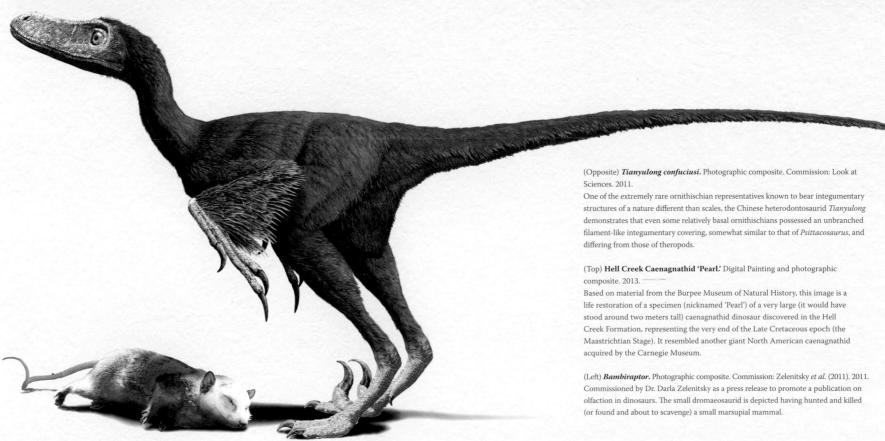

(Opposite) *Tianyulong confuciusi.* Photographic composite. Commission: Look at Sciences. 2011.
One of the extremely rare ornithischian representatives known to bear integumentary structures of a nature different than scales, the Chinese heterodontosaurid *Tianyulong* demonstrates that even some relatively basal ornithischians possessed an unbranched filament-like integumentary covering, somewhat similar to that of *Psittacosaurus*, and differing from those of theropods.

(Top) **Hell Creek Caenagnathid 'Pearl.'** Digital Painting and photographic composite. 2013.
Based on material from the Burpee Museum of Natural History, this image is a life restoration of a specimen (nicknamed 'Pearl') of a very large (it would have stood around two meters tall) caenagnathid dinosaur discovered in the Hell Creek Formation, representing the very end of the Late Cretaceous epoch (the Maastrichtian Stage). It resembled another giant North American caenagnathid acquired by the Carnegie Museum.

(Left) **Bambiraptor.** Photographic composite. Commission: Zelenitsky *et al.* (2011). 2011.
Commissioned by Dr. Darla Zelenitsky as a press release to promote a publication on olfaction in dinosaurs. The small dromaeosaurid is depicted having hunted and killed (or found and about to scavenge) a small marsupial mammal.

imilar in build (and maybe lifestyle) to modern flightless birds such as the ostrich and emu, *Ornithomimus* appears built for speed, with long limbs and toes, a short torso, and hollow bones, to save weight. Its toothless beak-like jaws hint at an omnivorous or even herbivorous diet. It has also come to light very recently (2012) that *Ornithomimus* is the first known feathered dinosaur from North America. Two adult specimens were discovered with raised nodules on their lower arms, similar to the quill knobs that are used to secure feathers on bird wings. A juvenile was also discovered bearing traces of structures similar to down around 5cm (2") long.

Researchers studying the specimens concluded that *Ornithomimus* was covered in a down-like coat all its life, but the wing-like structures only developed in adults, where they were used much like an ostrich's flightless wings, in mating displays and intra-species communication.

The fragmentary nature of *Ornithomimus* remains and its close similarity to its relatives *Struthiomimus* and *Dromiceiomimus* (also both from Canada and northern USA, and possibly contemporaneous with *Ornithomimus*) has made classifying these animals difficult, some researchers including one or both of the latter two genera in the former.

This image restores the first feathered dinosaurs found in the Western Hemisphere; the image was shown as a press release, and the individual dinosaurs (minus background) were published in the paper in *Science* magazine by Zelenitsky *et al.* (2012).

Ornithomimus. Digital drawing and painting. Commission: Royal Tyrrell Museum. 2010 (grayscale) and 2012 (color). Image courtesy of the Royal Tyrrell Museum of Palaeontology, Drumheller, Alberta, Canada.

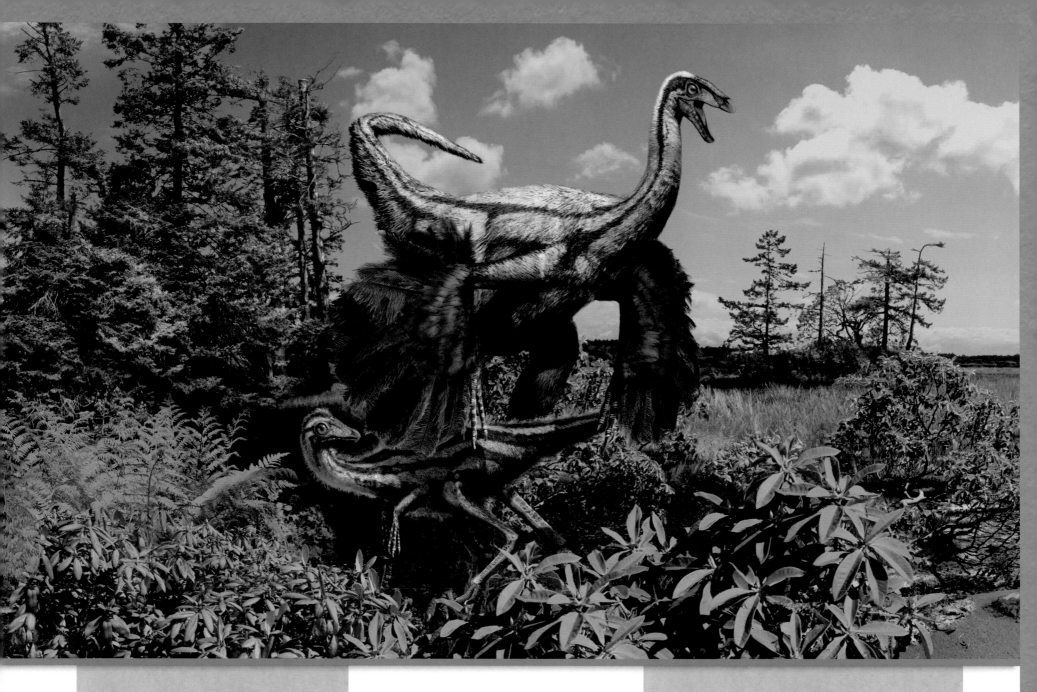

"This illustration is of the first known feathered dinosaurs from the Western Hemisphere, a depiction based on research of three ornithomimid specimens found in the Cretaceous rocks of Alberta. The specimens revealed that the plumage of ornithomimids changed during growth, where juveniles were covered in downy feathers and wing-like structures developed only later in life. These primordial wings of adult ornithomimids may have been used for purposes such as display or brooding. The opportunity to work on these specimens discovered by an amateur paleontologist has been tremendously exciting. While I was able to bring these specimens to science through research, Julius was bringing them to life through art."
Dr. Darla Zelenitsky, Assistant Professor, University of Calgary

Ornithomimus edmontonicus. Photographic composite. Commission: Dr. Darla Zelenitsky, University of Calgary. 2012.

"During the excavation of the first specimen in 2008, I was puzzled by black markings left on the flat surface of a block I had just extracted. Wondering if they could be some strange plant material that I had never seen before, I asked the field technicians if they had ever seen anything like that before, to which they answered no. I then joked, 'You know, if we were in China, we'd call those feather impressions!' To which we all laughed. Still, I couldn't help wondering if those black markings could be the real deal, so I decided to save the block rather than toss it. After showing my discovery to colleagues at the museum, we ruled out all mundane possibilities and decided to prepare the specimen right away, just to be sure. The full realization hit me when we started finding those black impressions all along the back of the animal: we had discovered the first feathered ornithomimid in the world!"
Dr. Francois Therrien, Curator of Dinosaur Palaeoecology, Royal Tyrrell Museum

BELOW THE SURFACE

Deciding what subjects go into a scene is generally pretty straightforward. Usually, the client already has a list of the most important components to show, as well as an idea of their interaction, if any. In addition to this, I scan the available literature to gain further understanding of the environment. In the case of the *Rhamphorhynchus* image, Dr. Dave Hone wished to depict the hypothesized feeding mode of the pterosaur on the squid whose remains were preserved in its gut. He proposed a 'gleaning' feeding strategy, similar to modern skimmers (*Rhynchops* species), which fly low over water and snag surface-swimming fish in their long beaks. The setting would have been warm Jurassic lagoons in a European archipelago, so I kept that in mind when establishing the lighting, attempting to convey a warm and sunny environment in shallow water.

Next came planning the composition, which was a bit more challenging. Although the subject matter of the piece was relatively simple – one pterosaur hunting one squid with a simple watery background – the biphasic nature of the scene presented a complication: how to clearly show both animals when they are separated by the visually distorting interface between water and air. In this case, I wanted the image to look the natural way a bystander would have seen it instead of splitting the image with a water-line (a technique that is very useful for illustrations that enumerate the flora and fauna of a riparian or wetland environment, but that looks inherently unnatural and a bit diagrammatic). So it came down to choosing whether to illustrate the image from the pterosaur's point of view or from the squid's.

My first draft utilized an atmospheric viewpoint, from low over the water (*Fig. 1*), similar to photos of skimmers feeding. This composition would be well suited to a warm late-afternoon sun, perhaps during that visually stunning part of the day that artists and photographers aptly refer to as "the golden hour." I love the warm hues that transmission of the sun's rays through the thick atmosphere near the horizon lends to scenes, as well as the long and visually interesting shadows generated, and a lot of my work is set in such conditions. However, the distorting nature of the water surface – especially when disturbed by waves or ripples, and especially under low-angle sunlight – makes this angle less practical for easy identification of the squid, and in this case it was imperative that the identity

of the meal be clear. An alternative atmospheric viewing angle would be a 'bird's-eye view', from above, but although this angle minimizes refractive distortions caused by the water, the squid necessarily remains a proportionally small and therefore ambiguous member of the scene.

So I abandoned the aerial view, and opted for the aquatic alternative (*Fig. 2*). Placing the squid closer to the viewer nicely solved the problem of the small cephalopod becoming lost in the distance. I also cranked down the effective focal length of the imaginary camera lens through which we're observing the scene, giving it a wide-angle look to preserve the large angular size of the nearby squid while fitting the full wingspan of the *Rhamphorhynchus* into the frame. This meant that the size of the pterosaur's head needed to be exaggerated, just like a dog's nose looks ridiculously large for their face in close-up wide-angle shots.

Water distortion is still potentially an issue for a scene viewed from below the surface. Objects above the water may be distorted both spatially and chromatically, and although this may make for an artistically interesting image, it can obscure aerial subjects. However, if we imagine relatively tranquil conditions, with few waves, and with the pterosaur approaching quickly from the distance, trailing the disturbance created by its mandible slicing the water, then distortions are minimized. This viewing angle allowed both subjects to be nearly equally prominent, and timing it a split second before squid capture put the focus on the strategy of the feeding method, making it clear that the hapless squid was about to become skewered on a fast-moving double row of procumbent needle-like teeth that were ready to be immediately clamped shut against a second double row to secure the otherwise slippery meal.

At this point I began painting the background (*Fig. 3*). As a rule, I block in the background first and work on the focal subject later, because the nature of the light that plays on the subject is much more reliably determined once I establish the locations of the complex reflective, refractive, and occulting surfaces of the environment that generate sources of illumination and shadow. Understanding the physics of light, especially the processes of reflection, refraction, diffraction, scattering, interference, black body radiation, and absorbance spectra of materials, will take an artist a large proportion of the way to a successful painting. So, although I studied my own

underwater snorkeling photographs and did an online image search for similar conditions in order to accurately depict the view up through the water's surface, a thorough understanding of optics would allow one to work out from basic principles most of the phenomena that manifest themselves in photographs. For example, notice that I have depicted a sharp, roughly circular boundary above which aerial subjects are visible and below which only the blues and greens of the submarine world are visible, and that the clouds appear to be increasingly distorted or squashed as they approach it. This

Fig 1

Fig 2

is a manifestation of 'Snell's window', the illusion caused by refraction or bending of light crossing the water-air interface in which the entire 180 degrees of the visible world above the water is compressed into a 96 degrees-wide cone. The sharp boundary represents the compressed horizon line of the aerial world, and any line of sight below this line (looking about 43 degrees up from the horizontal) sees light that is subject to the phenomenon of 'total internal reflection', meaning that all of it is reflected from the water surface, and none of it exits into the world above the waves. This is what gives the underside of waves that highly reflective mercuric look. Notice also that the edge of Snell's window in the painting is not smoothly circular, but deeply lobed. This is caused by small waves locally raising the angle of the surface above and below the critical angle as the surface bobs up and down. Thus, it is the dynamic interplay of reflection and refraction of light as it crosses the interface between different types of materials at changing angles that allows us to see ripples and waves either on the surface of a pond or beneath the waves of the ocean. An accurate underwater painting must accommodate all phenomena governed by Snell's Law.

To give the scene a hot tropical feel, I initially chose to place the sun within the frame of the image, mostly blocked out by the pterosaur's wing, with a bit poking out for dramatic glare effects. The backlighting would also allow a portrayal of the thinness of the wing membrane, by rendering diffuse light transmitted through it. Eventually, however, I felt that its intensity might be a little distracting to the action in the scene, and I moved the sun just barely off-stage, with the halo of light scattering off the humidity in the atmosphere near the

sun's position, communicating its proximity and preserving the warm feel (*Fig. 4*). At the same time, the removal of the sun left the sky a little too uninteresting, so I decided to add some growing cumulus clouds to either side, which then also served to help frame the image, much like strategically placed tree trunks, rocks, and bushes can do in landscape paintings.

As I move along, adding more of the environmental elements, I find that I often have to tweak some components that I added earlier for better harmony or increased accuracy. For example, the ocean looked too green once the sky and clouds were in place, so I altered the hue to something more like a turquoise marine lagoon and less like an algae-rich stagnant freshwater body. This is one area where working with digital media is very beneficial. If this were a watercolor painting, it would be a lot more difficult to alter the overall hue of the piece once some details were in place. One might argue that work with traditional media forces an artist to exert more effort in planning, but digital media do allow for more flexibility that can be invaluable when working with clients who require alterations part of the way through, due, for example, to new results from quickly developing research.

To paint the main subject of the artwork, I usually begin with a dark base coat (or a medium-tones one that I then digitally darken), one that will serve as the basis for areas of deep shade in the subject, with some saturation to avoid a dead look to the shadows. I then add successive layers of ever-higher value, establishing first the overall distribution of light and shadow before adding details. In digital media, at this stage I usually set a relatively high chromatic variation in the brush (with hue varying by as much as thirty percent and saturation up to fifteen

percent between applications of the brush) in order to generate a somewhat mottled appearance. I do this to avoid the perfectly smooth 'plasticy' look that can result from a completely monochromatic application of pigment, which is a trap even easier to fall into with digital media than traditional types.

An important thing to keep in mind during establishment of the initial distribution of highlights and shadows is that, unless we are in deep space, there is rarely only a single light source illuminating a subject, and the color, intensity, and position of the secondary light sources is strongly environment-dependent. Some of the most impressive paintings and photographs make the best use of secondary light sources. In the *Rhamphorhynchus* piece, the primary light source – full sunlight – is strongly dominant in the above-water environment, but we still see a little bit of illumination on its belly (otherwise in full shade from direct sunlight) from light that has been reflected from the surface of the water. The effect of a strong secondary reflected light source from the opposite direction to the primary light source is often a line of darker shadow just past where the shadow begins (the terminator). This is just visible on the belly of the *Rhamphorhynchus* at this stage, and I further intensify and clarify these secondarily illuminated surfaces in the application of subsequent layers of detail paint (*Fig. 5*).

Following the application of the base coats of shadow and preliminary highlights, I add fine highlight details. In the case of *Rhamphorhynchus*, this includes the pycnofibers (the hair-like integumentary covering that has been observed in some exceptionally well-preserved pterosaurs, such as *Sordes*), which I laid down in two successive layers of highlights to give

Fig 3

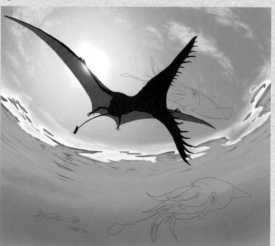

Fig 4

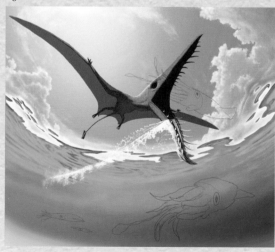

Fig 5

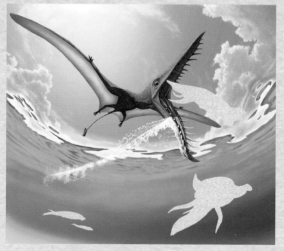

the integument depth and a feeling of complexity of texture. The upper layer is applied using a more intense blending mode, which causes highlights to be added disproportionately more intensely on already brighter surfaces than on darker ones, and effectively enhances the range of tones. I then apply the deeper local shadows that are cast by small features such as bony ridges or fingers or teeth, bearing in mind that not all shadows are created equal; the value of a shadow is darker in deeper recesses, such as the corner of the mouth or under the exposed tongue or where limbs meet torso.

It is important to firmly integrate the subject with its environment, and I don't mean merely by color matching or compositional choices. Whenever possible, it is beneficial to highlight the point(s) at which the subject is physically planted within the scene, as it helps the brain to judge scale and relative distances, immersing the viewer more effectively in the scene. In the *Rhamphorhynchus* image, this is accomplished by the wake of the animal's passage, made evident by the trail of disturbed water that its mandible generates. The position and orientation of the wake helps to establish motion and inform us about which parts of the animal are above water and which part below (only the lower half of the mandible) in an otherwise featureless intervening space, clear as the water is. In terrestrial scenes, sharp shadows cast on the ground play a similarly crucial role, as does interaction of animal subjects with vegetation and other landscape elements.

Here, the wake is delineated by a rooster-tail of water immediately behind the mandible and a trail of fine bubbles churned in at the trailing edge of the mandible and lingering for a greater distance behind it. Bubbles and disturbed water can be useful and dynamic indicators of recent motion, but one ought to exercise caution against their overuse. For example, bubbles should not be added to animals moving through water unless they are breaking the surface and are thereby able to mix beads of atmosphere into the water, or if they are air breathers and are in the act of exhaling under water, which may or may not be a characteristic behavior of species. Artists are also sometimes tempted to paint lines of motion in the water following a fast-moving animal to communicate the path that it has just traveled. This temptation should be resisted in realistic artwork, for we never see such lines in reality, aside from a faint blurring of the edges of the animal due to our own inability to completely resolve the position of quickly moving objects (or a more pronounced blur in longer photographic exposures). I sometimes incorporate motion blur into my artwork, to emphasize the rapid movement of a limb, for instance, but because motion blur destroys detail, I tend to use it only sparingly. Rather, I seek more creative yet still plausible indicators of motion, such as dust plumes or splashes in terrestrial environments, or disturbed mud on the sea floor.

The squid were painted following a similar overall sequence of techniques as the pterosaur. However, the greater translucency of the squid combined with their occupation of an aquatic environment with a lot of diffuse lighting would strongly limit the abundance of dark shadows, and this precluded the need for a dark initial base coat. The phenomenon of total internal reflection mentioned earlier results in a lot of scattered turquoise light from the side compared to the situation with the *Rhamphorhynchus*, so I added a pronounced turquoise edge to any squid surfaces that were not illuminated directly by the sun through Snell's window. Another illumination feature that I then added to the upper surface of both the squid and the sea floor was the reticulate pattern of highlights that results from the lens-like shape of waves focusing sunlight into points and lines, depending on wave shape.

Then it's on to adding the final details to the animals. This includes final tweaking of the anatomy (where again, the revision-friendly nature of digital media is useful). For example, the mandible needed to be less hooked to agree with the particular specimen associated with the squid remains.

Also, up to this point, the pterosaur has flown blind, as it is a general rule that I paint eyes nearly last. The blank, corpse-like stare of almost complete yet eyeless stages of many of my animal paintings frequently elicited disturbed shakes of the head from friends who were present during many of my painting sessions at a local café. Painting eyes does not bother me though; in fact, I leave them until the end because I especially enjoy painting them and wish to do so when as much of the surroundings and posture of the animal have been established, to give the eyes the most expressive quality. This is partly achieved by the specular highlights at an appropriate sunward location on the reflective cornea (or a lower intensity reflection of the sky under more overcast conditions) combined with a refractive focal point of color inside the eye on the iris at the radially opposite position as the corneal specular highlight. The iris highlight is roughly analogous to the point of light generated by a magnifying glass held under the sun, where the cornea and aqueous humor serve the role of the magnifying glass. Note that unlike for the *Rhamphorhynchus*, there is no point-like specular reflection of the sun on the squids' eyes. This is a common observation for submerged eyes and results from the fact that the twinkle in our eyes is due to the greater specular reflectivity of the thin film of water bathing the surface of our eyes than the tissue of the eyes themselves. When we're completely submerged in water, the reflectivity is due only to the surface properties of the tissues.

The final task was to apply color patterns to the *Rhamphorhynchus*, which I accomplished digitally by painting on layers of color through different blending modes (i.e., layers of pigment set to blend with or modify the layers beneath according to preset algorithms). For example, I can specify that only the hue of a color layer be transferred, or only its value, or that a color burn disproportionately more intensely into the existing shadows of the painting below than into areas of highlights. Colorizing is therefore one area where digital techniques are especially valuable and flexible. The choice of color is also not entirely arbitrary, even if it requires much speculation in cases where the putative colors have not been preserved in the form of structural or chemical traces on the surface of the fossil. In the effort to generate the most plausible color pattern (or at least one of a set of plausible options), it is best to consider living animals that occupy similar ecological niches to that of the prehistoric species in question. In the case of the *Rhamphorhynchus*, discussions with David Hone about its warm archipelago environment and the biology of the animal led to a decision to give it a relatively light color that would stave off overheating in an animal that exposed a large, blood-vessel-supplied part of its surface area to the hot sun. I also painted the underbelly white to function additionally in countershading, partly camouflaging the animal both from its prey and from larger marine predators against a bright sky.

Rhamphorhynchus **Gleaning Squid.** Digital painting. Commission: Dr. David Hone. 2013.
Based on new gut content research conducted in part by Dr. David Hone, this restoration shows *Rhamphorhynchus* feeding on squid in a plausible way, gleaning as do modern skimmers.

"Paleontologists long suspected that many pterosaurs ate fish – many lived in marine or aquatic systems and had jaws and/or teeth well suited to grab and hold slippery prey. This hypothesis has been confirmed with several specimens of the small Jurassic pterosaur *Rhamphorhynchus* being found with parts of, or even whole, fish preserved in their stomachs. However, this certainly doesn't rule out other prey and a recent find suggests that they also preyed on squid. A specimen of *Rhamphorhynchus* is preserved with a coprolite (fossilized feces) expelled from the back of the animal, the majority of which is composed of tiny hooks that have come from a marine cephalopod and most likely a squid. This is hardly a surprise; these would have been a plentiful food source and many living seabirds similarly will prey on these animals, but the delight in finding evidence for such an association (not least given that these soft-bodied animals preserve so rarely) is a wonderful addition to our knowledge of the ecology and behavior of these flying animals."
Dr. Dave Hone, Queen Mary, University of London

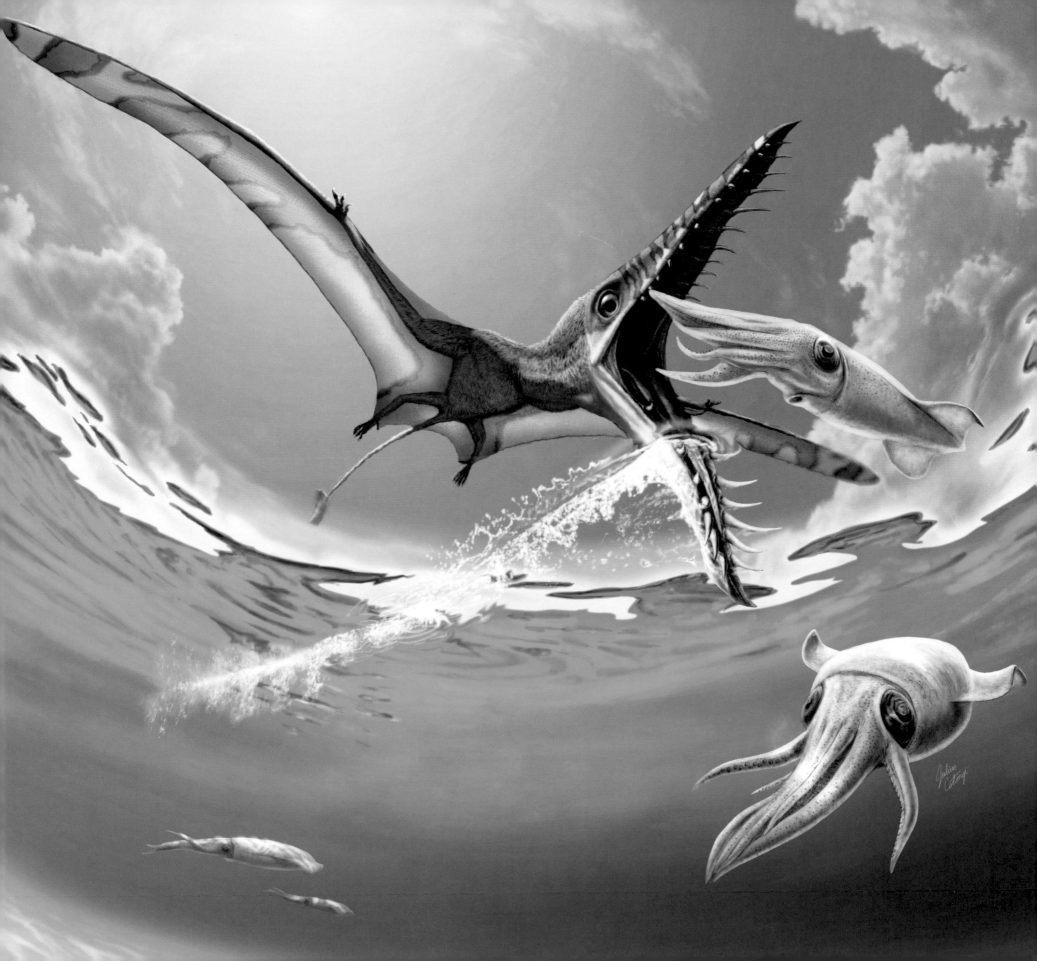

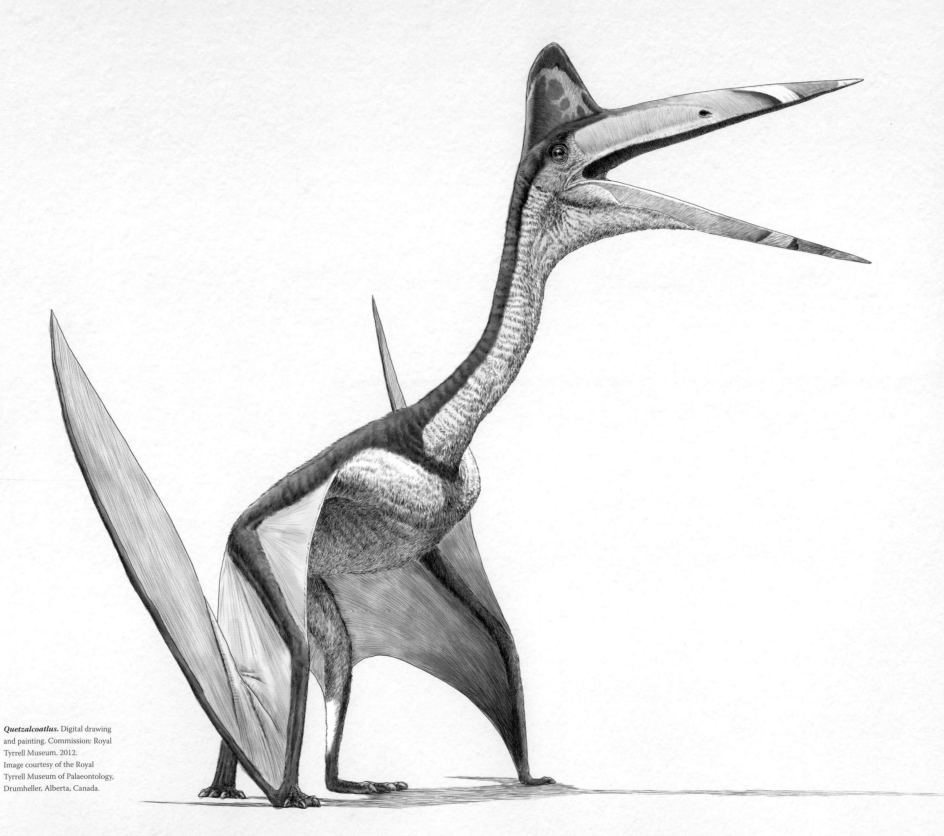

Quetzalcoatlus. Digital drawing and painting. Commission: Royal Tyrrell Museum. 2012. Image courtesy of the Royal Tyrrell Museum of Palaeontology, Drumheller, Alberta, Canada.

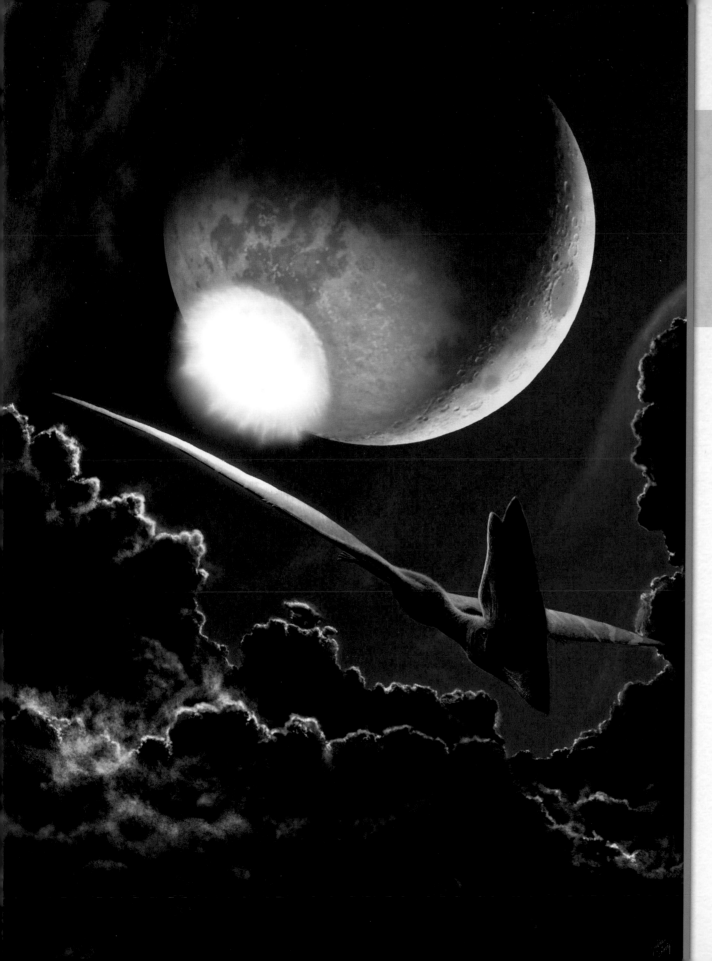

Tycho Crater Impact Event and *Thalassodromeus*. Digital painting. 2013.
The giant lunar crater called Tycho, which is nearly visible to the unaided eye and which is the most visually spectacular crater on the moon owing to its extensive ejecta rays, was created about 108 million years ago. This image explores what it may have looked like from Earth, from a point in the Cretaceous southern hemisphere, with the large pterosaur *Thalassodromeus* flying in the foreground.

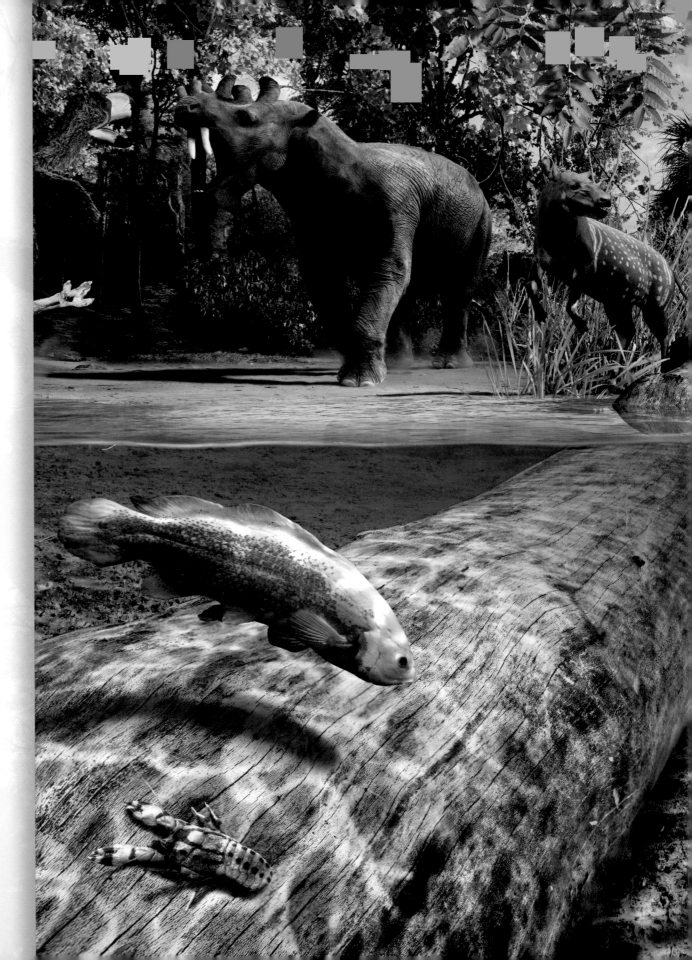

CENOZOIC

Eocene (Green River Formation) Split Aquatic/Terrestrial Scene. Photographic composite. Commission: Hall of Paleontology at the Houston Museum of Natural Science. 2012. Image illustrating the assemblage of flora and fauna from the Green River Formation, Utah. On land (left to right) *Diatryma*, *Uintatherium*, *Hyracotherium*, *Boavus*, *Borealosuchus*, and *Icaronycteris*, and underwater *Procambarus*, *Amia* (fish), a snapping turtle, *Atractosteus*, *Knightia*, a soft-shelled turtle, and *Heliobatis* (ray).

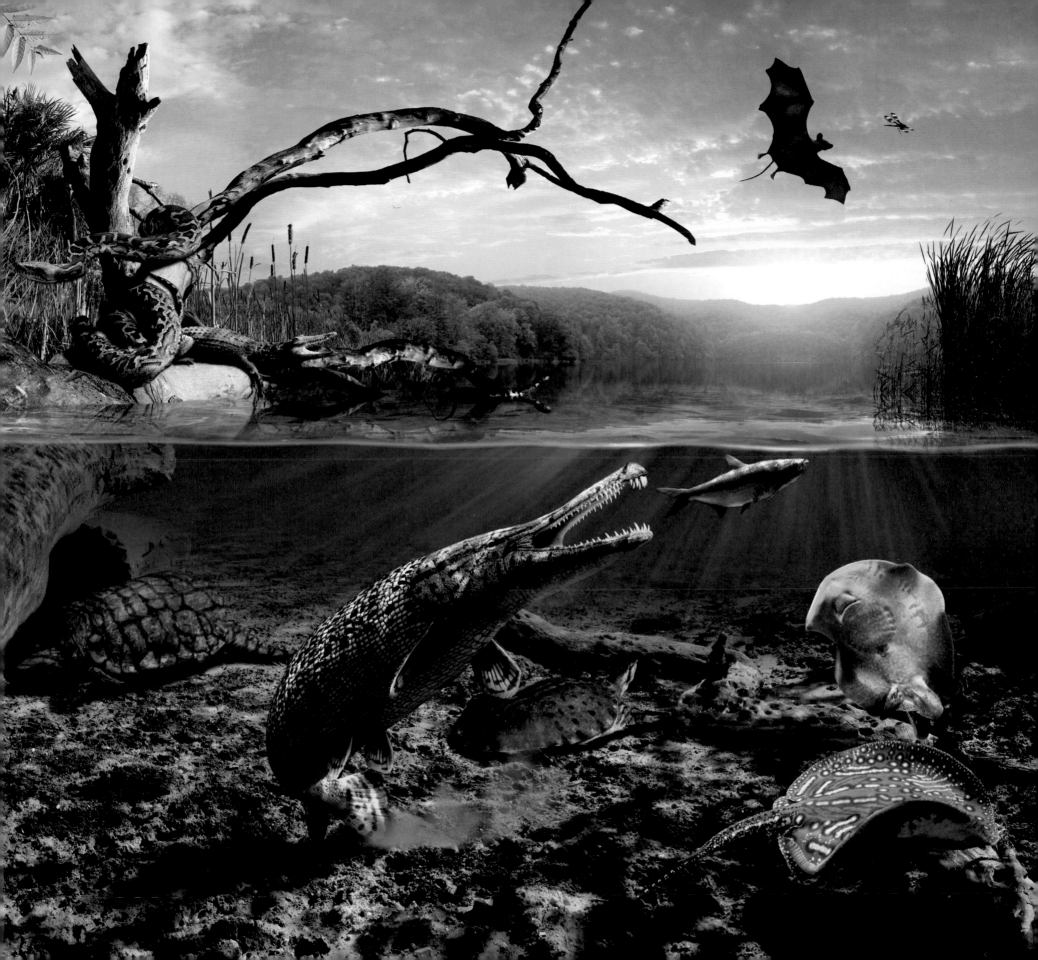

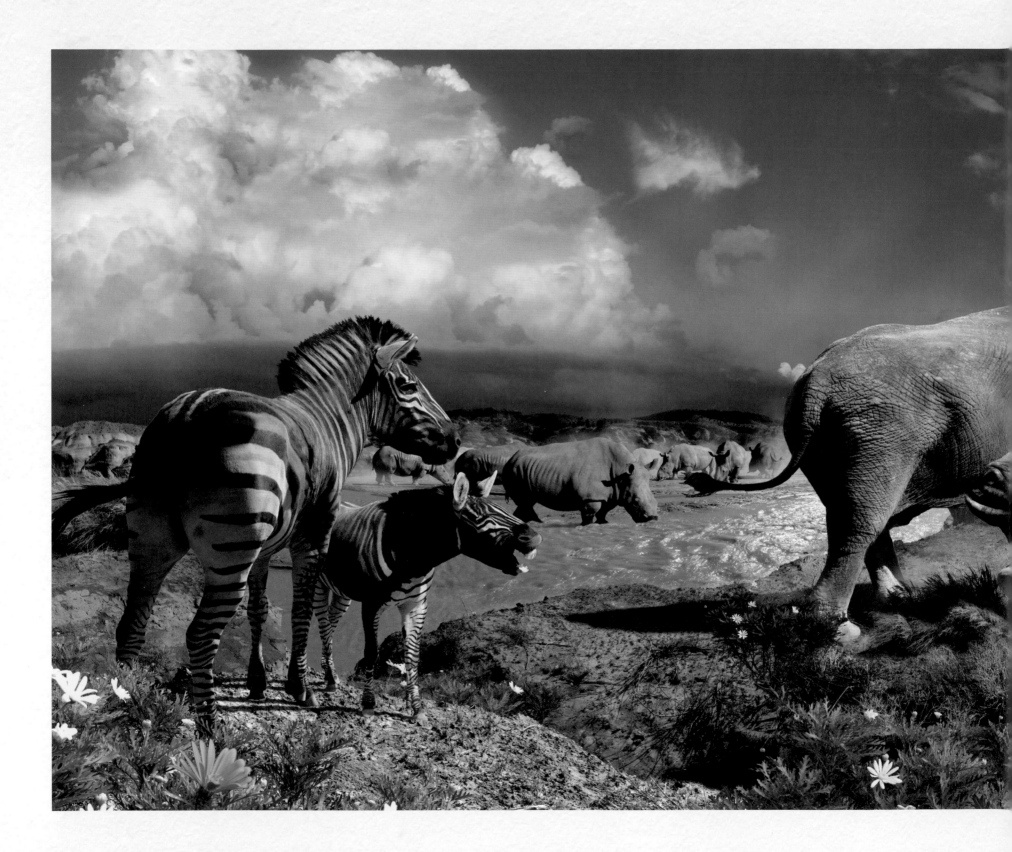

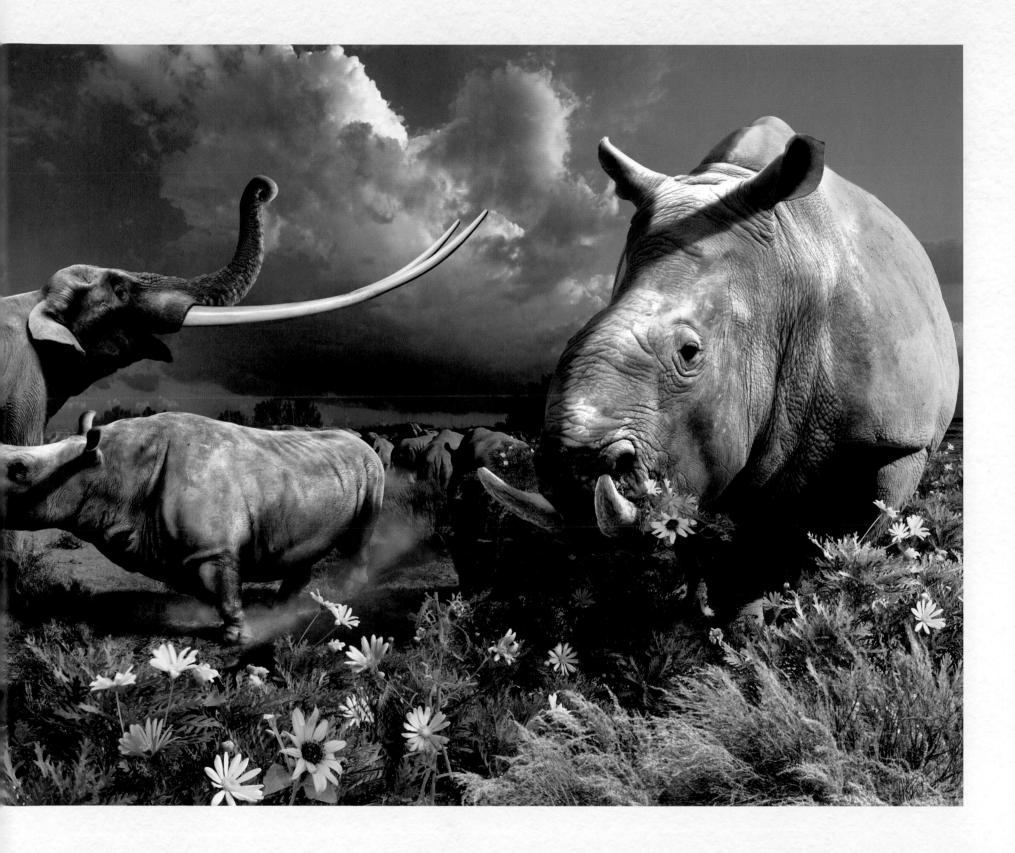

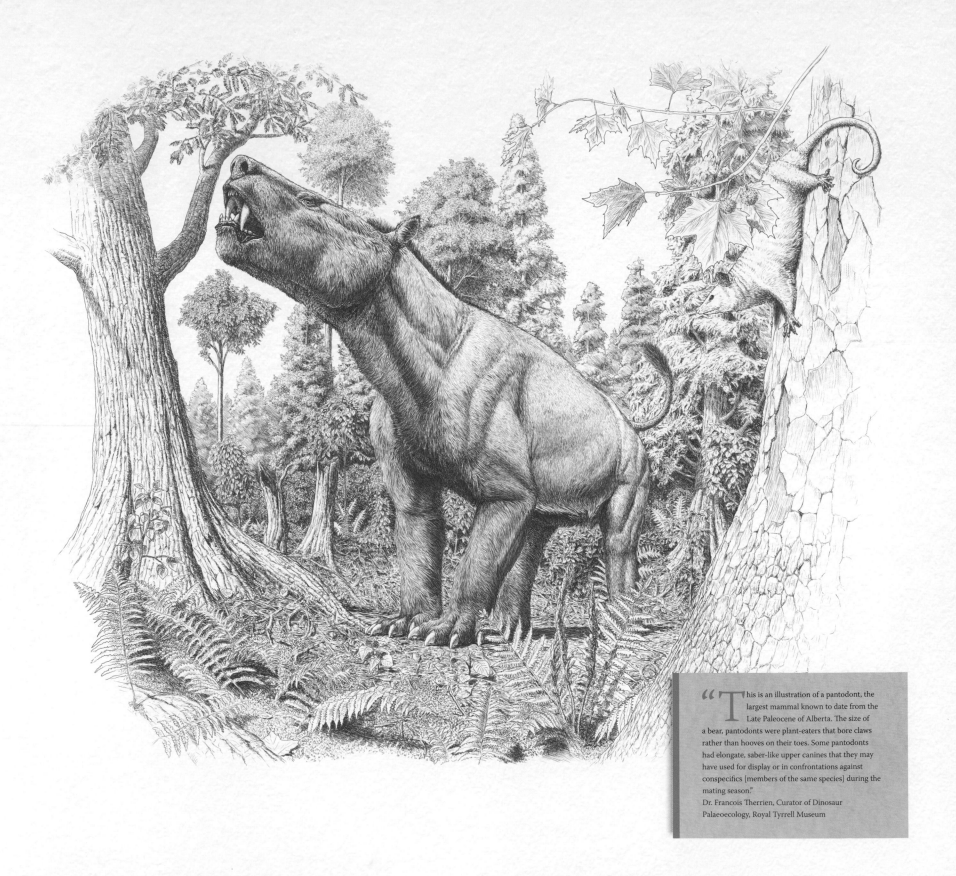

"This is an illustration of a pantodont, the largest mammal known to date from the Late Paleocene of Alberta. The size of a bear, pantodonts were plant-eaters that bore claws rather than hooves on their toes. Some pantodonts had elongate, saber-like upper canines that they may have used for display or in confrontations against conspecifics [members of the same species] during the mating season."

Dr. Francois Therrien, Curator of Dinosaur Palaeoecology, Royal Tyrrell Museum

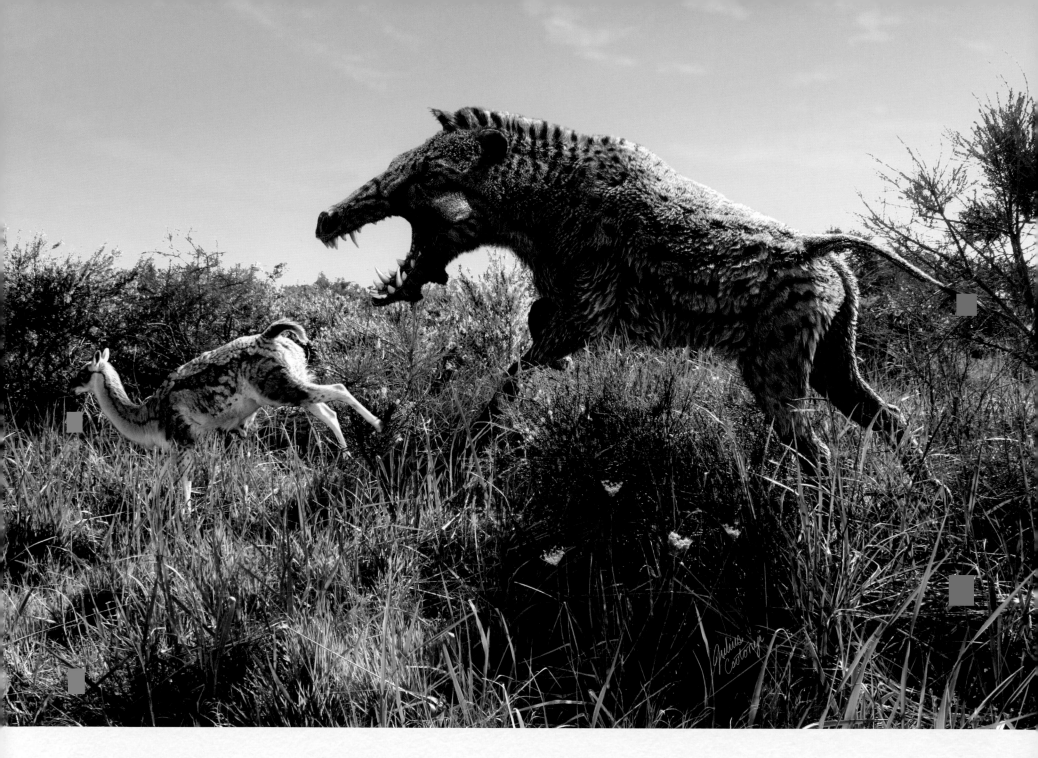

(Previous Spread) **Ungulates of Chinese Miocene.** Photographic composite. Commission: Hall of Paleontology at the Houston Museum of Natural Science. 2012.
Miocene assemblage of flora and fauna: *Hipparion*, *Mammut*, and *Chilotherium*.

(Left) **Red Deer Paleocene Scene.** Digital drawing. Commission: Alberta Fossil Trail signage project, Royal Tyrrell Museum. 2007.
One of nine drawings of prehistoric life featured on educational signs in paleontologically strategic locations in Alberta to promote tourism. This image features a pantodont and small marsupial in a *Joffrea/Metasequoia/Platanus* forest.

(Above) *Archaeotherium* **Pursuing** *Poebrotherium*. Photographic composite. 2008.
The Oligocene was a strange time, where the distant relatives of pigs (entelodonts) may have hunted dwarf early camelids.

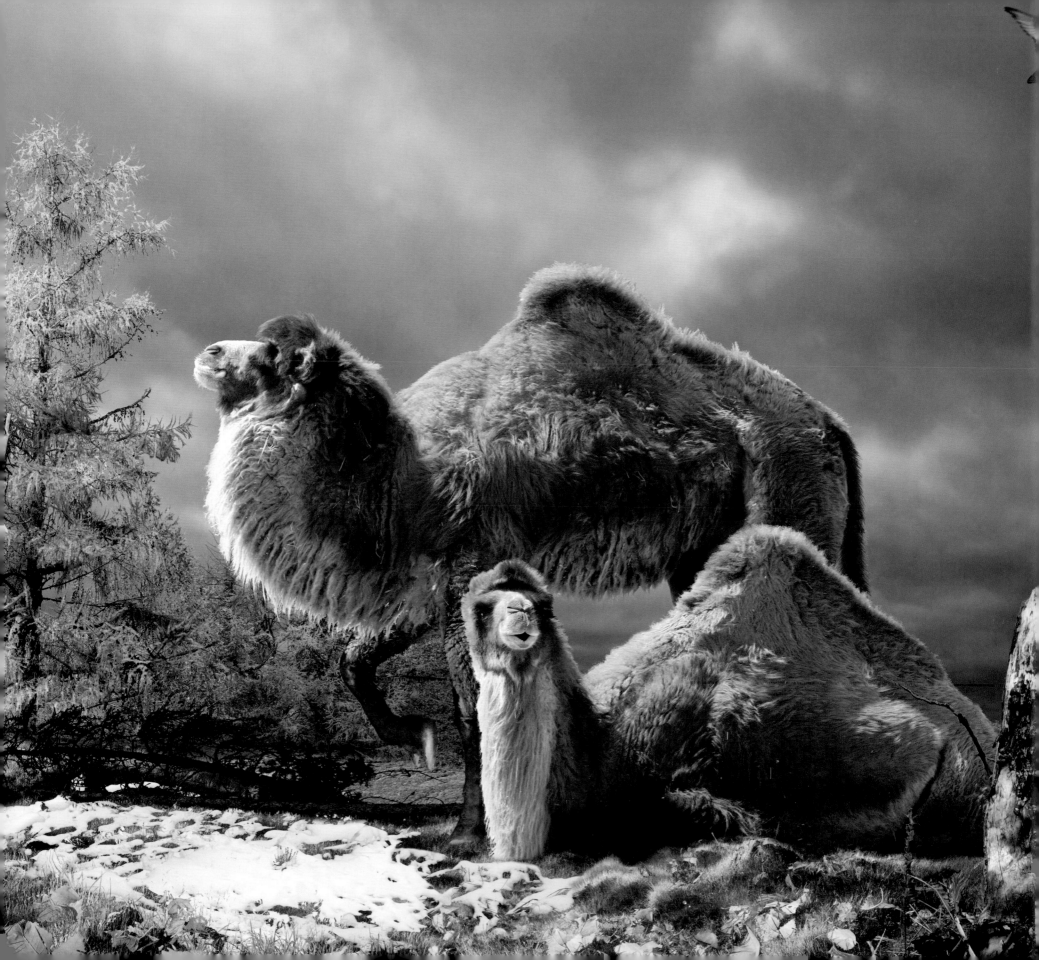

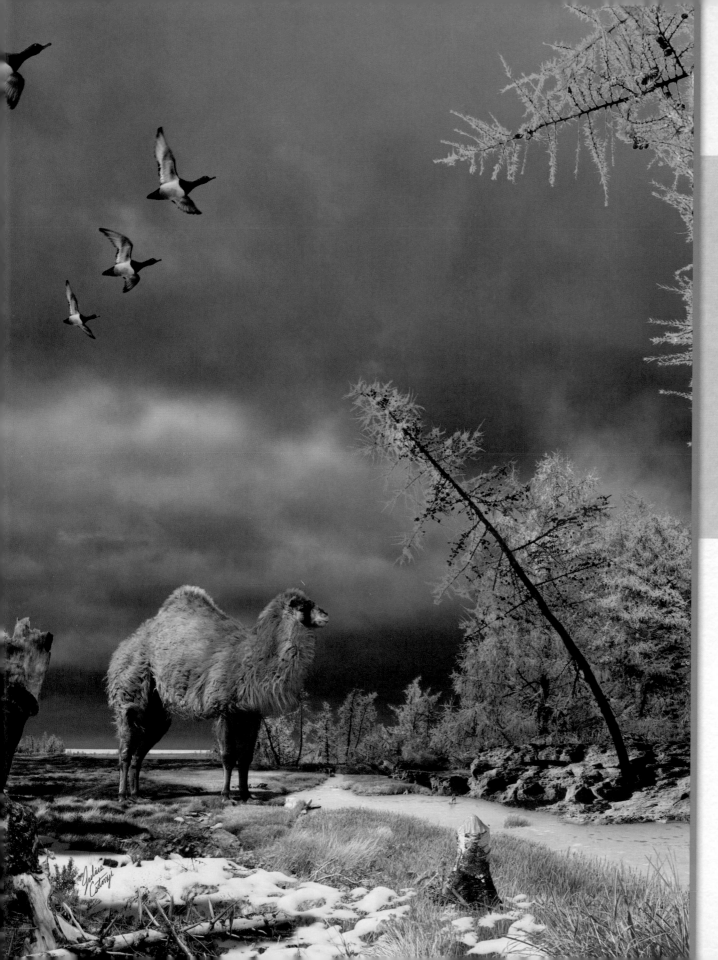

"I love this spectacular fall scene showing the high Arctic camel in a small clearing of a boreal-type habitat. The quality of the light is beautiful; low angled as required for this polar latitude (eighty degrees north). The camel shown in this restoration is actually known only from a fragmentary tibia. Based on other available fossil evidence it seems likely that the proportions of the high Arctic camel would have been similar to modern camels (though the high arctic camel seems to have been thirty percent larger). Given that both modern camels have a hump, it seems likely that their ancestors and near-relatives, like the high Arctic camel, would probably have had a hump (or two). I was decided to show the restoration with a one hump camel, because the collagen evidence showed greater similarities between the high Arctic camel and the one-humped dromedary (rather than the two-humped bactrian). Julius and I discussed some aspects of the appearance, such as the coat color (as a forest-dwelling animal, a light brown coat likely to blend well with the habitat might have been appropriate); Julius did a great job showing the details of the environment, too. The elements of the habitat are based on details I and the research team provided. Notice larch and birch trees, the sedges, the beaver cut stump, evidence of forest fire, and the ducks (scaups) – all are based on fossil evidence from the fossil record of west central Ellesmere Island. There is also a small stream transporting sediment to an ice-free ocean in the background. Julius is able to include these details, which represent important landscape processes in the Pliocene High Arctic."
Dr. Natalia Rybczynski, Adjunct Research Professor, Carlton University; Paleobiologist, Canadian Museum of Nature

Pliocene Arctic Camel. Photographic composite. Commission: Dr. Natalia Rybczynski, Canadian Museum of Nature. 2013. Based on giant camel remains from Ellesmere Island.

(Above) **Pantodont.** Digital drawing. Commission: Royal Tyrrell Museum. 2010.
Created for the Alberta Unearthed exhibit. Pantodonts such as this one were amongst the first large mammals to appear after the extinction of the dinosaurs, 66 million years ago.
Image courtesy of the Royal Tyrrell Museum of Palaeontology, Drumheller, Alberta, Canada.

(Right) ***Darwinius masillae.*** Digital painting. 2009.
One of the earliest primates, known from a complete and amazingly well-preserved specimen found at the famous fossil-bearing site of Messel, in Germany.

(Below) **Medicine Hat Holocene Scene.** Digital drawing. Commission: Alberta Fossil Trail signage project, Royal Tyrrell Museum. 2007.
One of nine drawings of prehistoric life featured on educational signs in paleontologically strategic locations in Alberta to promote tourism. This image depicts a family of *Mammuthus primigeneus*.

(Opposite) **Oligocene Landscape** by Julius Csotonyi and Alexandra Lefort. Digital painting. 2007.
The chaparral-like bushy landscape of the Early Oligocene, featuring the early saber-tooth *Hoplophoneus*.

(Next Spread) **Oligocene (White River Formation) Scene.** Photographic composite. Commission: Hall of Paleontology at the Houston Museum of Natural Science. 2012.
An image depicting a terrestrial Wyoming scene including (left to right) *Hyaenodon*, *Daphoenus* (in tree), *Mesohippus*, *Archaeotherium*, *Miniochoerus*, and *Dinictis*.

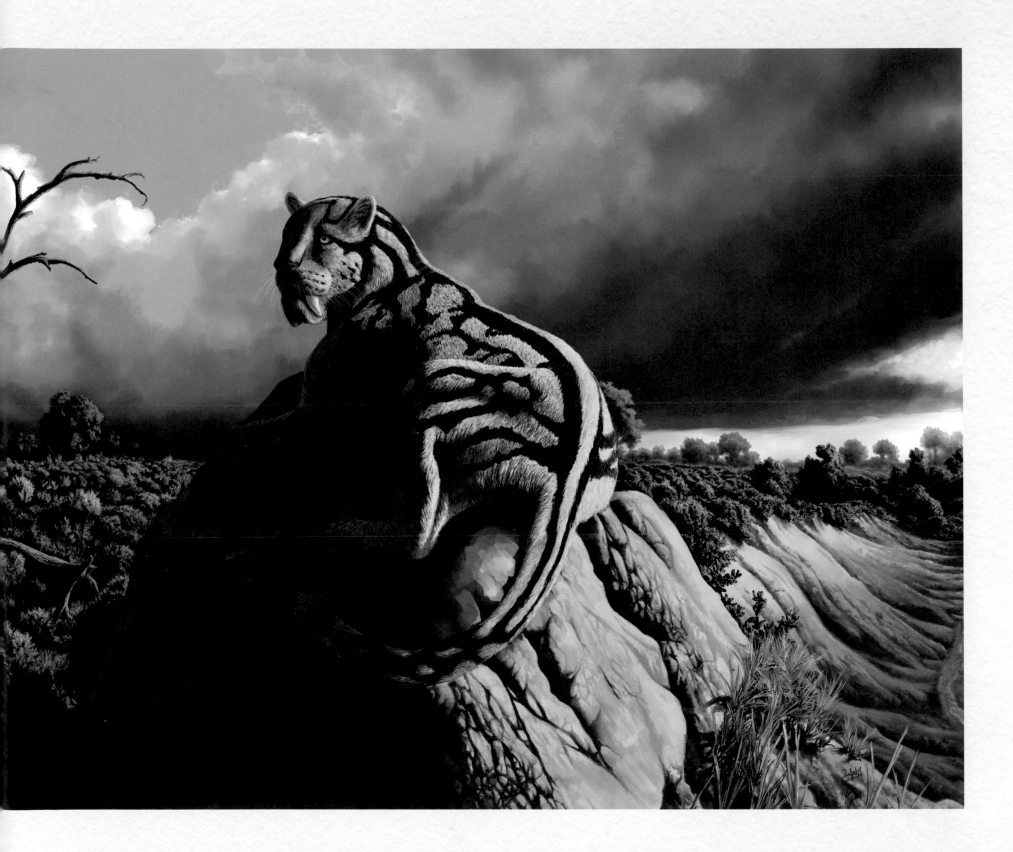

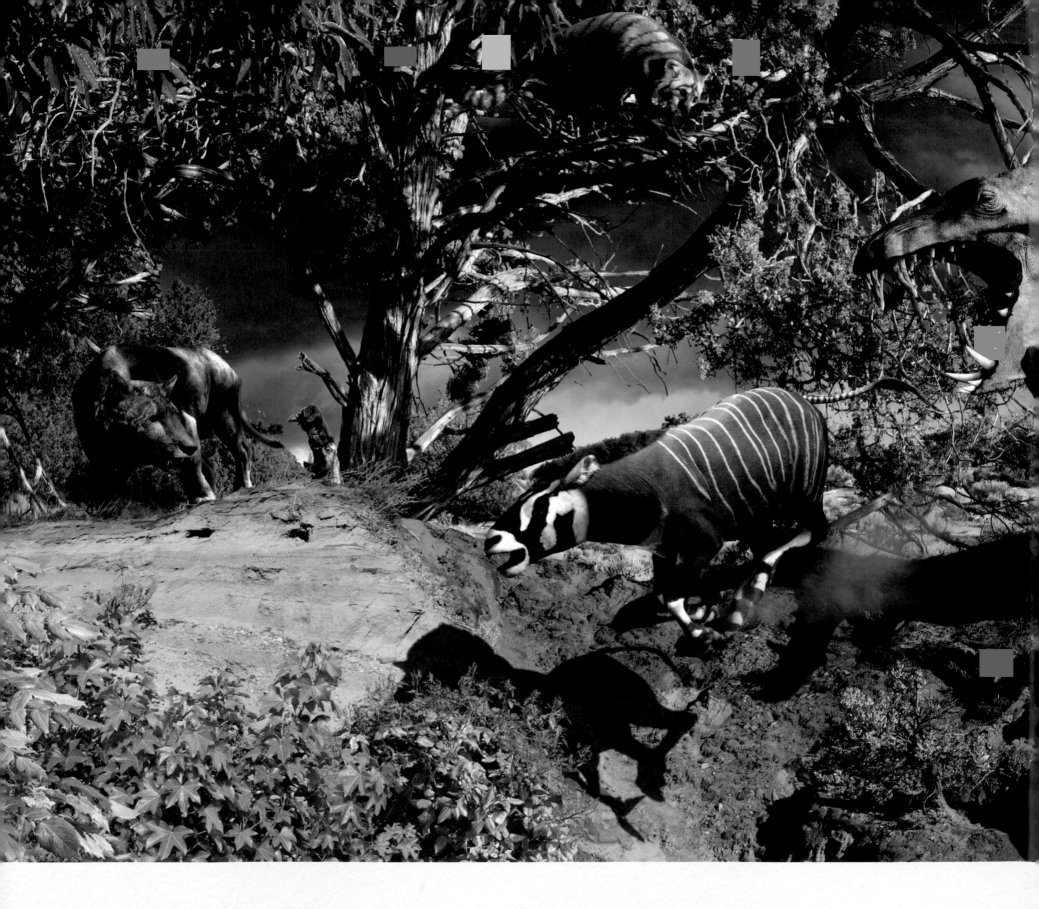

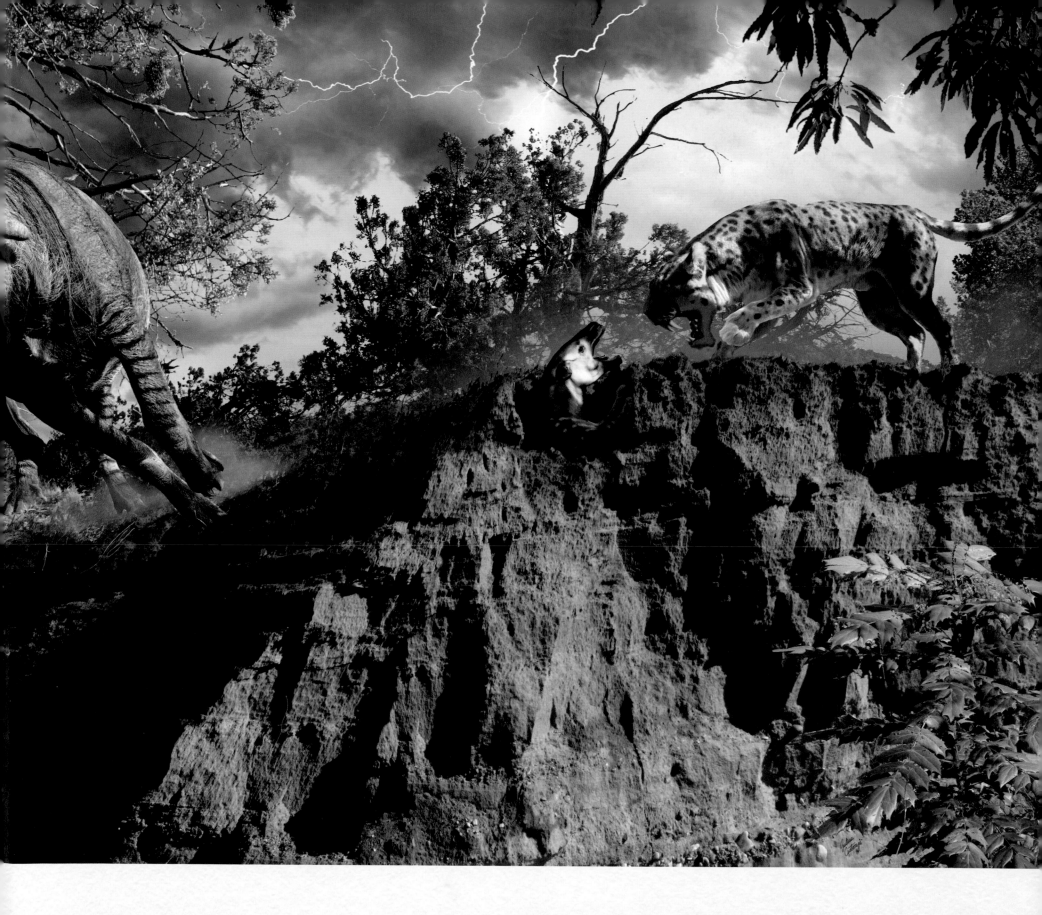

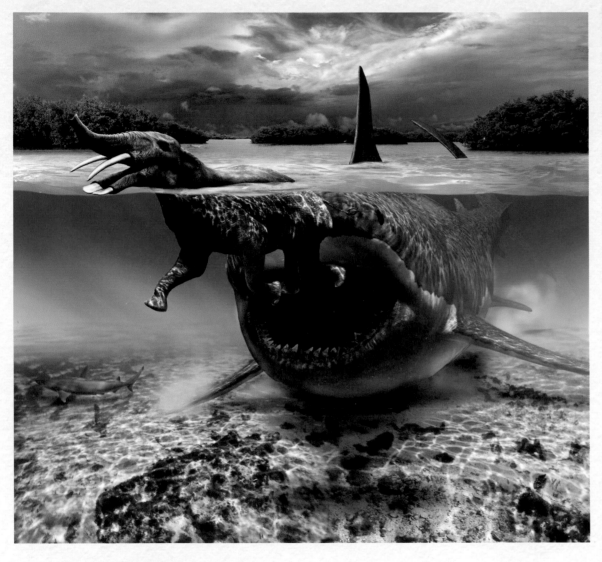

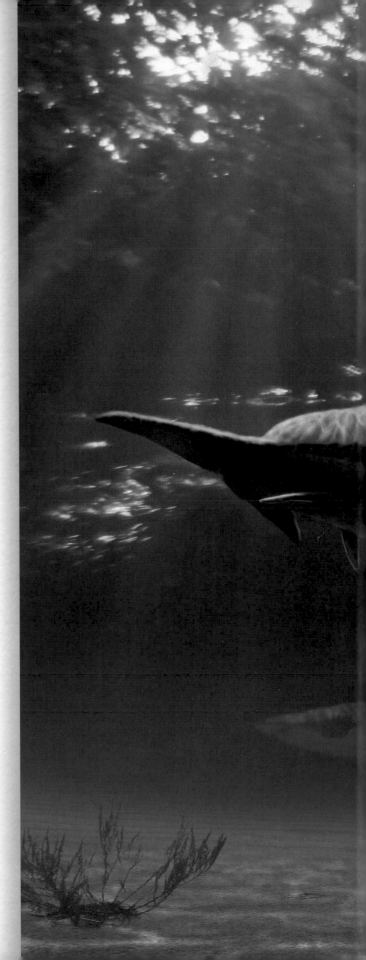

(Above) ***Carcharocles megalodon* Snacking On *Platybelodon* In Miocene Waters.** Photographic composite. Commission: Hall of Paleontology at the Houston Museum of Natural Science. 2012.

One of fourteen of my images appearing as backlit panels (about four feet tall) in the enormous new Hall of Paleontology at the Houston Museum of Natural Science, this image depicts the probably rare but plausible encounter between the giant shark *Carcharocles* (jaw diameter estimated at eleven feet) and a medium-sized proboscidean, *Platybelodon*. Whereas adult sharks likely dined in deep water on large marine prey, relegating their young to the safety of nurseries in shallow lagoons, it is plausible that an adult could enter shallow water occasionally, especially under stress.

(Opposite) ***Dorudon.*** Digital painting and photographic composite. Commission: Look at Sciences. 2009.

An early basilosaurid whale from the Eocene found in Egypt that exhibited vestigial external hind limbs, and thus represents a wonderful example of an intermediate evolutionary form. Later forms of whales possess internal vestigial pelvic bones, but no external hind limbs.

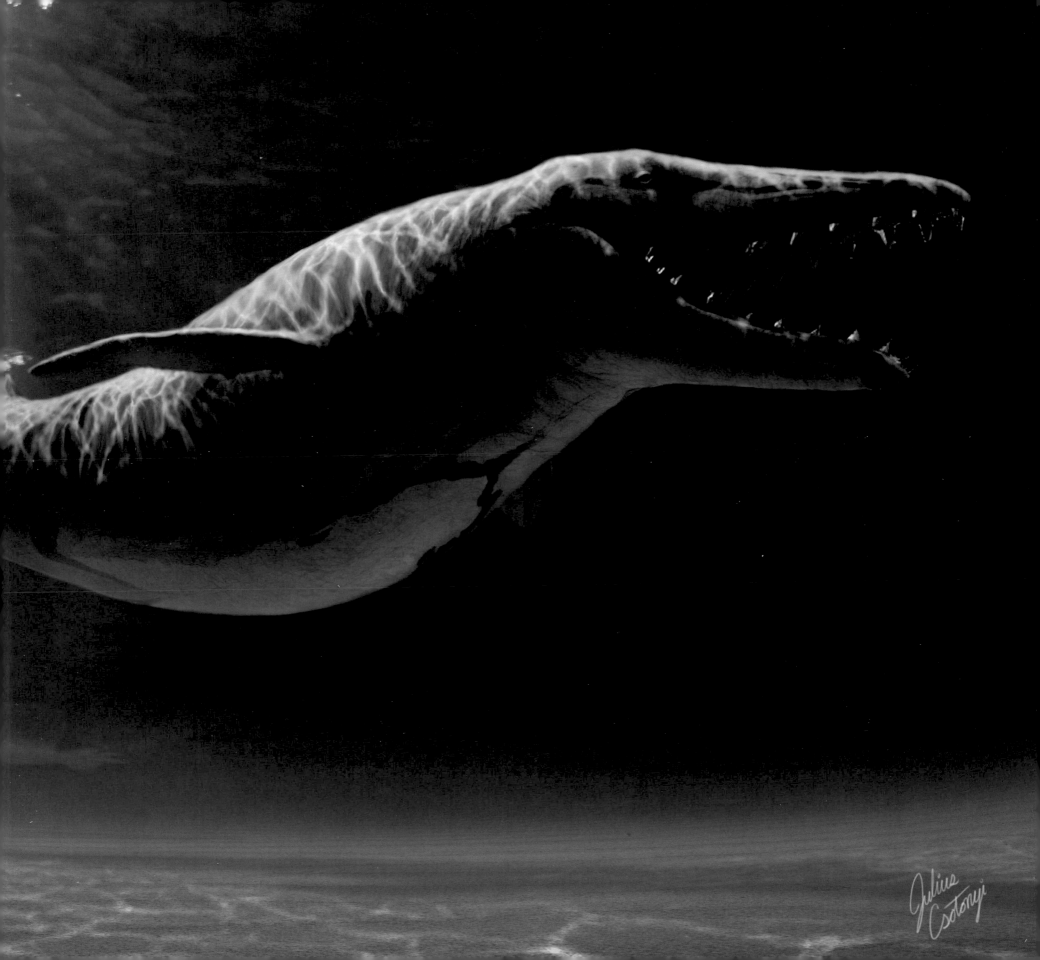

Julius Csotonyi

abelisaurids: A group of unusual theropod dinosaurs with short, tall skulls, usually decorated with horns or projections.

allosaurs: Term used for the group that includes Late Jurassic theropod *Allosaurus* and its close relatives, properly termed Allosauroidea. Allosauroids occurred worldwide during much of the Jurassic and Cretaceous.

ankylosaurs: A group of heavily armored dinosaurs, allied with stegosaurs in the ornithischian clade Thyreophora. Most belong to the sub-groups Ankylosauridae or Nodosauridae. Many possessed spikes covering their backs and/or flanks.

archosaurs: The group of reptiles that includes crocodilians, pterosaurs, and dinosaurs. They are diapsids – part of the enormous assemblage of reptiles that also includes lizards and snakes. One of their key traits is the antorbital fenestra, a large opening on the side of the skull between the nostril and eye socket. Archosaurs diverged early in their history into Ornithodira (pterosaur-dinosaur branch) and Pseudosuchia (crocodilian branch).

articulated: Refers to fossil skeletons (or parts of skeletons) where the bones are found in positions roughly equating to how they would have looked in life.

azhdarchids: A group of large-to-enormous pterosaurs, predominantly from the Late Cretaceous. They include the largest animals ever to take flight.

benthic: The bottom of a body of water, in particular the deepest part.

blackbody: A hypothetical physical form that absorbs all electromagnetic radiation no matter the type, frequency, or angle it strikes the form at.

brachiosaurs: Informal term for sauropods thought allied to the long-armed, short-tailed Jurassic giants *Brachiosaurus* and *Giraffatitan*. Some/most sauropods once grouped together as brachiosaurs are actually early members of the titanosaur lineage.

ceratopsian: The horned dinosaurs – though not all had horns – including psittacosaurids, as well as the neoceratopsians, leptoceratopsids, and the large, often horned ceratopsids.

crocodylomorph: Term for members of Crocodylomorpha, the technical term used for the archosaur group popularly termed crocodilians.

crypsis: The ability of an organism to avoid observation or detection by other organisms using methods including camouflage.

formation: (As in Morrison Formation) A geological unit consisting of clearly defined levels of rock strata of a certain age.

genus: A term used in the classification of an organism. It is understood to house a number of related species, though there is no consistency over how 'inclusive' a genus should be. Members of a genus typically look similar.

hadrosaur: Also known as 'duckbills', the hadrosaurids were abundant plant-eating ornithopod dinosaurs, best known from the Upper Cretaceous of North America, Europe, and Asia. Many had bony head crests.

ichnofossil: Also called a trace fossil. A fossil representing not an actual organism but a record of biological activity, e.g. footprints, nests, burrows, tooth marks, or dung (coprolites).

ichthyosaur: A group of Mesozoic marine reptiles.

integument: Skin or body covering.

lagerstätte (*pl.* lagerstätten): A sedimentary deposit containing fossils of exceptional preservation and/or diversity, e.g. the Burgess Shale of British Columbia, Canada, Solnhofen Limestone of Germany, and Xixian formation of China.

Laramidia: An island continent formed by what is now the western mass of North America during the Late Cretaceous Period between 100 and 65 million years ago.

maniraptor: A grouping of dinosaurs that includes several families closely allied to birds (which many researchers consider part of the Maniraptora). Amongst the subgroups are the Deinonychosauria, e.g. *Velociraptor*, Oviraptorosauria, and Therizinosauridae.

mastodon: Term usually restricted to the American mastodon (*Mammut americanum*), a fossil relative of elephants that inhabited North America between 3 1/2 million years ago and 10,000 years ago.

mesic: A habitat with a well-balanced supply of moisture.

mosasaur: Informal term for the large-to-enormous, mostly marine lizards of the Cretaceous.

ontogeny (ontogenetic): The development of an organism from conception to maturity, e.g. fetus to adult.

ornithischian: The Ornithischia or 'bird-hipped' dinosaurs, a group of plant-eating dinosaurs recognizable by their beaks and distinctive hip structure. The major ornithischian sub-groups are Thyreophora, Ornithopoda, and Marginocephalia. They share a Triassic ancestor with the saurischians or 'lizard-hipped' dinosaurs.

ornithopod: A group of ornithischian dinosaurs that includes small, bipedal forms like *Hypsilophodon* and the dryosaurids, as well as larger, more quadrupedal kinds like *Iguanodon* and the hadrosaurs.

oviraptorid: A group of bizarre, beaked, bird-like theropods of Late Cretaceous Asia and North America. They are part of the larger group Oviraptorosauria.

placoderms: An extinct class of armored fish that includes the first to develop jaws. They lived from about 450 to 359 million years ago, although the exact date of their appearance is currently unknown.

plesiosaur: Informal term for members of Plesiosauria, a group of Mesozoic marine reptiles that includes both long-necked plesiosauroid- and short-necked pliosauroid-type forms. The term 'plesiosaur' is sometimes used only for long-necked forms, in which case it might be helpful to refer to all members of Plesiosauria as plesiosaurians.

pliosaur: Informal term for short-necked members of Plesiosauria, not all of which are closely related.

processes: The various flanges and extensions of bone seen on the vertebrae of many animals.

protofeathers: Quill-like structures resembling a feather without its barbs or down. They have been discovered on a number of different types of dinosaurs.

pterosaur: Members of Pterosauria, a group of flying archosaurs, closely related to dinosaurs, that dominated the Mesozoic skies since first appearing in the Late Triassic. Their membranous wings were supported by a hyper enlarged fourth finger.

rhamphorhynchoid: Unofficial term for all those pterosaurs that are not members of the longer-necked, longer-handed pterosaur clade Pterodactyloidea.

sauropod: A member of the large (in every sense) group of generally long-necked, plant-eating saurischian dinosaurs that include some of the largest animals ever to walk the Earth.

species: A term used in classification to describe a population of organisms that generally look alike and are capable of interbreeding and producing fertile offspring.

taxon (*pl.* taxa): Term used for any unit in classification, ranging from a single species all the way to a huge group containing millions of species.

tetrapod: A superclass of all four-limbed vertebrates, extinct and living, including amphibians, reptiles, birds, and mammals.

thecodont: Informal, and mostly abandoned, term for a broad range of archosaurs.

therapsids: A diverse group of mammal-like reptiles from which true mammals evolved and to which they are closely allied.

theropod: The predatory dinosaurs and birds.

tyrannosaur: Informal term used variously for members of the theropod clade Tyrannosauroidea, or for the tyrannosauroid clade Tyrannosauridae.

vertebrate: Any animal with a spinal chord.

Eon	Era	Period	Epoch (million years ago)	
Phanerozoic	Cenozoic	Quaternary	Holocene	
			Pleistocene	Late
			(to 0.01mya)	Early
		Neogene	Pliocene	Late
			(to 1.1mya)	Early
			Miocene	Late
				Middle
			(to 5.3mya)	Early
		Tertiary / Paleogene	Oligocene	Late
			(to 23.7mya)	Early
			Eocene	Late
				Middle
			(to 33.7mya)	Early
			Paleocene	Late
			(to 54.8mya)	Early
	Mesozoic	Cretaceous	Late (to 65mya)	
			Early (to 99mya)	
		Jurassic	Late (to 144mya)	
			Middle (to 159mya)	
			Early (to 180mya)	
		Triassic	Late (to 206mya)	
			Middle (to 227mya)	
			Early (to 242mya)	
	Paleozoic	Permian	Late (to 248mya)	
			Early (to 256mya)	
		Pennsylvanian (to 290mya)		
		Mississippian (to 323mya)		
		Devonian	Late (to 354mya)	
			Middle (to 370mya)	
			Early (to 391mya)	
		Silurian	Late (to 417mya)	
			Early (to 423mya)	
		Ordovician	Late (to 443mya)	
			Middle (to 458mya)	
			Early (to 470mya)	
		Cambrian	D (to 490mya)	
			C (to 500mya)	
			B (to 512mya)	
			A (to 520mya)	